D0937965

SEARCH
FOR
NEW ARTS

BIEDERMAN

ART HISTORY
RED WING, RT. 2
MINNESOTA

1979

SEARCH

CONSTABLE

TURNER

BOUDIN

ROUSSEAU

JONGKIND

COROT

MONET

MOREAU

CEZANNE

REDON

TALBOT

BRADY

FOR

COURBET

SEURAT

MONDRIAN

GRIFFITH

BRETON

DOESBURG

ROOT-BELL

WRIGHT

NIEPCE

OUD-MIES

ERNST-GABO

COURBUSIER

HULSENBECK

SULLIVAN

NEW ARTS

1979 RED WING

PAINTERS

MONET -

ROOT-

CEZANNE

NEW ARTISTS

Photo credits from left to right. Above: Claude Monet, Paul
Cezanne, permission of John Rewald; Opposite page: John Root
permission of Donald Hoffman; Mathew Brady, 1857 oil by
Charles Elliott, photo cropped, permission of The Metropolitan
Museum of Art; Frank Lloyd Wright, permission of Iovanna Lloyd
Wright Schiffner; David Griffith, permission of The Museum of
Modern Art Film/Stills Archive, New York.
Library of Congress Card Number: 79-90835 ISBN 0-935476-01-6
Copyright © Charles Biederman 1979.

ARCHITECTS

O'SULLIVAN - WRIGHT

BRADY - BELL - GRIFFITH

PHOTOGRAPHERS FILM ARTISTS

C O N T

1. SEARCH BEGINS 2

2. PAST COMPROMISED 4

3. SEARCH CONTINUES 6

4. BEYOND PERCEPTION 12

5. CRISIS OF NEW 18

6. NEW REJECTED 26

7. CRISIS OF CONSCIOUSNESS . . . 30

8. NEO-IDEAL 34

E N T S

9. PAINTING AS NEW 36

10. SCULPTURE AS NEW 44

11. PAST AS COLOSSUS 54

12. A NEW VISION 58

13. NEW VISION OF CREATION 67

14. NEW VISION OF ARCHITECTURE . . 77

15. UNIFICATION 119

To my late wife Mary Moore who, from 1941 to 1974, was consultant and editor for all my published writings. Whatever merit this essay has, I owe to her. My art and writing are inestimably in her debt.

ACKNOWLEDGMENTS

I would like to express my appreciation and thanks to Pierce Butler; his help and advice in the publication of this book were indispensable. My thanks and appreciation to Sybil Woutat whose conscientious editorial work brought the manuscript to its final improved form. To Eugenie Anderson for her concern with this project, my appreciation. To Frances Smith my thanks for her diligent typing of the manuscript. Finally, I wish to express my appreciation to the many authors and their publishers whose works were indispensable to my research and to the individuals and institutions who permitted me to reproduce their art works.

C.B.

PREFACE

The essay to follow was begun early in 1964; the last draft was concluded late in 1976. During those years most of my time was devoted to my art; I wrote infrequently. This extended time, however, proved invaluable in an unexpected way due to developments in my own perceptual experience of nature. As a result, what had begun as an analysis of the machine as a medium appropriate for the realization of a genuine New Art was extended. Photography and architecture were now included, and were contrasted with the obsolete handcraft arts of sculpture, painting and masonry architecture.

Hence, the original inquiry into the aspirations and consequences of European painting and the New Art replacing it developed into an awareness of the unification inherent in all three New Arts. Beginning with the latter part of the 18th century continuing to the present, unification of the arts had increasingly become fragmented between and within each of the three handcraft arts. Now it had become possible to resume unification which had characterized all past great periods of art.

If I have approached this problem without offering a sociological exposition of the history with which I deal, that is not to deny the significant relations of the arts to the total society from which they emerged. I believe, however, that one must begin by analyzing the perceptual behavior of the artist as it reveals his view of reality. Everyone distinguishes between good and bad art but not whether it is perceptually good or bad for our society. This problem is especially pertinent when one considers that children are perceptually brain-washed with whatever surfaces out of the market place of art. Indeed it would seem of fundamental importance to inquire into the kind of perceptual behavior the artist asks us to adopt. Such an inquiry would provide a relevant focus for discerning the significance of those social factors involved in the arts.

While an inescapable part of their times the arts reveal themselves as harbingers, destructively or creatively, of the future condition of society. Thus, 25 years before the great revolutions of modern science and 35 years before the great debacle of European civilization in a world war, the art of painting was anticipating the despair and conflict over a civilization "gone forever," and the need for a new reality perception of nature and art to meet the demand for a new civilization. Rather than confronting this conflicting state of art and nature the art world offers us, to say the very least, the desperations of perceptual vacillations.

INTRODUCTION

In 1936, I left America for Europe to learn more about both countries, this time from the other side of the ocean. It seemed to me that American art was nothing, that European art was everything. Living and working in Paris, however, the expectations that brought me to Europe dissipated. Out of that experience I came to understand that America was the only hope for the future realization of a genuine "new" art, one that would replace the obsolete forms of European art. The "nothing" of American art became the precise reason which compelled me to return to America in 1937.

In New York my views on Europe and America met with as much incredulity as had been the case in Paris. Two decades later, when New York appeared to have replaced Paris, the eventual resurgence of xenophobia labelled me "unAmerican." I had committed the cardinal sin, by now of long standing, of insisting that American art would remain "nothing" unless it continued the achievements of Europeans.

While it was understood that European civilization had collapsed in World War I, few realized that European art had also collapsed with that very civilization which had nurtured it. Yet even before the turn of the century eminent Frenchmen saw the coming collapse of both European civilization and art. Thus, if the position of Paris seemed untouched until after World War II, it was as a false art center. For Paris, like all the artists it represented, turned inward upon itself. When New York seemingly replaced Paris, it was as a false art center too, even representing a false American art, because such art simply continued the decadence of 20th century European art. If then New York artists insisted on the utter purity of their "noble savage" Americanism, the Europeans status-quo in art correctly appraised such American artists as their own heirs.

The noisy babble of American artists today is the direct result of their not understanding their own past, not perceiving that the first great American artists began to appear from the middle of the 19th century on into the early decades of our century. These artists were photographic, architectural and film artists who had prepared the way for Americans to realize the future of art just as European art was collapsing with the opening of our century. By mid-century, however, New York had become the new center for art by pulling the shroud of Paris over its own head.

* * * * * *

Our century takes unbounded pride in the spectacle of ceaseless art revolutions in Europe and then in America. Indeed, revolutions became fashionable. The genuine revolutions, however, had already taken place in the 19th century. What remained for the 20th century artists was to take the final step, to consummate the revolutions. The alternative was counter-revolutions which was inadvertently confirmed by counter-revolutionaries themselves in their incredible contempt for the remarkable European art of the past and for nature as well.

The only other time in the history of Western civilization, besides in our own century, when the past and perceived nature had been so completely condemned and so completely replaced by perceptual retreat, was when the Christian view of reality replaced the pagan view. In both periods, contrary to popular belief, art had not become genuinely new but rather had reverted to primitive perception. What appeared new in both periods was the new form given to primitive perception, a form inescapably motivated by the pathological demands of regression.

Paradoxically it was the tenacious presence of rejected representational visual habits which resulted in the gradual and inevitable regression to pathological primitivism in 20th century European art. Under these paradoxical conditions, modern art labored under a nagging insecurity manifested in a panicked contempt for the Renaissance past and for nature. Those European artists who felt this insecurity most deeply turned for salvation to the allure of the great revolutions of modern science. They felt the revolutions of art and science were similarly motivated. That assumption, more than any other, drove the ancient perceptual habits even more deeply into the subconscious, where they disappeared completely. What had previously been obvious became confused; i.e., whatever similarities might exist, the revolutions of art and science were not similar. Hence the great innovations of art which had their inceptions in the 19th century remained unconsciously or consciously opposed with respect to their fundamental challenge to 20th century artists.

Certainly the enormous distinction between classical and non-classical science and between representational and non-representational art, i.e., between object and non-object perception which involved both art and science in the problem of the separability of form from space as at best displaced, were of such an overwhelming distinction

that artists and scientists felt compelled to deny or affirm the past's perceptuality with an underlying attitude of protest.

If the revolutions in science began at the turn of the century with Mach and Einstein, the revolutions in art began even earlier with Monet and Cezanne. While the momentum of the scientific revolutions increased from relativity to quantum mechanics in the first three decades, the same period saw the opposite course take place in European art. Milic Capek pointed out, however, that the habits of classical thought persistently intruded in modern physics precisely because they were rejected, for rejection served to drive the old visual habits deep into the subconscious where they remained undetected and therefore much more insidious. Something similar occurred in art with far more disastrous consequences.

With the turn of our century, past representational habits in art were denounced in fits of hysteria. As a result the ancient visual habits became so deeply buried that the irrationality which denounced representation also served to reject any rational consideration of the problem. Consequently the old perceptual habits persisted in a disguised form in *all* aspects of European "new" art, in spite of dogmatic disclaimers to the contrary. The whole European past, from Leonardo to Monet and Cezanne, was denounced as no longer the continuing source of art. Suppression of representational vision does no more than that, because the old vision simply cannot be eliminated, it can only be extended. The alternative is to regress perception. The recent efforts to escape the more apparent forms of regressive perception by a return to the formerly despised realism simply place art in the hands of the mortician, and proclaim that Madame Toussaud had, after all, discerned the future art.

In spite of the enormous number of destructive forces which have dominated all the arts, there have been those few artists who have built on the past and nature and gave birth to those genuine arts that are truly expressive of our century.

* * * * * *

In the essay to follow, the above and related problems will be considered by pursuing the course of European painting and American and European architecture, for these two arts played the determining roles in what European and American art became in our century. This essay is directed to those weary of revolutions which are only the expediencies of fashion. As have Root and Wright before me, I will show the extraordinary potentialities for art in our times are uniquely open to the midwestern American temperament.

SEARCH
FOR
NEW ARTS

1. Search Begins

The landscape! It is in the landscape that a new perception of nature and art will be sought. But first two great English landscape painters will be among those who bring the past's vision to its last extension in a realistic and romantic depiction that, at the same time, seems to promise a new perception of nature and art.

Constable, the realist, expressed the sheer joy of amalgamating his subjective self to the direct perception of visual nature. He sought to capture an instant of nature's light. He revealed visually what he believed could be seen by all who would learn to see. (fig. 5)

Turner, the romantic, took an opposite course. Instead of submitting his subjective self to nature, he submitted nature to his subjective response. He thus transported what could be seen into what could never be seen except in his paintings.

If Constable brought a further perception of *light in nature*, Turner evoked a new awareness of *light in painting*, as no one before him had done.

While France produced landscape painters such, as Michel, who were more or less contemporaries of Constable and Turner, none was comparable to the Englishmen. In 1824, however, an exhibition in Paris opened the eyes of the French to what the English had achieved with their perceptions of the landscape as Light. Thus in the mid-19th century French landscape painters took up the pursuits of the English. Courbet belonged to this effort and had a special role in establishing the significance of the landscape.

Courbet was a summation and a conclusion of the Renaissance period of European figurative painting. In his work, "form" appears in the grand manner of the old masters, to burst into what was to be its final exuberant glory. For no one after Courbet would ever again approach such achievement. In concluding the past's vision of "form," he was the last to brush the life of paint into the human figure. (fig. 10)

Courbet was not only the last giant of mimetic art, but, with equal vitality, he responded to the new interest in the landscape. He became a bridge to those who saw the landscape as the means to a new future for art. He achieved this by ignoring the now false controversy between the classicism of Ingres and the romanticism of Delacroix. Instead he brought art to a direct perception of nature. This was a necessary step if the landscape would lead to a perception of nature beyond mimesis. (fig. 9)

In the past, nature was largely a backdrop for the main event — man. Now the painter literally centered his being in the landscape as such. Man no longer placed himself in contrast to nature, but saw himself as nature. No longer outside of nature, man discovered he was an extension of nature. (fig. 7, 8, 9)

"Form," which had dominated the optical orientation of past vision, was now centered directly in the optics of the perceived image as the experience of light. Light, exclaimed T. Rousseau, literally "gives life." Without this recognition of light, he felt, there could be "no creation." [1] He was the first to depict a single subject in its various aspects of light, which Monet later took to a further and different perception of light as color.

"The earth," exclaimed Boudin, is "enveloped" by light, it "transforms everything." [2] The new painter was evolving from a vision limited to "form," to a perception of the ceaseless changing motions of light. The sky and the sea as the epitome of motion, Boudin found, were "so beautiful" when perceived in "light," and in the "air." [3] The new visual perception of nature was evolving in what Boudin called light's "magic." [4] The limited vision of "form" had begun to be replaced by light as a higher order of structural perception. The restricted skylight of the studio, the old domain of "form," had been replaced by the open air, the sky and sunlight, of nature itself.

The human form, as the dominating subject in the past, had received limited perceptual awareness. Light served largely to refine "form," as color it merely distinguished the quality of one form from another. Light as simply revealing form gave way to light revealing the spatial structure of form and color. In the new landscape painting, light as color, or color as light, came to dominate the ancient notion of form. Light filled the very "air," that space which past artists saw as "empty" simply because form was absent. Light was now achieving a perceptual palpability which had previously been reserved for form. Light was in the "air," a spatial experience. Light revealed a new structure for "everything," without which "no creation" was possible. The landscape painters were discovering the means by which to go beyond exhausted imitation to "creation." This was the new attitude of French painters as they sought what they called an "impression" of nature.

Monet discovered these early artists of light, Boudin and Jongkind in particular who, with Courbet, opened the way for what became his own search. (figs. 7, 8) In time, Monet possessed the perceptual interests of both Turner and Constable, but with critical differences. He responded, as Constable did, to each particular light condition of nature, but for purposes of realizing further one aspect of the effort of Turner — to achieve color creations of light

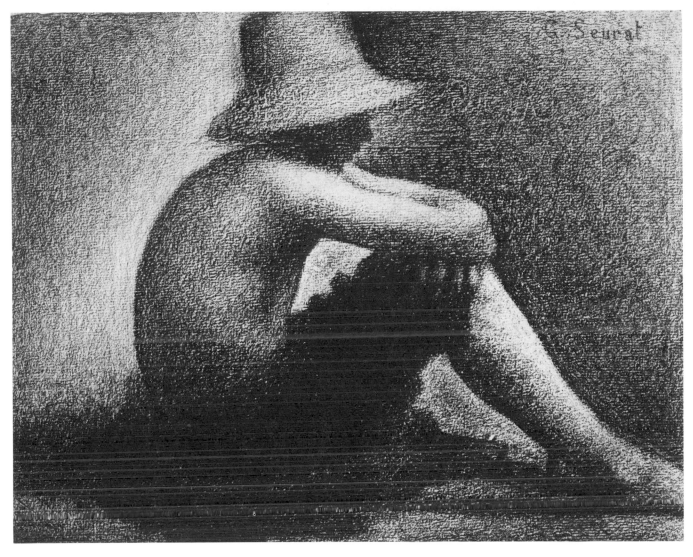

1. Georges-Pierre Seurat, *Seated Boy With Straw Hat*, (Study for "Une Baignade") 1883–84, Yale University Art Gallery, New Haven.

unique to the potentialities of painting. Unlike Turner, however, Monet was not seeking a new version of past perception, but rather a truly new perception of vision as light.

Around 1880 Monet had begun to realize what the painters of light before him had opened to perception. He now created with light, but beyond the limitations of mimesis, to begin creating what was unique to painting. Color, color as light, now became the center for the perception of all aspects of structure. Monet once remarked that there was "only one teacher," saying which he pointed to the sky and its flooding lights.[5] (figs. 14, 15, 16)

With Monet, form sought an integration with the spatial color of light. The particularity of nature now became the means for achieving that particularity unique to painting. To this end, he advised the young painter to "forget what objects you have before you" and concentrate on geometric shapes and colors to structure a painting. He expressed the wish he had been born blind to later acquire sight.[6] Thus he hoped he might more readily perceive nature anew in perceptual terms appropriate to painting as an act of creation.

Through the artist's subjective experience, Monet was extentionalizing perception to a new and deeper vision of nature's objective reality. He was beginning to see nature and art as similar but different forms of structural creation. For that reason he refused to be limited by the past's notion of form, which he described as the "solidity of unified volumes."[7] That was his way of characterizing the past's limited notion of structure as largely sculptural. He would go further and give birth to a new perceptuality, the spatial motion of light.

2. Past Compromised

Around the beginning of the 1880's, Monet alone was achieving the only realization of what could properly be called Impressionism. This is acknowledged in a reverse way, for in those same years all but one of his original followers concluded that Monet had led Impressionism into great errors. What disturbed them, but in a more subtle way, was precisely what had disturbed all those academicians who had rejected Impressionism from its beginnings. Namely, that neither the old content, nor the old perception of structure as "form," remained the central concern of Monet's Impressionism. As the subsequent works of his former followers indicated, they wished to see Impressionism only in terms which would be a continuation of past art; i.e., mimetic abstractions representing descriptive and/or literary goals. Their assumption was, knowingly or not, that the mimetic method of art was still capable of renewing itself. In short, they would make the old yield the new once more.

Accordingly, Seurat was certain that with Monet, Impressionism had gone astray. In his view, Renoir, Degas, and Pissarro, not Monet, were the really important Impressionists.[8] Like himself, they were not disturbing the structure of the old image in any fundamental way. He, in any case, without ever understanding his underlying objections to Monet, would direct Impressionism to what he considered its proper goal, by making it "scientifically" based in its use of color.[9] He flatly rejected Monet's intention to take structure beyond the old "solidity" limits of "form." To the contrary, Seurat insisted that painting was a matter of "hollowing out a surface."[10] That is, he would retain the past's limited notion of structure as painted sculpture (fig. 1); indeed, it was precisely the "sculptural qualities" he approved of in Gauguin.[11] As his work sharply indicates, his vision was so bound to the ancient perception of structure that he appears to have constantly recalled that most overwhelming manifestation of form, namely, the "solidity" of Egyptian sculpture. Although Seurat denied having any literary intentions, his work quite properly received the admiration of Symbolist writers. In fact, he was one of those who attended Symbolist gatherings and banquets.

Renoir, for his part, expressed nothing less than a hatred for Monet's Impressionism. He denounced it as "retrograde."[12] If Seurat turned his vision to the Egyptians, Renoir looked back to the art of Pompeii as he, too, sought to recover the ancient structure of sculptural "form." (fig. 2) Clearly, both painters were securely held in the grip of the old content and structure of art.[13]

Van Gogh, who regarded Monet's Impressionism as being limited to the "small sensation," also returned to the vision of the ancient past, (fig. 3) this time to Oriental art, and to the Japanese print in particular. His version of Impressionism would also make the old yield the new by submitting mimetic perception to the directives of his personal symbolizations. Painting, then, was to express "thought" and "ideas," as if the chief role of the visibility of painting were to convey literary induced experiences.

Gauguin, too, saw Impressionism as too narrow in its intentions, as if it were making an inventory of the physical aspects of nature, merely "material" in its intentions, therefore, a "superficial art." In his view Impressionism was too much concerned with the workings of the eye, instead of with the "mystery of thought." Like Van Gogh he appealed to the use of literature. He too insisted on going further back into the past, even beyond Pompeii, Egypt and Oriental art, back all the way to the stimulation of "savage sources."[14] He would make the old yield the new. In short, he regarded art as a "conceptual" problem, the "expression of an idea," the function of form being a "symbolic" one. (fig. 4)

The former followers of Impressionism were clearly in opposition to Monet, their intention being to rejuvenate the old vision through the stimulation of earlier forms of such art as the means to new art. They did not understand that the final significant act of mimetic vision had taken place in Courbet's art. Consequently they were unaware of being perceptually conditioned, which gave them no other option than to be confined to the perception of the distant past, although each of them had acknowledged that the art of imitation had reached an impasse in realism. Hence their return to primitive and other earlier forms of imitative art and structure was rationalized by appeals to that which was not painting, such as literature and science. Indeed the whole future of "modern art" was foretold, even to specifics, by the art of Courbet and Monet and the art of those who opposed them.

It is understandable, then, that at an exhibition of Monet's art Pissarro found the work not "highly developed," agreeing with Degas that it was not even "profound decoration." With the critic Feneon, the chief advocate for Seurat's art, Pissarro agreed that the work was even "more vulgar" than before.[15] Of course, Monet's art was bereft of all they looked for, so it was regarded as mere decoration and failing even in that. It was simply "vulgar." They found none of their own concerns with descriptive and/or symbolic depictions, above all, the absence of their principal interest in the human form — e.g., dancing, picnicking, circus, bordello, etc. To make

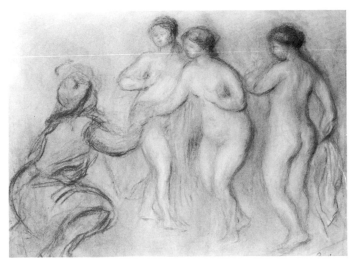

2. Pierre Auguste Renior, *The Judgement of Paris*, The Phillips Collection, Washington.

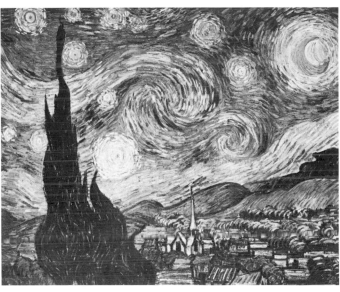

3. Vincent van Gogh, *The Starry Night*, 1889, oil on canvas, 29 × 36 1/4 in., collection The Museum of Modern Art, New York, Lillie P. Bliss Bequest.

matters worse, Monet appeared to have destroyed the very mode of form structure necessary to their own effort to continue the old and make it yield the new.

Monet's art seemed strange and disturbing because his former followers were measuring his work according to those obsolete values they applied in their own art. In such a comparison Monet's work was certain not to appear as "highly developed." Under such circumstances it was impossible to see that Monet was the beginning of a fundamentally new perception of both nature and art.

Thus Impressionism became divided into two separate and opposing purposes. While Monet was bent on giving extension to the perceptual actualities of nature as light, his former followers refused to go beyond the ancient perception of mimesis. In place of Courbet's direct reliance on the actualities of vision, they denied such vision while paradoxically being confined to manipulating such a vision. A perceptual division had become manifest that would prevail throughout the future of modern art with crucial consequences.

Monet continued to evolve further the notion of extroverted perception, as against those who would introvert perception. *The latter would force the old to yield the new, while Monet would go beyond the old to reach the new.* Here there has arisen the problem that will dominate all future art. It comprises a conflict between those who would appeal to the verbal introversion of literature, and those who would appeal to the non-verbal extroverted experience of the perceptual world of vision.

It is apparent that all who rejected Monet's Impressionism would more properly be called neo-Impressionists, in the sense that they would re-do what had already been done by Monet.

In the rest of this essay, the use of the prefix "neo-" will *similarly* be applied to subsequent art movements. With the exception of Seurat and Mondrian, this has not been the general practice.

3. Search Continues

As if to chide the former followers of Monet, Cezanne remarked, "I don't hide it," referring to his having been an Impressionist.[16] Contrary to those who would reject Monet, Cezanne was bent on continuing and furthering the new direction of art which Monet had introduced. It was inevitable, therefore, that the neo-Impressionists would have even more difficulty with the work of Cezanne than with that of Monet. According to Pissarro, they found his work both "strange" and "disconcerting," with faults which "we all see."[17] They were not as certain, as they were with Monet, why they were disturbed. Since Cezanne made even more radical structural changes than Monet, they could only speak of his work as "disconcerting." Again, as with Monet, their perceptual conditioning to the mimetic past made them completely incapable of understanding what Cezanne was about.

Cezanne alone understood the discoveries Monet achieved. Namely, that a new vision, one that went beyond the "vision ready made" within the eyes of the artist,[18] was beginning to form; that a new perceptual structure of nature and art was evolving. Cezanne would further Impressionism by giving it a "framework," to make it "durable" as in the art of museums.[19] He was to do so in such an extraordinarily simple way that no contemporary was aware of what he achieved.

First, he adopted three of the basic geometric forms — sphere, cylinder and cone — with which to begin his inquiry into a new perceptual structure of nature. He found that these three geometric forms applied to the structural study of nature's forms could, when combined in various relations, account for all forms and form relations that could possibly occur in nature.[20] He thus established a geometry with which the study of nature's structure could commence. Some have assumed that what Cezanne was doing was no different from what past artists had done to facilitate their imitations of nature. Past uses of geometry, however, had the purpose of simplifying the complexity of nature's structure to facilitate visually the representations of the human form. Cezanne had a reverse intention. He adopted a geometry of *simplicity* whose interlocking relations could account for the full *complexity* of nature's structuring. He was not concerned merely with depicting natural forms, but with establishing a geometric foundation appropriate for an inquiry into the creative process of nature's structure. He then further evolved the structural function of his geometry in order to further his inquiry into nature's creative process, "translating" the results of his inquiry into the goal he shared with Monet. That is, to achieve an art unique to the special structure of painting.

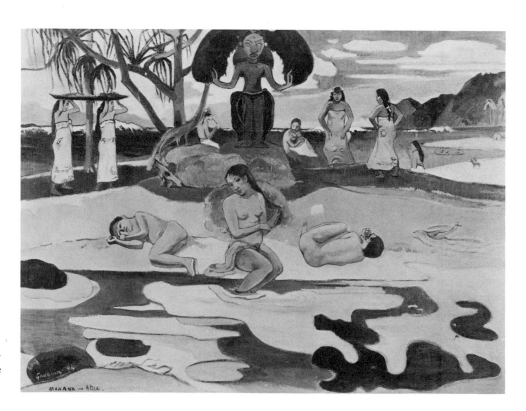

4. Paul Gauguin, *The Day of the God* (Mahana No Atua), 1894, The Art Institute of Chicago.

6

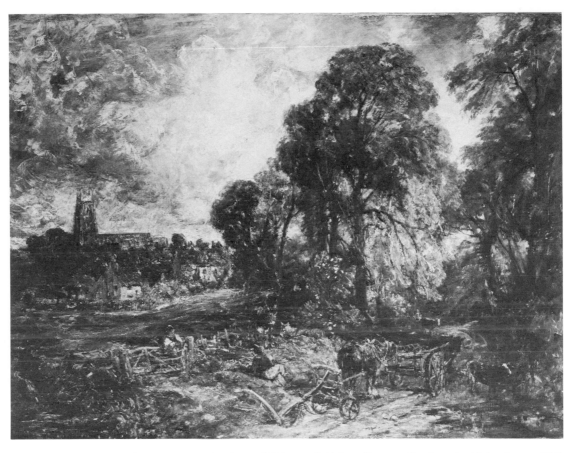

5. Above: John Constable, *Stoke-by-Nayland*, 1835, The Art Institute of Chicago. 6. Below: Gustave Courbet, *An Alpine Scene*, 1874, The Art Institute of Chicago.

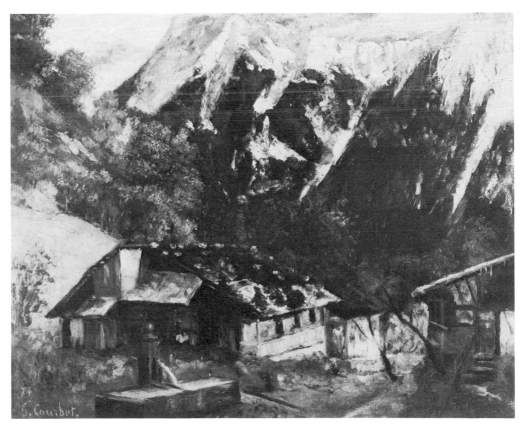

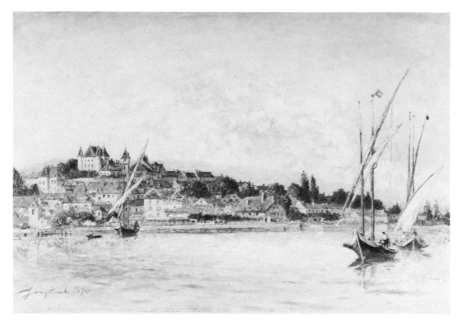

7. Johann Jongkind, *Landscape from Lake Leman*, The Minneapolis Institute of Arts.

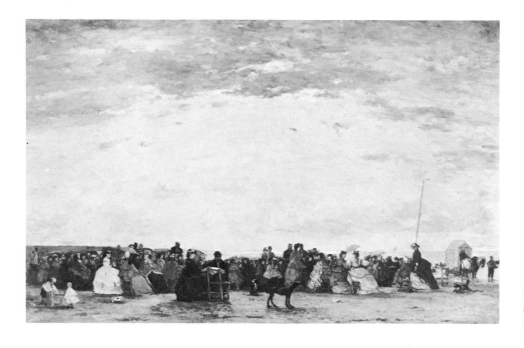

8. Eugene Boudin, *On the Beach of Trouville*, The Minneapolis Institute of Arts.

Accordingly, Cezanne subjected his geometry to a simplification. Curvature, the single, endless changing plane of curvature complexity which envelops the sphere, cylinder, and cone, was simplified by replacing it with a series of linear planes. All structuring was now a matter only of straight, linear planes, but still bound to the old structure of "form" as "solidity" or "sculpture."

Next Cezanne set to work to free the geometry of his planes from the structural limitation of "solidity." To do so he introduced another geometric form, the cube. It is the most fundamentally structured and the most simple geometric form in actual dimensions. To begin with, it is already composed of linear planes which previously Cezanne had imposed on the other basic forms of geometry. Now Cezanne began what later was vaguely understood as Cubism. He all but eliminated the great curvature complexity of nature, sharply evident in his late landscapes, largely rendering structure in terms of the visually far more simple linear planes. The first stage of Cubism, however, was limited to the structural boundaries given by the form of objects. (fig. 17)

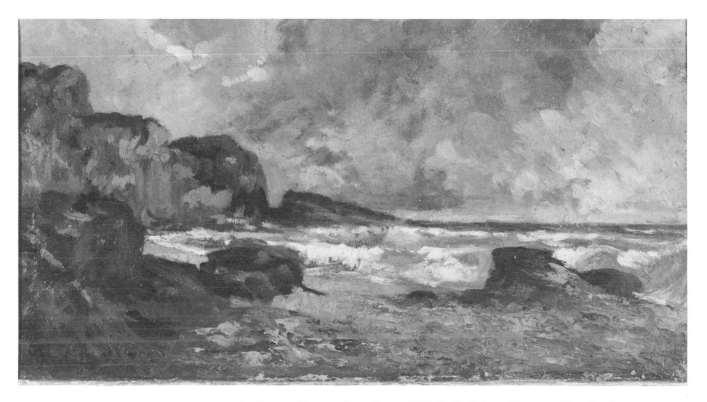

9. Gustave Courbet, *Coast Scene*, 1865, Smith College Museum of Art, Northampton, Mass.

The Cubist "research" of Cezanne now allowed him to proceed with two new and highly important developments. The planes began to free themselves from the old limited structure of mass, from "sculptural" and "solidity" perception. Following this development, the planes began to shift towards the unique linear structure of the picture *plane*. (figs. 19, 26, 28) In short, the planes were seeking their greatest reality structure *in a painting*, by orienting themselves to the full reality of the picture plane. The very last grand landscape paintings of Cezanne were largely free of the ancient sculptural perceptuality of form, structuring themselves directly and parallel to the spatiality of the picture plane.

Thus the ancient structure of form as mass was expanded into a deliberate forming of space as light, those spatial light planes that are everywhere in Cezanne's last works done before the panorama of nature's landscapes. A new perception was beginning to be achieved, a new vision of structure. *Cubism had become Planism*.

Cezanne observed that when a painting was no longer structured sculpturally, there could only appear one color *next* to another on the canvas's linear plane. There are "no forms," he said, "only contrasts." [21] Cezanne discovered that once a painting ceased to imitate literally the structure of nature, and was "translated" into structuring amenable to a painting, painting attained its greatest structural reality in its linear aspect. It was not that three-dimensional illusions had been eliminated. That was simply impossible. By gradually simplifying the *structural process* of nature, Cezanne also simplified the structuring of a painting. He was achieving the means for the eventual discovery of an art of pure creation.

With Cezanne, the immensity of the perceptual revolution became evident. A veritable structural revolution was in progress. The forms of Cezanne's art, the planes, could no longer be confused with simple space displacement. Form had been transformed, to "amalgamate" with space as a palpable structural experience in the light. Space became a fullness in which Cezanne would realize the merging of the "planes in the sunlight." [22] When death intervened, Cezanne was approaching what he sought when long before, he had stated his goal as "knowledge only of creation." [23]

Cezanne's achievements were extraordinary. He not only took all that had begun with T. Rousseau and had developed to Monet, (fig. 7 to 16) but gave their efforts a coherent perceptual evolution towards a new creative form of structuring art. (figs. 17, 18, 19) He was able to do so because he recapitulated structurally the previous five centuries of painting in order to reach a new mode of structural perception of nature and art as a new mode of creation.

Yet it is necessary to look at another aspect of Cezanne. To the very end of his life there was an ever-present

10. Gustave Courbet, *La Grand Mere*, The Minneapolis Institute of Arts.

problem in his work that could have destroyed him at any time. Hence the artist often expressed anxieties. There was a division in his work, a hurdle he was always having to surmount, which cannot be fully appreciated until 20th century artists are examined.

While the number of Cezanne's landscapes steadily increased in later years, he still continued portraits, still-lifes and, of central importance, the *Bather* paintings. (fig. 25) The latter were the largest works he was to make. The consequence of these various activities was that he lived in two worlds. One world was that of his immediate predecessors, all the new landscape painters of light; the other world was the five centuries since Renaissance painting in which the human form was the dominant concern.

Both worlds, the new landscape and the ancient concern with the human form, remained in his work from the beginning to the very end. Both subjects increasingly dominated his work as he developed. The *Bathers* revealed his fervent admiration for the great figure painters of the past — Giorgione, Tintoretto, Rubens, Poussin, etc. There

10

11. Dias de la Pena, *Boy in the Woods*, The Minneapolis
Institute of Arts.

were two worlds, the European one of the great past, and the new one to which he and Monet were giving birth through nature's landscape.

Cezanne's *Bather* paintings were begun around 1870. When we examine the last thirty years of these paintings there is a ceaseless traversing of a circle, for nothing significant for the future of art is achieved in spite of Cezanne's applying to the figure what he had learned before the landscape. Certainly nothing he garnered from the *Bathers*, not to mention from portraits and still-lifes — all objects that emphasized the ancient structure of "form" — could be of any significant use to his landscape studies. Hence Cezanne's work consists of two structural strands, one retaining the old representational content of the past, one leaving the old for a new content not yet "realized."

The division in Cezanne's work was to have devastating consequence upon all art that came after him. It is not an accident that all those who followed him seemed largely concerned with his "apples" and *Bathers*.

4. Beyond Perception

Once Monet's followers became his detractors and adopted the attitude of introverting perception, the paradigm of reality became centered in the artist and denied to nature. Actually this attitude had been adopted sometime before by Moreau and Symbolist writers. While there were any number of past painters, from Bosch to Blake, who were generally considered to be the progenitors for such artists as Moreau and those who followed him, this is not the case.

Moreau, like all his contemporaries, was confronted with a momentous event which no artists from Bosch to Blake ever had to face. That is, when the mimetic image acquired the "realism" of Courbet it was eventually ensnared in a devastating perceptual crisis. Even the last great realist, Courbet, in his final years became frustrated by the perceptual crisis and sought escape in "social" and "photographic" painting. Clearly painters of the last half of the 19th century found themselves in a traumatic perceptual crisis, the enormity of which no western artist had ever faced, i.e., the literal breakdown of mimetic perception in art. Consequently Moreau, and Redon after him, made no appeal to the "fantastics" of the past, but rather to their contemporaries, the Symbolists, whose literature was similarly introverting perceptual reality.

Therefore, Moreau was not a perceptual "bridge" as was Courbet, who opened the way for Monet and Cezanne toward an extension of past vision. His art would not permit it. To the contrary, his perceptual introversion constituted a flat denial of past vision in art since the Renaissance. Indeed, he would rectify the realistic outcome of the past. In short, Moreau was the beginning of the "modern" attitude.

Moreau dealt with the mimetic crisis by the drastic intention of transferring the paradigm of reality from its previous center in visible nature to that of the artist's subconscious. (figs. 20, 32) Courbet who would have nothing to do with anything he could not see in the visible world, and who detested the Symbolists, represented all that Moreau in turn detested. Indeed, Moreau sharply denied all that one could "see" or "touch," in order to center reality in his inner world, a world "I don't see."[24] Paradoxically, he was denying the very perceptual reality that, after all, reappeared in his art however transformed, which he believed originated in what had never been "seen." Inevitably such perceptual contradiction left only the recourse of appeal to irrationality, to perceptual paradox itself. Hence, the validity of reason must be denied, and so Moreau regarded "reason" as a "doubtful reality."[25] What was more "certain," in his view, was "unbridled imagination."[26]

Certainly writers like Baudelaire and painters like Moreau were involved in a similar literary retreat from the perceptual realism of Courbet and Zola, a retreat into a world of their own making. It is not surprising then that the writers who were far more articulate about what was essentially a literary enterprise, were better able to present the case of Moreau than the painter himself. The goal was well expressed by writers as the effort to "objectify the subjective." That is, the past relationship between the artist and nature would be reversed, resulting in the introversion of perception. For Baudelaire and the Symbolists the "exterior world" had become "deprived of all significance."[27] Nature, according to the anthropomorphizing of Baudelaire, had "no imagination." Like literature, painting had the intention of achieving the "externalization" of an "ideal," from which would flow a "purely idealistic" philosophy which replaced the perceptual "banality" of nature.[28] Thus the "comprehensible" would be replaced by the "incomprehensible."

Clearly Moreau's direction of art constituted a fundamental break with the past. Its precedent lay in contemporary literature, where perceptual introversion began earlier, inspired by Kant and Hegel. Thus Victor Hugo referred to the "terrified magician,"[29] and was haunted by ghosts and other terrifying mysterious forces. In fact, he felt especially chosen to communicate with God. Later, both Baudelaire and Moreau experienced a similar schizoid world, in which life was both a "horror" and "ecstasy."[30] They would go "outside the world" to seek the "unattainable," the "absolute," a world "beyond" in which a "revealed paradise" existed.[31] It was, Moreau insisted, a world of "artistic madness" which eluded the grasp of "reason." In that way he hoped to recover the "virginity" of art, hence his attraction to the primitives who preceded the Renaissance. For him, such primitives possessed the "modern spirit." In fact he was the precursor of all those into our own century who sought salvation in some sort of primitive art.

In spite of his denial that his art was based in literature, which later painters following in his direction will not deny, Moreau spoke in terms similar to those of Hugo and Baudelaire. He spoke of the artist's "inner world," of the primacy of the "unconscious" and the "unknown," a world "mysterious" and "perverse," "diabolical," "monstrous" and "satanic."[32] This was to be the new reality, born in "unbridled imagination;" namely, the painter would objectify his subjective conjurations.

12. Jean Corot, *Misty Mourning*,
The Minneapolis Institute of Arts.

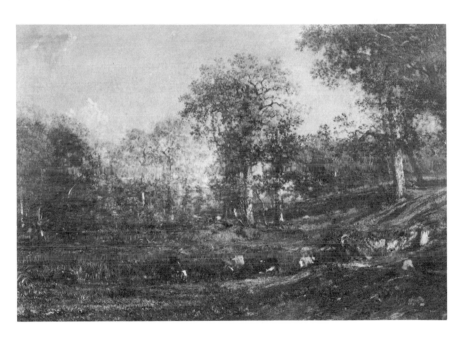

13. Jules Dupre, *The Countryside*, The Min-
neapolis Institute of Arts.

While much admired by Symbolists, Puvis de Chavannes was a bland participant when compared with Moreau or Odelon Redon. Indeed, the writer Huysman called the latter the "pupil" of Moreau. Certainly he was to take the direction of Moreau a good deal further, and his rejection of Courbet was even more intense. "Realism," he concluded, had run its full course, and Courbet's realism could only "set limits" which would deny art its "fruitful sources." [33] He too insisted that consciousness cease to submit to the perceptual world, that it "docilely" submit to the demands of the subconscious. [34] (fig. 34) Like Moreau, it was the "idea," the "thought," which Redon cited as the "fruitful source" for determining reality. In short, the "probable" of the perceptual world must submit to the "invisible." [35] That was to ask the impossible, and his very verbiage reflects his perceptual conflict. He put it in more probable terms, when he said the "unlikely" would be realized by means of the "likely." [36] The artist would represent "imagined things," make the "unbelievable" real by means of the "believable." The new reality, said Redon, would be achieved by the "agent of the mind," [37] the unconscious, where nothing can be "defined" or "understood." Art becomes "equivocable," "ambiguous," "undetermined," subject to the "caprice" of what he

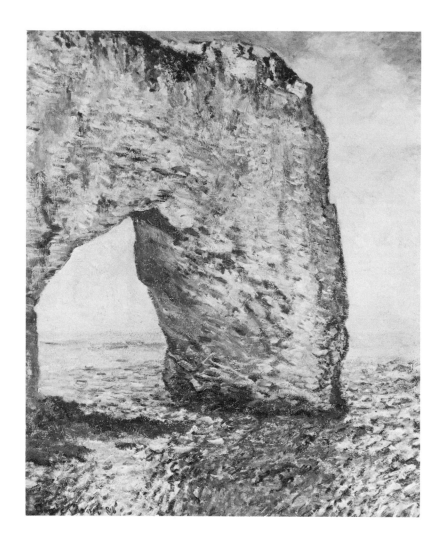

14. Claude Monet, *The Manneporte*, Etretat II, The Metropolitan Museum of Art, New York, Bequest of Lillie P. Bliss, 1931.

called the "unknown."[38] If Redon seems to acknowledge that the source of his images are in the perceptual world, he denies it when he says the "mirror of distortion" is beyond the determinations of that perceptual world. He is not, however, as independent of the latter as his remarks suggest. He is, in fact, as dependent upon the visible world as any past artist. Without it there would be nothing for the "mirror" to distort.

So intense is Redon's denial of the perceptual priority for the visible world that he made no distinction between Courbet's realism and Monet's Impressionism. The latter was simply another variant on realism. He assumed that the perception of nature could not yield any further vision except some kind of realism. His conditioned perception prevented his seeing what was all too obvious to all his academic contemporaries. The latter, unlike Redon, were not yet in great conflict with their own conditioned vision. Hence they rejected Monet as much as Redon, but precisely because Monet failed to achieve the realism Redon accused him of achieving. (figs. 14, 15)

Painters, such as Moreau and Redon were not prepared even to consider the possibility that the art of mimesis had concluded in Courbet. They were compelled to resist any effort to understand the significance of Courbet's art and, even more, that of Monet, who was an even greater threat to what had been. Instead they retreated to the distant past, hoping to capture the vitality of ancient arts in their effort to escape the perceptual conflict churning within themselves. They were unable to admit to themselves that in turning the perceptual world upside down with introversion they were doing violence to themselves. This violence was directed towards the perceptual world and toward artists who accepted perceptual nature as the determinant of their art, whether they were realists or not. The intensity of the conflict was evident when Redon asserted that he must "do battle" with perceived nature in order to "realize his superiority."[39] One then understands why the idealism of such artists had to be more than the idealism of the past, why they insisted on the "purely idealistic." The past saw the ideal inherent in perceived nature brought to realization by the artist alone. Now, however, the ideal was inherent only in the artist's unconscious; in the "agent of the mind;" in the "dream;" all of which rejected the "banality" of the visible world.

14

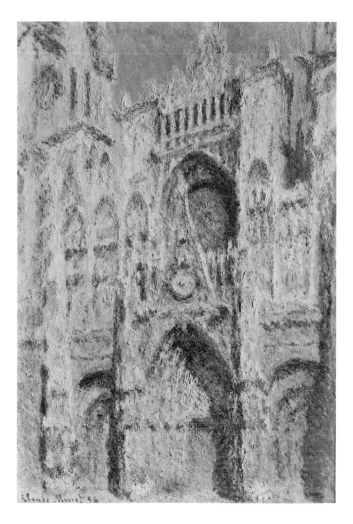

15. Above: Claude Monet, *Rouen Cathedral*, The Metropolitan Museum of Art, New York, Bequest of Theodore M. Davis, 1915. 16. Below: Claude Monet, *The Poplars*, 1891, The Metropolitan Museum of Art, New York, Bequest of Mrs. H. O. Havemeyer.

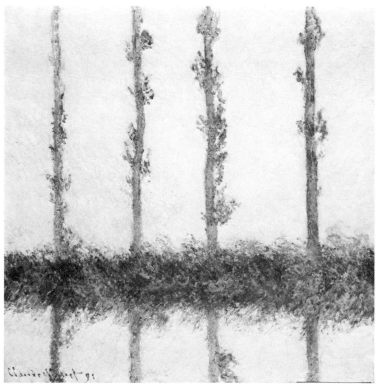

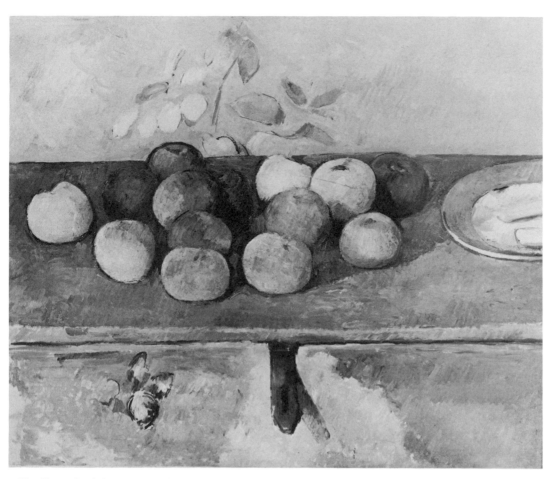

17. Above: Paul Cezanne, *Apples and Plate of Biscuits*, 1879, National Museum, Paris, Collection Walter-Guillaume. 18. Below: Paul Cezanne, *Aix: Paysage Rocheux*, reproduced by courtesy of the Trustees, The National Gallery, London.

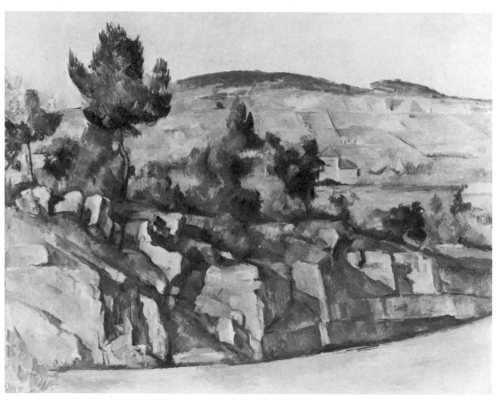

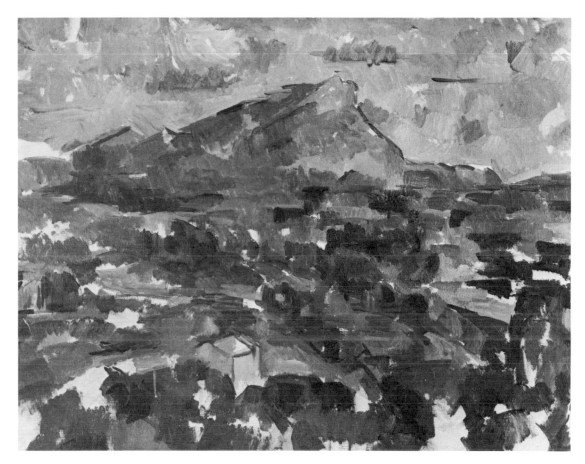

19. Paul Cezanne, *Montaigne St. Victoire*, 1904–06, Kunsthaus, Zurich.

The notion of ideal beauty was set on its head to become the "perverse," the "monstrous," the "satanic," all that welled up out of the unconscious, the supreme reality, what Redon called the "secret" ideal.[40]

According to Baudelaire, the new reality would be achieved by breaking up the perceptual one, destroying its rationality along with its banality. The parts were then reassembled in ways that did not occur in the perceptual world, thus achieving the new visibility of reality.[41] This is precisely what Redon had done. Redon dissected various objects in nature, then reassembled them into what he called "composites." The result was distorted, dismembered forms of monsters and beasts, insects and plants, or combinations of all of them. This world of "terrifying mystery" was the perceptual world remade in the cauldron of the artist's terrified subconscious, his "madness."

* * * * * *

The two major responses to the demise of mimesis in the 19th century have been delineated: that of Monet-Cezanne, (figs. 14, 19) and that of Moreau-Redon. (figs. 32, 34) The latter saw the perceptual world as exhausted, emptied of any further meaning for art. Hence the artist turned inward, introverting perception, reason, and beauty, too. It was a retreat to the caprices and verbal obscurities of the subconsciousness, a retreat to the studio where the artist was shut off from the visible world as never before. The artist, seemingly undisturbed by nature, was in his studio cell where the ancient "solidity" of the human form seemed to reign on, now directed to the "dream," not the reality.

In the sense that the prefix neo- was explained earlier, it is apparent that the Moreau-Redon effort, like the neo-Impressionist attempt, was one of neo-mimesis. They would re-do what had already been done in the past. Perceptually conditioned to the past vision, such artists were structurally conditioned, too. Just as the neo-Impressionists rejected Monet's rejection of "solidity," so Redon found Monet's art lacked a "feeling for form."[42]

A sharp division has been drawn between those who would subject perceptual consciousness to the demands of the "capricious unconsciousness," and those who would further perceptual consciousness itself. To introvert or to further the extraversion of vision — that was the issue: namely, what should constitute the new paradigm for reality in art?

5. Crisis Of New

During 1904, 1905 and 1906, the year Cezanne died, 56 of his paintings were exhibited in Paris. In 1907, two memorial exhibitions were held in Paris; one of 79 paintings, one of 56 water colors. In 1910, another 68 works were exhibited again in Paris. Out of this erupted the influence of Cezanne in what came to be called Cubism. Since Cezanne had originated his Cubism long before, the Parisian Cubists were actually neo-Cubists, as the following will demonstrate.

The significant aspect of neo-Cubism appeared in the 1908–1909 landscape paintings of Braque, Leger, and Picasso in particular. These works contain the most direct result of Cezanne's influence, and are informative in a way the figurative and still-lifes of the same period are not. In these landscapes one is struck at once by the overwhelming dominance of form as sculptured structure. (figs. 21, 22) Bulging forms run across the whole face of the canvas, as if determined to shut out space from going beyond the ancient structure of form displacement. Hence, the neo-Cubists usually preferred landscapes containing sculptural forms — houses, boats, bridges, etc.; what was not sculptural in a landscape was simply rendered sculptural.

Neo-Cubist sculpturing is most pronounced in Picasso. Indeed, Gonzalez, who technically helped Picasso with his sculpture, spoke of him as a "man of form," referring specifically to the work of 1908. Speaking of these particular works, Picasso himself insisted that they were so sculpturally rendered that all one had to do was to cut out the planes of the forms and reassemble them as sculpture.[43] (fig. 22) In fact, he would later make sculpture that imitated his paintings, and paintings that imitated his sculpture. It was evident that neo-Cubists began without having perceived Cezanne's work deeply enough to comprehend and so to heed his often expressed admonition that "painting is not sculpture."

If Cezanne had released the plane from being limited to the object's space displacing form, the neo-Cubists returned Cezanne's plane to its former structural captivity. The neo-Cubists, like the neo-Impressionists before them, among whom Seurat's Egyptian-like forms were of chief interest, (fig. 1) also refused to condone Monet's rejection of form confined to "solidity." As though anxious to leave no doubt, they stated they would "abandon everything" that represented Impressionism for an "opposite course."[44] It was inevitable, then, that structurally they would also do that to Cezanne, as the 1908–09 landscapes leave no doubt. After all, it was Cezanne alone who carried further Monet's intention of going beyond the structural limits of "solidity." Thus neo-Cubists were of a mind with Redon, who said that painting such as Monet's attempted a "fatal path" because it lacked a "feeling for form." This leads to an important observation. Namely, while neo-Impressionists, neo-mimesists who were now neo-Cubists, were all agreed on reordering the perceptual image, all rejected any revision in form structuring that characterized the perceptual image contained in past art.

Kahnweiler, the "authorative historian" of neo-Cubism,[45] was consoled to find that the inviolability of "solid bodies"[46] had been made secure by the neo-Cubists. He chided Monet for his opposing view as an unforgivable violation of what had been structurally sacred for five hundred years of painting.[47] But what of the past's mode of perceptual depiction? Was that not as sacred to the past as "solid bodies," since they were one? Just such expedient appeals to history literally prevented painters and critics from really being able perceptually to comprehend Monet, not to mention Cezanne. Like Redon, neo-Cubists were so conditioned to the past's limited form structuring of an image, in spite of their distortions of that image, that they literally were not able to see Monet. Indeed, it is their structural conditioning that confines them simply to distorting the ancient image of art. Hence, they could only look at Monet for what they wanted to see and, not finding it, project into his work what was not there at all. That is, they saw Monet Impressionism as some contemptible return to realism, but rendered with false structure. That was a mistake that the realist academicians did not make. Like Moreau-Redon, neo-Cubists assumed that the perceptuality of the visible world had been exhausted, and so any continuance of such vision could only lead to more realism. The contradictions and ensuing confusions of neo-Cubism are seen in the fact that, while permitting themselves to distort the image of realism, at the same time they implicitly accused Monet of distorting the structure of realism (form) in order to perpetuate the very realism they presume to detest.

Having returned Cezanne's spatial plane to the sculpturally closed form of space displacement, i.e., the cube, neo-Cubists soon discovered that their landscape efforts were leading nowhere except to repetition. They were painting the same landscape every time. Locked in sculpturing structure, sculpturing the landscape became a neo-Cubist dead-end. The figure and still-life works of this period suffered a similar fate. It is critically important to note that the confrontation of interchangeability between sculpture as painting or painting as sculpture in the art of neo-Cubism indicated a breakdown in the ancient mediums in that each appealed to what was in fact the very

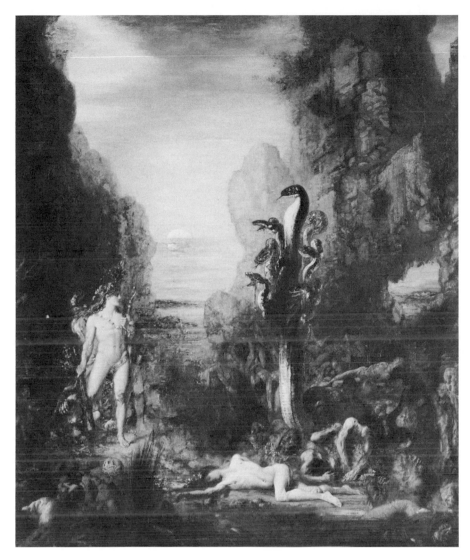

20. Gustave Moreau, *Hercules and the Hydra*, The Art Institute
of Chicago.

different but combined perceptual structure of sculpture as distinct from painting. The fundamental key to what was indeed a general breakdown was that from here on neo-Cubism would abandon the world of unmolested nature.

Therefore, the neo-Cubist's solution was to drop the subject of the landscape altogether. Nor was any neo-Cubist ever to make a serious return to nature's landscape. They left the open air of nature and, like Moreau-Redon before them, returned to the closed perceptual world of the studio. Here the seemingly more malleable and more diverse forms of "solidity," above all the human form, abounded to the exclusion of nature's frustrating landscape. But still the problem remained of how to get out of the sculpturing impasse of painting.

At this point it appears they took another look at Cezanne, this time at another aspect of his work. For the next phase of neo-Cubism, in which the landscape is no more, has a great but superficial similarity to the later landscapes of Cezanne. (figs. 24, 27) Planes seem to abound everywhere across the entire face of the canvas. At first glance it seems that planes are freeing themselves from the ancient role of form as space displacement, but it is necessary to look again. All the subjects are sculptural structures, the human form above all. Their concern still revolves around the notion of "solidity" structure, only now they will deal with form in a new and drastic way. "Planes" of a sort are being used, only they do not seek a spatial release from solidity but rather function now literally to break up "solidity." Painting became, as Picasso frankly put it, a "sum of destructions."[48] Structurally the "plane" had been transformed into a destructionist device. The "plane" now has the function of destroying the structural perception of "form" instead of giving the old perception of form structure an extension into a new sense of space and light.

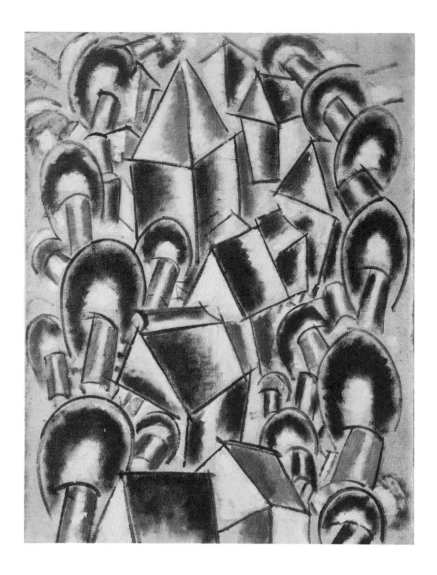

21. Above: Fernand Leger, *Houses Among Trees*, 1914, The Kunstmuseum, Basel. 22. Opposite page: Pablo Picasso, *Landscape With Bridge*, 1909, National Gallery, Prague.

Neo-Cubists probably did not see themselves as contradicting their former objections to Monet's view of "solidity." Their actions were the result of their reading Cezanne backwards, as if Cezanne himself used planes as the means of breakingup "form." As they had previously brokenup the realistic image with the means of distortion, now they were bent on breakingup the structure of the realistic image with the distortions of literal "destruction." Planes that are pseudo-planes, break into, in order to breakup, the subject and its form, stabbing, slashing the old sculptural perception of structure. (figs. 24, 27) Yet in all these works, up to around 1912, structural conditioning to the old remains, for the whole face of the canvas appeared as one continuous over-all sculptural relief that shut out the space from entering the work. Form continued to displace space. Even the color of these works is sculpture-like, being largely limited to the monochromatic. If the first destructionist phase of neo-Cubism consisted of applying distortionist manipulations of the subject, while keeping intact the ancient structure of form as space displacement, this led to a structural and perceptual dead-end. That is, the old structure limited the extent to which the distortionist method of destruction could be continued. If the second phase removed the structural impasse by applying the destructionist effort to the "solidity" of form itself, the result was that a new and more serious problem arose. Around 1910–11, neo-Cubist works seemed poised to go beyond the further retention of the "subject." (fig. 27) Thus arose the decision of whether or not to retain the ancient mimetic content. However, this question appears not to have arisen for the neo-Cubists in any serious degree. As an informed admirer reported, they simply "recoiled"[49] at the thought of any consideration having to do with the removal of the old content. They "recoiled," because being perceptually conditioned they reacted without stopping to think.

With the third phase of neo-Cubism the painters had two problems to confront. Not only must they assure that the subject was retained, but the relief sculpturing of the second phase eventually promised another structural and perceptual dead-end. Therefore, having tried sculpturing painting, then relief painting, neo-Cubists now tried

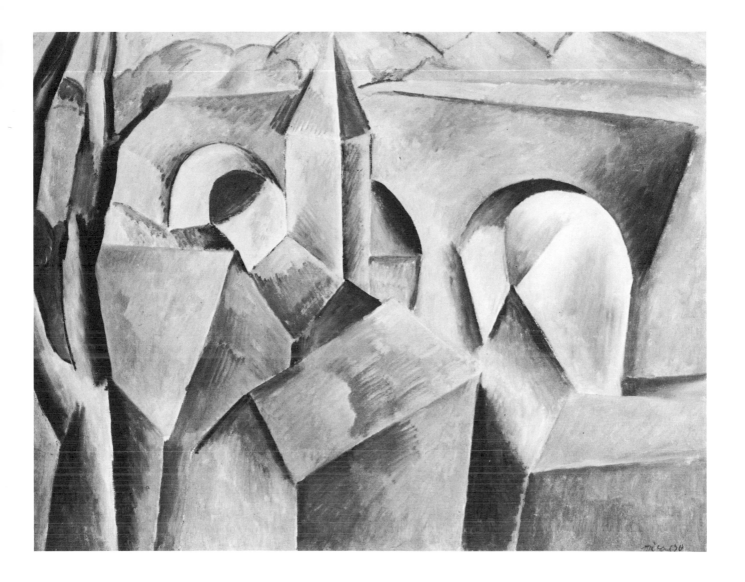

linearizing the entire painting. The destructionist planes now slide in, across and out of an object, slicing it into linear shapes parallel to the picture plane. (figs. 29, 30, 31) At the same time there was an accelerated return to mimesis. Around 1912–13, this third phase was completed as the pseudo-planes stood in parallel layers to the picture plane. Everything was again firmly held in the grip of neo-mimesis.

About this last phase, the "authorative historian" of neo-Cubism explained that these painters were concerned with the "fundamental problem" that had concerned Cezanne. Namely, how to represent the three dimensionality of "solid bodies" on a surface having "only two dimensions."[50] This interpretation is more convenient than correct. (figs. 19, 26, 28) There is no awareness that Cezanne had freed the plane from its simple role as but a unit of space displacing form, thus extensionalizing perception of structure by releasing the plane (indeed, releasing the notion of form, itself), into a new awareness of space and light as structure.

By 1912–13, it was all too obvious that neo-mimesis was again the prevailing attitude. (figs. 30, 31) The preservation of the old mimetic content, not problems of structure, had been their principal concern all along. Braque correctly insisted that to leave the traditional subject of art would leave "only painting," without, however, comprehending the full import of his observation. For him, painting would thus become "mute." He had failed to understand Cezanne's remark, that an "object" was simply a "pretext" for the goal of "Creation." Nor did Picasso understand either, contending that the painter would be deprived of all that "excited" his "ideas" and "emotions."[51] Neo-Cubists were now all agreed that the subject's importance "was considerable."[52] That was to put it mildly. For without neo-mimesis, neo-Cubism would have been impossible, since it is but another simple expressionist variant on the neo-mimesis theme.

According to Braque, one had to "start with nature" to thus "find a subject."[53] Nature? The neo-Cubists had

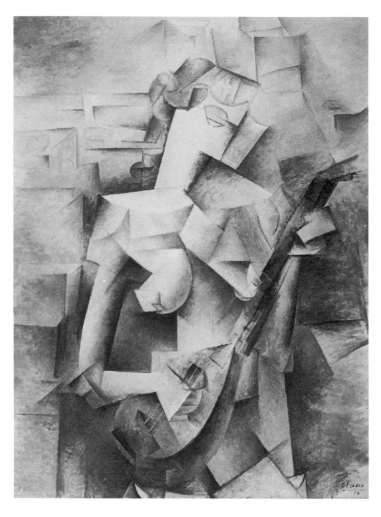

23. Left: Pablo Picasso, *Woman's Head*, 1909, Bronze 16 1/4 high, collection The Museum of Modern Art, New York. 24. Right: Pablo Picasso, *Girl With a Mandolin*, 1910, Private collection, New York, photo Charles Uht.

in fact turned their backs to nature when they abandoned landscape in 1909 in favor of introversion. What was being called "nature," was the space displacing bric-a-brac of the closed studio in which the sculptural human form was depicted.

Picasso was more candid. In his view the modern painter no longer "obeyed" nature, he "transcended it." [54] With schizoid determination, he insisted that the visible world of past art must be retained, but only to "wage war" with it,[55] as earlier Redon would "do battle" with nature. Picasso was to "wage war" on nature too, through the "destruction" of the image that past art had created from its perceptions of nature. Thus running through his work we see images whose derivations range from Greece to Courbet. Painting in the traditional manner, said Picasso, must be "violated,"[56] but not to the extent of disturbing the visual "habits too much."[57] How could this be done? By "mixing," Picasso explained, what viewers "don't know" with what "they know."[59] As Redon had explained earlier, without the subterfuge of Picasso, the artist combined the "unbelievable" with the "believable."

Now Picasso was not a painter whose sole desire was to be some sort of a visual valet to the "visual habits" of ordinary folks. More to the point, it was he who was conditioned to the perceptuality of past art and thus had to appease his own "visual habits." Then one understands his insistence that we must "start with something,"[60] that is, a subject, and that neo-Cubism was not all that different "from any other school"[61] of past painting.

The "mixing," however, produced only the old disguised as new. Of relevance is a report by Gertrude Stein. While walking with Picasso down a Paris street during World War I, they passed a camouflaged cannon. Picasso immediately exclaimed, "We have created that."[62] Was not that exactly how the neo-Cubists were camouflaging the old art as if it were something else? In any case, "visual habits" could not produce, indeed would prevent, the achievement of a new perceptuality.

If, in the beginning of neo-Cubism, there was a structural breakdown between the differing perceptual structures of sculpture and painting, now still another perceptual confusion made its appearance. It was in the last, or

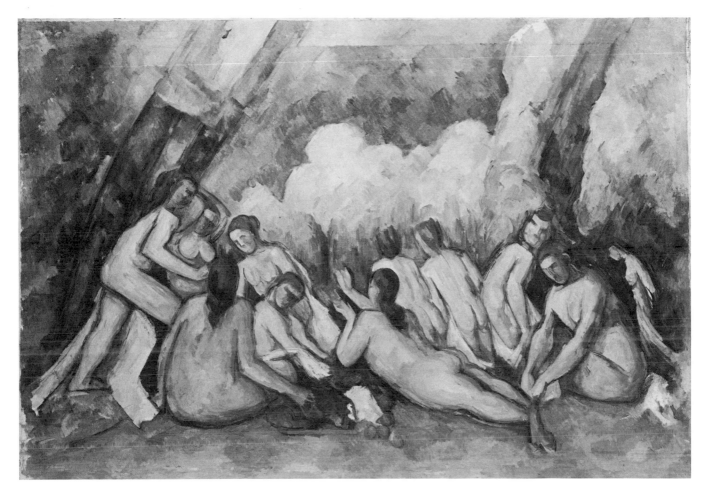

25. Paul Cezanne, *Les Grandes Baigneuses*, courtesy of the Trustees, The National Gallery, London.

linear, phase of neo-Cubism that the most destructive structural device made its full appearance. The line of drawing appeared in painting. (figs. 29, 31, 38) For the first time, since cave artists had evolved beyond the perceptual limits of linear art as drawing, the perceptual — and so structural — distinction between drawing and painting also broke down and became confused. In the beginnings of neo-Cubism the underlying drawing served to distort the perceptuality of the mimetic image's realism. In the last phase of neo-Cubism, drawing surfaced to become itself the structural visibility of a painting, to become the prime device for the "destruction" of the perceptual image and its structure as "form." Several decades later Mondrian would suddenly discover that he had been drawing instead of painting. Here, too, Cezanne had warned that in painting the line was "a failing." For the line represents structurally *the most primitive representation of form*. It was painting itself that was being destroyed. Once again, each effort to compel the old to yield the new simply resulted in a structural regression of past image perception. That was the principal result of the neo-Cubist "revolution," in which the artist appeased his own perceptual conditioning, the "visual habits," of both himself and his viewers.

In spite of the endless reams of printed matter about the structural concerns of the leading neo-Cubist, nothing could have interested Picasso less. For what Cezanne understood as the structural means of creation became a means of structural "destruction." Picasso himself explained that "pure plastic" was "only secondary" to his concern with the far more important factor, what he called the "drama" of the "plastic act."[63] His concern with "pure plastic" was actually nil. He was not at all concerned with the "drama" of the "plastic act," but with submitting the plastic to a "sum of destructions," that he might be able to continue the *expressionist "drama" of manipulating the old art*.

As with Moreau-Redon and van Gogh-Gauguin, so with the neo-Cubists. Painting would relinquish its visual authority as painting and become a literature of the subconscious, to produce another variant of "painting" as

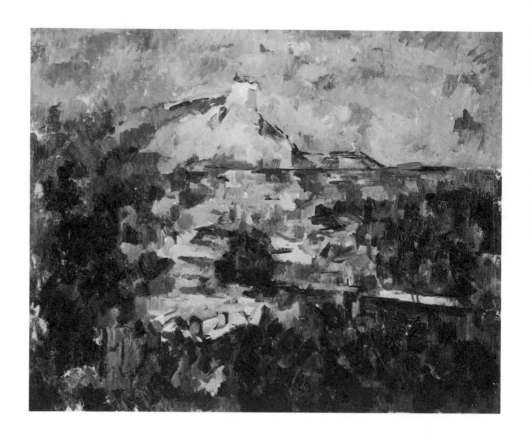

26. Paul Cezanne, *Le Montaigne Saint Victoire*, 1904–06, The Kunstmuseum, Basel.

obscurity. Here, too, Cezanne had warned against the prop of literature. A leading advocate of introverted perceptuality was correct when he stated that without Cezanne's "surface," neo-Cubism would not have emerged so rapidly, but that it was Mallarme who supplied the "atmosphere" out of which "cubism became possible."[64] So with Braque-Picasso we once more hear of the "idea," the "thought," the "pure idealism" of the "painter as poet," all to be evoked by resorting to the unconscious. Accordingly, Picasso referred to what his "subconscious registered"[65] with which he produced his art, and Braque referred to the means of "hallucinations"[66] just as Moreau-Redon had done. Art would be "symbol" (van Gogh), that is, "conceptual" (Gauguin), thus to "objectify the subjective."

Like the first neo-mimesists, as well as the neo-Impressionists, the neo-Cubists were caught in a paradoxical perceptuality. On the one hand, they could not conceive of perception as other than what was visually exhausted by the art of realism and, on the other hand, they proposed miraculously to create a new art by simply destroying the past's perceptuality. The consequences could not be other than to regress past art in all its aspects. It is this schizoid relation between the artist and nature's reality that allows one to comprehend Picasso's ceaseless concern with a reality "split apart,"[67] a reality "torn apart."[68] Hence Picasso's stated preference for "tension," flatly rejecting any motion of "equilibrium."[69] He denied painting any further concern with "aesthetics," because art had been transformed into a kind of magic which acted as a "mediator" between himself and a "hostile world." This was to echo the earlier utterances of Moreau, Hugo, Baudelaire, Redon, etc. Picasso claimed that the role of painting was to materialize "our terrors" and "our desires."[70] The world of the studio became a magical refuge from the perceptual reality of nature. Braque was reported as "shutting himself" in his studio, to search "within himself" for the source of painting without any concern with the "analysis of nature."[71] After all, confronting nature directly would only frustrate attempts to introvert perception. Gilot, who lived with Picasso for a decade, reports that there was only one time she saw the painter display any interest in nature.[72] To achieve such immunity to the vision of nature requires years of perceptual introversion to dull the sense before one's vision is immune to the actuality of nature.

Once the last, or linear phase, of neo-Cubism was on its way, Cezanne was no longer of use to these painters. He was eventually replaced by the neo-Impressionist van Gogh, whom Picasso regarded as the "archetype"[74] for artists of our times.

In 1908, one year after the memorial exhibit of 79 Cezannes in Paris, 52 works by Redon were also exhibited

24

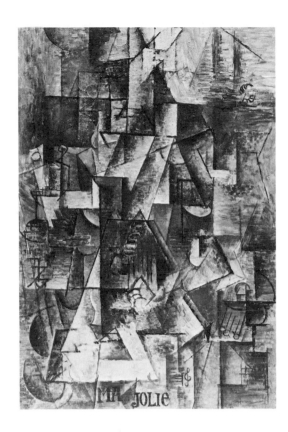

27. Pablo Picasso, *Ma Jolie*, 1911–12, oil 39 3/8 × 25 3/4, collection The Museum of Modern Art, New York, Lillie P. Bliss Bequest.

there. These two exhibitions, the Redon on the heels of the Cezanne, forecast the entire future of European art. Out of them, the "crisis of the new" replaced the "crisis of the old," which became definitive with neo-Cubism.

What had happened to Cezanne's influence? In 1904 and 1907 Bernard had published some of Cezanne's important theories, during which period 188 Cezannes were exhibited in Paris. His work would begin to free the artist's conditioned vision from the exhausted limits of mimesis, to a higher order of perceptual creation. He indicated the way to achieve a new perception of structure in nature which gave promise of a new art for the future. But all his achievements were turned around in the opposite direction, converted to destructive devices in a futile effort to compel the old to yield the new. The consequence was all kinds of regressive art. Cezanne was made into what he was not for the convenience of all those who would deny his specific goal of "Creation." In 1904, Bernard had said to Cezanne, "They will exalt you to aggrandize themselves," [73] and that was what happened.

As each of the neo-Impressionists revised Monet and thus regressed Impressionism, so the neo-Cubists revised Cezanne to regress his work. Yet Cezanne not only originated the Cubistic method but went beyond it to achieve his wonderful Planist works before the landscape, where light, space, and form assumed an entirely new perception of structure which, if its development were continued, would lead to a new art of "Creation."

6. *New Rejected*

At the beginning of the 20th century there existed in Europe two opposed but clear alternatives, that of Moreau-Redon and that of Monet-Cezanne. It was the neo-Impressionists, however, who compromised and confused both alternatives with their wish to have the best of two different worlds. With neo-Cubism, the neo-Impressionist compromise increasingly prevailed to complete the obscurity between the two alternatives. Picasso eventually proclaimed van Gogh as the prototype artist for the 20th century, and neo-Cubists in general denied Monet. In rejecting Monet, however, they were compelled to arrive at a falsification of Cezanne. Like neo-Impressionists, neo-Cubists also wished to have the best of two different worlds, with their "subject" and "plastic" fallacies.

Certainly the dichotomy in Cezanne's work, between the landscape and *Bather* directions, contributed to the crisis which would envelop all European art. The influence of that dichotomy, however, could only be short-lived. For whatever Cezanne painted, it was always with an extroverted perceptuality. Hence it was necessary that his influence be replaced by that of others. What was needed was the influence of a Redon, a van Gogh, to push the retreat into perceptual introversion. Only in this autistic effort did Picasso go "far beyond,"[75] while Braque "outstripped,"[76] Cezanne.

After Cezanne had been shunted aside, the neo-Cubists believed they had begun a new direction of art. Yet it was all followed by the "crisis of the new," reflected in the mushrooming of new schools of painting, each claiming

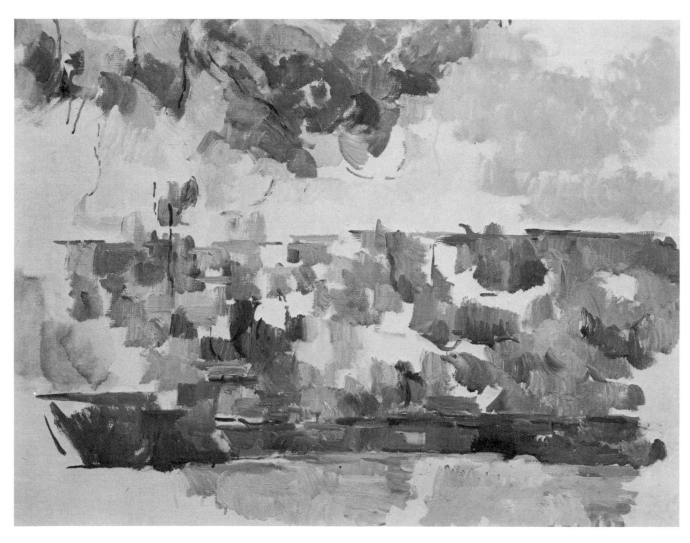

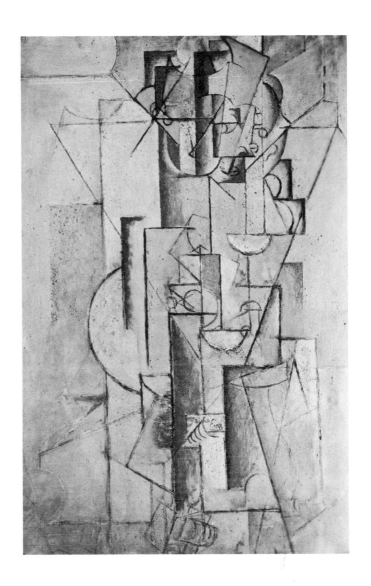

28. Opposite page: Paul Cezanne, *Jardin des Lauves*, 1906, The Phillips Collection, Washington. 29. Above: Pablo Picasso, *Portrait Arrangement*, 1912, The Columbus Gallery of Fine Arts, Ohio, gift of Ferdinand Howald.

to possess the truth. The most important, most significant school, was Dadaism. Dadaists came to feel that something had gone badly wrong with the advent of neo-Cubism. Indeed, they were the only ones in European art who recognized there was a "crisis of the new." Neo-Cubists, in their view, had deserted the revolution they had begun. Admirers of both schools have carefully avoided any real inquiry into this charge of the Dadaists.

In any case, Dadists proposed to resume the revolution that had been deserted. The manner in which they hoped to do so, however, was weighed down with impossible demands. Nothing less would satisfy them than to deliver the artist from all reality imperatives, whether perceptually introverted or extroverted, whether "visible" or "invisible." With desperation, they put all their energy into the use of the neo-Cubist's destructionist attitude, intending to carry it to its absolute end. Whatever one may think of such aspirations, the Dadaists were propelled by a profound reaction to the condition of European art.

While admitting their debt to neo-Cubism, Dadaists rejected it. They would "oppose all cubist" efforts,[77] they would smash the "thought" characteristic of neo-Cubism.[78] In their eyes, such art remained too dependent upon perceived reality. If, like neo-Cubists, they could not conceive of any perceptuality beyond the exhausted one of mimesis, nevertheless, Dadaists refused the neo-Cubist compromise with the old vision. In their view the compromise would only lead to a "materialistic solution," an "odious aestheticism."[79]

The perceptual crisis made manifest by neo-Cubism was part of the general crisis of European culture. As neo-Cubists were retreating to their visual conditioning, World War I enveloped Europe, followed soon after by Dada. The whole period could well be designated Dadaist, as some of its adherents recognized. Dada invaded all the arts.

While Dadaists presented themselves as not advocating either an artistic or a philosophic position, that was

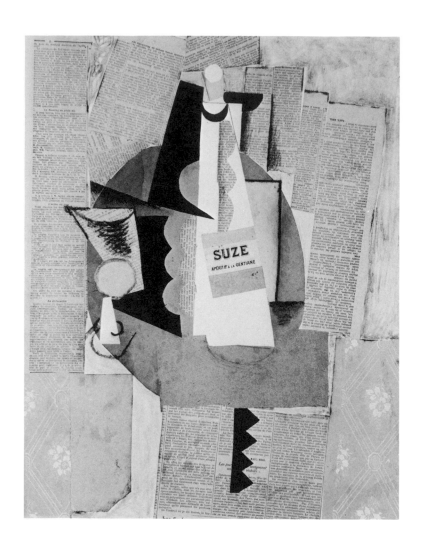

30. Pablo Picasso, *The Bottle of Suze*, 1913, Washington University Gallery of Art, St. Louis.

actually impossible. The principal requirement was unequivocal anarchy. Philosophically, they arrived at complete nihilism. Dada, Lemaitre noted, represented a "collective despair," a state of "mad desire" in which the young wished to "insult everything" esteemed by the "sheep-like masses," whose idols they wished to drag in the mud. In all this, Lamaitre continued, Dadaists were finding relief in an all but "sadistic delight." They would invoke a "frantic destruction" upon a civilization already in "decay" and "disintegration."[80]

In a world that appeared to them as an intellectual absurdity, they would acclaim the unintelligibility of the absurd. Thus, failure to understand the meaning of Dada, Dadaists insisted, was to understand it. Dada was without meaning.[81]

The proposed solution for art was to demand instant "unlimited freedom."[82] This was possible, however, only when there was nothing of consequence for which to be free. The purpose of such freedom was to liberate art from the objective attitude of the past, a past regarded as an intolerable adversary, but also from the equally rejected subjective attitude of the "moderns." Dada wished to clean away everything, to begin all over again. Everything must be subjected to "ruthless destruction." In reality, however, the option to reject everything was not possible. As if not knowing where to turn, they would deny there was anywhere to turn.

While Dadaists correctly sensed the decadence and ensuing confusion of the so-called new art which was emerging, and revolted against the false revolution, their own revolt only increased the confusion. They were lost, without bearings, and, as Lemaitre observed, the new generation could only "proclaim its agony."[83] Art became merely a "dumping ground" for one's refuse.[84] The revolution ceased to be for art but for revolution itself. Revolt for the sake of revolt is the direct consequence of the meaningless goal of "unlimited freedom."

If at first Dada's public antics aroused indignation and/or amusement, the public was soon bored by the repetitive. What had been surprise and shock was soon dissipated, since everything could be anticipated. As Lemaitre put it, everything became an innocuous "form of rioting," a "farce."[85]

28

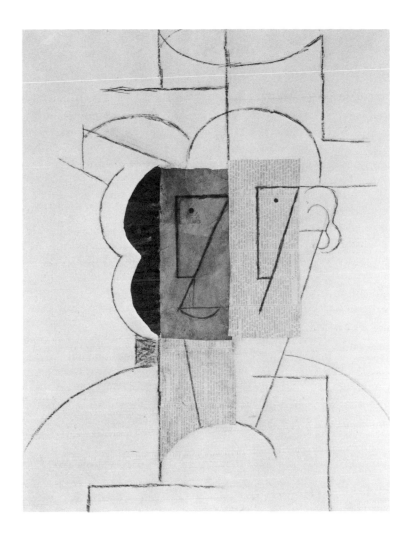

31. Pablo Picasso, *Man With a Hat*, 1912, charcoal, ink, pasted paper, 24 1/2 × 18 5/8 in., collection The Museum of Modern Art, New York.

Yet that generation of painters and poets who followed the crisis of neo Cubism cannot simply be dismissed. Not only were Dadaists aware of the failure of modern art generally, but they were also aware of the step that must be taken to remedy the situation. Namely, to clean the slate, both of impositions from the obsolete past and the present failures of what purported to be new. But while sensing the heavy, frustrating weight of the past upon all efforts to reach the new, they were unaware that everyone, themselves no less, was perceptually conditioned to the past. Under such conditions one can understand the inevitable intensity and excesses by which Dadaists expressed their hatred for the past. Huelsenbeck was correct to claim that Dadaists were "far ahead" of their times in becoming "aware of the approaching chaos," and in attempting to "overcome it."

Had Dada cleaned the slate, the whole course of European art would have been drastically altered. But Lemaitre was incorrect to assume that Dadaists had achieved a "perfectly clean slate." [86] At best they could only promise a perfectly clean desert. For they would clear away not only what needed clearing away, but also all that was needed to reach a new art, such as Monet and Cezanne. In their own words, they had "no aim." [87]

Renato Poggioli noted the "nihilism" and "infantalism" of the "avante-garde," such as is "innate" in a "child." [88] It was this attitude that led Dada to become the victim of itself, its only victim. "Death," they finally insisted, was a "Dadaist affair." [89]

From its beginning, and throughout the course of neo-Cubism, the breakdown of the perceptual distinctions and ensuing confusions between sculpture, relief sculpture and painting, between drawing and painting, between literature and art, was indicative of the more fundamental breakdown, in whatever form, of the mimetic content for art. Nature and the perceptual uniqueness of each of the ancient mediums were all sacrificed for escape into the dubious salvation of literary obscurities.

If neo-Cubism was a counterrevolution, Dada was an abortive revolution.

7. "Crisis of Consciousness"

Appolinaire was the first to sense the general character of what was emerging from neo-Cubism. In 1913 he saw such art as the "beginning" of a "subjective movement."[90] He was not aware that it was but a continuance, not a beginning, since the latter took place several decades earlier with Moreau. In 1917 he coined the term "surrealism" which will be adopted for the "new" direction of art.

At first Surrealism, among whose followers were former Dada writers and poets, was intended to be only a literary movement. Hardly had the group begun to form before the notion of limiting the group to literature began to wear thin. The writers needed the support of the painter, because he possessed a medium which apparently had the credibility of the visual. With calculated naivete these writers asked whether Surrealist painting was possible when, in fact, a number of painters had already acted upon notions similar to those Breton proposed for literature. That is, the "model" of art could no longer be found in the "external world," therefore, the artist must have recourse to his "internal world" for the determination of his art.[91] Long before Moreau, Redon and Baudelaire had stated the problem in Breton's exact words.

Actually there had been a cross-breeding of attempts at new art and new literature since mid-19th century. While the literary aspect was always present in past mimetic art, now a literary inversion took place. Surrealist Aragon had correctly observed, that painters were using objects "as if they were words."

In any case, former Dada painters were the first representatives of what was later called Surrealism. Indeed, the whole Surrealist movement, as will be demonstrated, is properly labelled neo-Dada. As one Dadaist said of Surrealism, it was the "sawed-off son" of the Dadaists.[92] This is reflected in the many claims of neo-Dadaists to have achieved what Dadaists sought but failed to achieve. The self-destructive actions of Dada were simply replaced by calculated efforts. Dada had pushed perceptual introversion over a cliff; neo-Dada would revive and continue it, retaining Dada's "point of view." In place of the excesses of individual caprice which had fragmented Dada, Breton as "leader" would lay down the law for a calculated collective effort. Indeed, he was often referred to as the "pope" of "Surrealism."

Like Dada, neo-Dada also took off from neo-Cubism, from Picasso in particular. Breton felt the debt of "surrealism" to Picasso was so considerable that he ought to be called a "surrealist," not a "cubist."[93] In that, he spoke to the point. Neo-Dadaists, however, like the Dadaists, eventually rejected the limit which neo-Cubists imposed on the use of "destruction." Their intention was to continue it without limitations.

Contrary to Picasso's wish to appease his own and his viewer's "visual habits," neo-Dada proclaimed the necessity of completely destroying these very "visual habits." Neo-Dadaists did not indulge in the neo-Cubists' lip-service to so-called "plastic qualities," and candidly asserted the central importance of literature for visual art. Hence their concern with visual "dislocation." They wished to completely "dislocate" the recognizability of the visual world. In place of the past's visual illusions of reality, they would effect the total delusion of that perceptual reality. This "dislocation" had been proposed long before by Baudelaire, and in Redon's "composites" that first appeared in the 1880's, diverse fragments were combined in ways they did not appear in perceptual reality. The difference between Picasso and the neo-Dadaists was the latter wished to completely "dislocate" the very "visual habits" that were necessary for Picasso. They would place no limits on autistic perception, least of all for the convenience of the viewer's visual conditioning.

The neo-Dadaists also made much of the device of "automatism," as if it were a new discovery. But that too was used by Moreau-Redon when they insisted on "docile submission" to the unconscious, a practice continued by both neo-Cubists and Dadaists. Breton actually used the very phrase of Moreau when he, too, called for "unbridled imagination."[94]

Perhaps no other neo-Dadaist cultivated the art of delusion, self-hypnosis, as much or as seriously as Ernst. Nor was any other more reliant on literature to render the effusions of his unconscious as the irrational reality. Hence, while the neo-Cubists were called "painters as poets," Ernst was simply referred to as "poet." So steeped was he in the effort of introversion that he saw himself as an "indifferent or impassioned" participant in the making of his work.[95] To what degree he achieved this subjective automation is less important than indicating how heavily he relied on perceptual introversion. More than any other he continued the Moreau-Redon effort to submit the "probable" to the "improbable," the "visible" to the "invisible," to achieve "ambiguity," the "undetermined," which erupted out of "docile submission" to the unconscious. (fig. 33) Like his predecessors, he wished to evoke "new objects," such as those apparitions that arose out of Moreau's "monstrous dreams" emerging from the "satanic precincts," the "perversity" of the unconscious. What Huysman had said of Moreau-Redon could be said

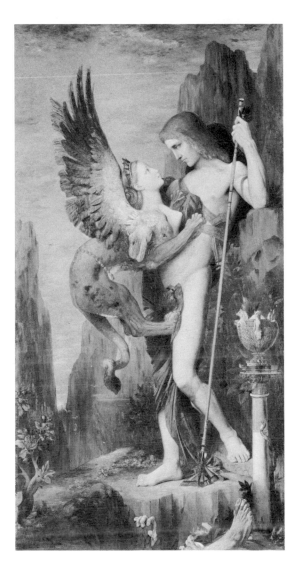

32. Gustave Moreau, *Oedipus and the Sphinx*, 1864, The Metropolitan Museum of Art, New York, Bequest of William H. Harriman, 1921.

of Ernst, that to acquire the subjectivism of the "invisible world" one must induce "hallucinations." Only thus, Huysman concluded, could one take the "dream of reality" and substitute it "for reality itself."[96]

Having noted the similarities that prevailed throughout the whole course of the perceptual introversion of art, a crucial distinction can now be made between perceptual extension as developed by Monet-Cezanne, and the course of perceptual introversion from Moreau to Ernst.

Monet began the transition from mimesis into an art of structured light, achieving the first major extension of the past's limited perception of nature's structure as essentially form displacement of space. This was followed by Cezanne's further extension of form and light as spatial structuring, "to see the planes," the "planes in the sunlight."[97] Thus a new perception of visual structure had been secure which needed but a few more developments to reach full realization. Most important, this whole effort of Monet-Cezanne was never based on the denial of past perception, but rather on its extension. To a large degree, visual conditioning to the past had been overcome to produce a perceptual break-through.

From Moreau-Redon to Picasso-Ernst there appears nothing resembling any sort of a development, let alone a genuine new art. Every theory advanced for perceptual introversion, from Moreau to Ernst, had already been set forth from the very beginning by Moreau-Redon and Baudelaire, along with Symbolist writers. After that there was only a superficial elaboration of both the theory and art. The consequence has been ceaseless perceptual regression, not merely a regression to the past but a regression inferior to past accomplishments. Wishing to become more than the past, at the price of the "destruction" of the past, they became incomparably less than the past. In that sense they *regressed the past*.

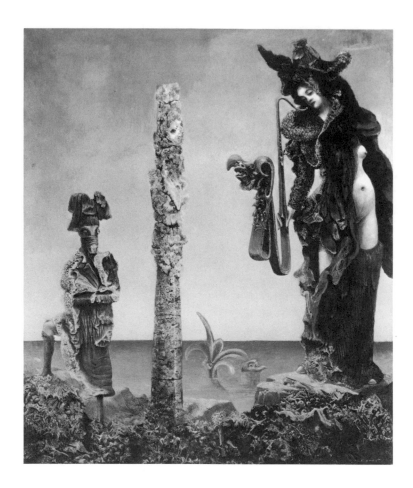

33. Above, Max Ernst, *Napolean in the Wilderness*, 1941, oil 18 1/4 × 15, collection The Museum of Modern Art, New York. 34. Opposite, Odilon Redon, *Cyclops*, 1883, lithograph printed in black, Sh: 21 7/16 × 13 7/8 in., comp: 8 3/8 × 7 13/16 in., collection The Museum of Modern Art, New York, gift of Victor S. Riesenfeld.

From Moreau to Ernst, the dominant, almost the sole, subject was the human form, that limiting form of space displacement which sustained the painters' perceptual conditioning to the past. Invariably the human form appears in a great void of loneliness and despair amid visual apparitions, in a visual wilderness, where the terror of the psychopath rides through the soul of man. It is a portrait of man, helpless and hopeless. Perceptual introversion represents man's defeat. (fig. 35)

The need of man to realize his supreme quality as an essentially creative being vanished in the smothering cubicles of the studio. Creation had been replaced by what Hodeir aptly called "pictorial masochism." Neo-Dada, according to Breton, must embrace the "whole psychopathic field," leaving the "field of consciousness" only a trifling role to play. This psychopathic effort must exercise a "merciless iconoclasm" upon the "external world," which Breton found had "suddenly become empty."[98] There is no question that the perceptual world became "empty" for Baudelaire and Breton, but this was due to their own perceptual failure, as Monet and Cezanne make clear.

This perceptual isolation of man also isolated the artist both from nature and his own art past. Monet and Cezanne did not deny the past, they admired it. They saw themselves as deepening the visual perception of nature, as all great artists before them had done. But there was this immense difference: namely, perception had evolved through new visual experiences of nature's landscape, emerging on an entirely new perceptual plateau of vision.

Such a relation with the past was impossible for all from Moreau to Ernst. Finding the "external world" "empty," they perceptually regressed the obsolete vision of that world. For all artists who failed to evolve extroverted perception were doomed to remain in that very perception they denounced in the art of the past as obsolete.

They were the casualties of the most extraordinary perceptual crisis ever faced by Western artists, a crisis in the act of vision itself. Hints of the coming crisis appeared with the perfection of photography in 1839 and, a few years later, began reaching towards an even greater crisis when Monet, Moreau, Redon and Cezanne were attempting to solve the "crisis of mimesis" by moving towards new forms of perception.

Most artists were left in a state of traumatic visual confusion. Imagine it, that single form of vision which had

prevailed in art for some 50 thousand years or more — and it had been silently assumed that it would reign eternal as the vision of art — had collapsed. That this visual trauma prevails even more intensely to this day is due to the expedient decision destructively to introvert the old vision as the means, paradoxically, to a new vision. The expedient appeal to paradox and irrationality assured that Breton and his followers would not be aware that they had "dislocated" only their own perceptual capacity to perceive even what they had perceived before their introversion. For now they could not know that they remained captives of the "visual habits" from which they thought to be free. Indeed, the fury they expressed against the past indicated the extent of their captivity in the past's obsolete vision. The more artists intensified perceptual destruction, the deeper they suppressed their "visual habits" from the range of their consciousness.

Like Dadaists, neo-Dadaists wished to clean the slate and begin anew. But if their goal was desirable their method for achieving it was quite another matter. *For any art based on the "destruction" of the past is doomed to be no more than a regressive distorted reflection of past art. To begin a new art one must begin a new art.* Neo-Dadaists were doomed to fail in their purpose of achieving "emancipation" from the exterior world,[99] and instead of achieving a genuine new art they simply transformed the past form of art into a psychopathic perceptuality.

Breton, who Calas thought had "upset Cezanne's apple cart," correctly saw Cezanne as the principal threat to the psychopathic introversion he advocated. In his view, Cezanne had failed to give even a "glimpse" of what Breton regarded as the "final solution" for art.[100] Cezanne was, he correctly observed, "inimical" to the realization of such a solution. Yet he was only stating the obvious fact that Cezanne was never a part of the flight from perceptual reality.

Breton was correct also when he characterized the condition of art as a "crisis of consciousness." His wish, however, was to sustain and intensify that condition. Here, too, Cezanne got in the way, since he wished to secure a "conscious image" of nature.[101]

Above all, Cezanne warned the artist that he was "done for" if he resorted to literature, and referred to those writers who pursue modernism by "leaning upon" painters.[102] He saw the writers among his contemporaries as leading the painter away from the study of nature, in order to lose himself in "intangible speculations."[103]

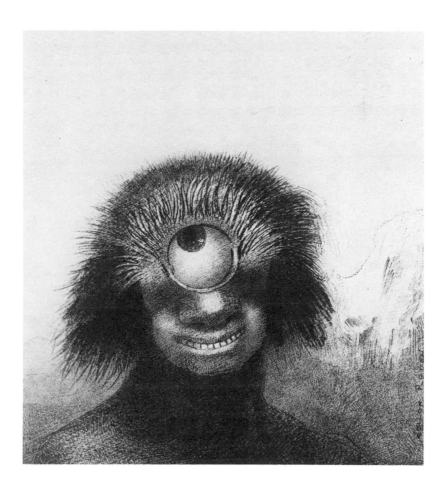

8. Neo-Ideal

Up to this point, the direct perception of nature as the paradigm for visual reality has been contrasted to the effort to introvert perception. But what about that "purified idealism" the introverters have adhered to from Moreau to Ernst? Then, too, the problem of idealism appears implicitly in Monet and explicitly in the theories of Cezanne. It is apparently an important issue worthy of consideration.

The real and ideal have existed since the beginning of art in the caves of France. Both elements literally welled out of the cave man's aspirations within the seemingly infinite, illusive diversity of nature. However, the real and ideal existed unconsciously in his art in an undifferentiated unity. As such, it formed man's attitude towards nature and himself. The most intense manifestation of this unity of the real and ideal is seen in the depiction of animals.

All this was altered once the Egyptian sculptor achieved a high degree of realism in the depiction of the human form. By giving distinction to the real, differentiation then entered perceptual consciousness. The appearance of differentiating the ideal began to take place when the priests of Egypt, hoping to regain their dwindling authority, compelled sculptors to desist from further realism and return to the past's practice of what was now seen as the idealization of the human form.

With the Greeks the problem shifted from religion to philosophy. Parmenides saw a real world that was constant, eternally unchanging, in contrast to the ceaselessly changing illusions of the sensory world. Thus there were two worlds, one perfect, one not. Mathematics, geometry, logic rationalized as absolutes, all seemed to confirm a world of perfection absent in the immediate sensory world. Perfection, then, was attributed only to what was beyond the range of the senses — the assumed perfection of planetary orbits and the spherical, indivisible world of atoms.

In that aspect of the sensory world which the Greeks themselves created, their art and architecture, the real was rejected for the perfection of the ideal. It remained for Aristotle to complete the logical differentiation between the real and ideal, which distinction prevailed for 2,500 years.

Up to the time of the great Greek philosophers, man had indeed reasoned about the world and human existence. Now there began something very new, that is, the effort to reason about reason, the beginning of becoming conscious of the structure of logic. This was a watershed in man's coping with his mode of determining what constituted the reality of the world in which he found himself. The development of the logical function of language had reached a high point where words, in the face of the palpable experience of reality as ceaseless change, as process, contrived a reality to the very opposite of experience; that is, as an absolute, unchanging reality. From that time to our own day, all the problems of art would be caught in the confusion between the flexibility of words to contrive a static and absolute reality as against the particularity of perceiving the world as the means to establish the dynamic process character of experiencing that world. Words were used to deny, to contradict, experience. Logic was used to appeal unknowningly to the illogic of paradox. It was the beginning of what Gauguin would later call a "conceptual" attitude in art.

Henceforth, the realist sought a correspondence between art and the perceptual determinations of the visible world. For the idealist, however, the visible world was a kind of container of an inherent perfection but which only the artist, not nature, could bring to fruition. The idealist would perfect the real, while the realist sought to attain the perfection of the real. Nature was the measure for the realist; man was the measure for the idealist. For the latter, "thought" took precedence; for the former, the senses.

The mimetic era came to its close with the robust realism of Courbet and the wilting idealism of Ingres. Both aspects participated in the "crisis of mimesis." To understand that crisis, and what followed, it is necessary to understand what happened to both the real and ideal views. Attempts to deal with this dichotomy, as with other major problems of recent art, have failed because the problem of perceptual conditioning was not even recognized.

Monet was the first to begin consciously to work his way out of the old "visual habits;" to pursue a new perception of nature and art. Monet achieved nothing less than a visual revolution, and a new relationship began to form between the real and ideal. This would no longer consist of an ideal superior to nature, or a real like nature, but an art unique to man while remaining based in nature as the continued paradigm for perceptual reality. Art would now exemplify the unique creative quality of man, not a creation imposed upon nature or confused with its unique creations. Can it be said then, that the creative aspirations of the great idealists of the past were at last released by Monet, as man began his first steps towards a creative art unique to himself? The full import of this extraordinary development was to be acutely perceived by Cezanne alone.

Cezanne saw Monet as the "most prodigious eye"[104] of all painters that ever lived, leading art to a "new use

of the palette,"[105] that is, a new use of color as light. Unlike the neo-Impressionists with their revisions of Monet, Cezanne realized that Monet had opened the way to a new perceptual relationship between the artist and nature. With all due admiration for the achievements of the past, he saw that painting had become "another thing" compared to reality, that is, it ceased to be "an imitation."[106] With acute perceptual awareness, Cezanne saw a new relationship forming between the ancient rival viewpoints. Thus, while he would be a "true classicist," he would reject the ancient priority for "thought" which imposed perfectionist aspirations upon nature. He would be a classicist "through nature," that is, "through sensations" experienced perceptually before nature.[107] In another way, he expressed this to Bernard when he spoke of Poussin being "entirely redone" in the open air of color as light.

Cezanne would thus seek an art unique to man, to be obtained through the study of nature as creation. He sought knowledge, he said, "only of Creation."[108] To this end it was necessary to see nature as it had not previously been seen by anyone[109] in order to achieve the "new vision" appropriate to a new kind of art. Cezanne saw the need to work one's way out of "visual habits" towards new perception. It was a problem with which he coped to the end of his work.

Cezanne's rejection of the ancient priority of "thought" to center instead all problems in the "sensations" of vision, led him to consider literature as destructively leading the artist into "intangible speculations." The artist, he insisted, must never rely on an "idea," a "thought," or a "word" as a substitute for "sensation."[110] Only so would it be possible to avoid the now obsolete "classicism which restricts" the artist.[111] With Cezanne, then, the priority of words, thought, logic which had been solidified by Aristotelianism, was terminated and replaced by the priority of perceived nature. It was that realization, that revision, that rested behind Cezanne's frequent warning against "literature" and writers on art.

It then becomes clear why Cezanne stated that his "method" was "realism"[112] which literally invoked a new perception of the "ideal and reality."[113] The dichotomy of the ancient past no longer prevailed for Cezanne.[114] The new relationship between the artist and nature was a question of the two becoming one. He would "unite them,"[115] "amalgamate" man and nature. The ideal was no longer "superior" and the real was no longer "inferior" to nature. In Cezanne's view, nature and art had become "parallel" to each other as "Creation." Through the study of the creative process of nature's structure, man would secure an art inherent in nature as uniquely man's creation. For the first time in the history of art since the realism of the ancient Egyptian sculptors, but on a new plateau, the differentiated real and ideal became unified as they had not been since their undifferentiated unity in the cave arts.

Contrary to the position of Monet and Cezanne, the response of Moreau-Redon to the real and ideal as the "crisis of mimesis," immensely increased the role of literature in art at the expense of perception. They would deny the ancient ideals of reason, logic and perception to adopt what Redon called the "secret ideal;" an ideal not inherent in a nature now regarded as "deprived of all significance." The "agent of the mind," the "interior vision," determined the reality of the "purely idealistic," uncontaminated by the old idealist's partial dependence on extroverted perception and reason. Thus they would "objectify the subjective."

Moreau saw nature as a "mindless force" with which the artist must "do battle" in order to "realize his superiority."[116] Reigning over all the arts, according to Breton, was the "omnipotence of thought,"[117] in which the condition of art consisted of a ceaseless "crisis of consciousness" which gave access to the "psychopathic field."

Unlike Cezanne, the introvertors of vision do not unify, but intensify, the ancient split between the real and the ideal. The ancient dichotomy is not resolved, but acerbated. The perception of reality is "split apart" completely. Instead of giving extension to the real and ideal, as had Monet-Cezanne, those from Moreau to Picasso to Ernst simply regressed the achievements of past idealists and realists. The neo-ideal as the super-real produced the schizoid perceptuality of neo-mimesis.

9. Painting As New

The extraordinary aspect of Mondrian's ambition was to achieve what he believed all past painters unknowingly had sought but failed to achieve. This was essentially the ancient idealist theory which, until now, had been applied only to nature. Now it was being applied to all past painters. Mondrian's goal was a neo-painting.

Past painters, Mondrian explained, were simply too subjective; too much concerned with surface perception, the world of objects. Therefore, painters must reject the past's mode of "expression" in order to "continue" only its "real content."[118] Until now this "real content," this "essence" of art, was "veiled" by the "particular" form, by which he meant objects.[119] Until now this real "essence" of art was largely invisible but had finally attained visibility in his neo-painting.[120] The "capricious" perceptuality of nature, that is, its ceaselessly changing "surface," had been replaced by what Mondrian called "super-reality."[121] Such art would be a product only of "the mind,"[122] leaving no role for the perceptuality of nature. It appeared that he, too, would elaborate on past idealism to become one with the "pure idealists" of Symbolism. For example, recall Redon and his "agent of the mind."

The shades of Parmenides appeared as one listened to Mondrian's views; namely, that nature's constantly changing imperfect reality was replaced by the "absolute" of "pure reality" which "remains constant."[123] These are exactly the two worlds of Parmenides; one of absolute perfect reality, the other superficial and imperfect. In this way the neo-painter presumed independence from imperfect nature and also "liberation" from the past's "oppressive"[124] concern with the superficialities of perceptual reality. Here again, as with the "do battle" and "wage war" attitudes of Redon and Picasso, there appeared that great intensity of the conflict between the artist and a schizophrenic view of nature. For Mondrian nature was a "dammed wretched" thing which he could "hardly stand."[125] Seuphor described Mondrian's attitude towards nature as "irreverent," and reported that he would be especially "irritated" by the sight of trees or "anything green."[126] Like Redon he must "do battle" with nature in order to achieve "his superiority" over it.

In fact, artists taking similar directions to that of Mondrian seemed to be of one mind on the problem of perceptual nature. Malevitch saw art as seeking "domination" over nature,[127] and maintained that art had "nothing in common"[128] with nature. He saw art as a sort of immaculate conception; in that he claimed it came out of "nothing" and thus led "to creation."[129] Indeed even the square shape was seen by him as exemplifying the very epitome of man's "mastery over nature." Doesburg also insisted that art "surpassed"[130] nature, that art did not[131] follow but was "above" nature. And from him, too, we hear about a "super-reality."[132] Like all those in the line from Moreau, Doesburg, like Mondrian, replaced nature with the "idea," the "thought," as the supreme reality. Vantongerloo just as emphatically insisted that the artist must not only "abandon," but must "absolutely ignore" nature.[133]

All these remarks are one with the perceptual dilemma of all the painters, except two, so far discussed. One could cite many more such quotes from many other artists. They all assume that realism had terminated all further usefulness of perceptual nature. However, the painters here considered would not settle for a simple introverting of the obsolete content of art. They were determined to eliminate every shred of the visible world from art, including the very character of structuring present in perceptual nature. Like painters since Moreau, they too would deal with the perceptual crisis of mimesis by introverting their vision, except that their paradigm of such a reality would emerge out of a more rigid, absolute, autistic attitude. Thus the partial or equivocable rejection of nature by some neo-idealists became the absolute rejection of perceptual nature by neo-painters. Just as Mondrian would make more absolute the "purely idealistic" of Moreau, Symbolists, and neo-Dadaists, so he wished to make their rejection of nature more absolute by eliminating all aspects of "optical vision," and replacing them with a more absolute form of an "inner vision."[134] If all the neo-mimesists since Moreau called for a reality superior to the perceptual one, Mondrian more emphatically insisted on an absolute "super-reality." He would exclude all "descriptive" and "literary"[135] painting. In practice, however, he only rejected the literature of prose and poetic verbiage, he nevertheless appealed to a form of literature when he wrote that art was logic made concrete[136] and referred to the "art of the word."[137]

In any case, words, which Cezanne had warned against substituting for "sensation," continued to be the source of art. Indeed, Mondrian's wish to make logic concrete is of a piece with writer Breton's "omnipotence of thought" in art. If, as seems quite indisputable, the world and ourselves are not words, or logic, or theory, words can only arouse arbitrariness and nonsense unless they have a corresponding reference to the only viable world we can know; the non-verbal perceptual world. For however inner the inner world may be, its utterances will inescapably have some reference to the outside world. But the credibility of such references cannot be assured by

35. Yves Tanguy, *Response au Rouge*, 1943, The Minneapolis Institute of Arts.

claiming independence of that world. We cannot have it both ways.

In 1911, when Mondrian was already a neo-Cubist, he painted a triptych of three nudes literally frozen in frontal positions. It could well have been painted in the heyday of 19th century Symbolist painting. In fact, he felt an affinity to all the neo-mimetic introvertors from Moreau to Picasso to Ernst, except that he proposed to achieve the goal he thought they had failed to realize. With all of them he shared the method of "destruction" except, like the Dadaists, he claimed to accept the full consequences of that method. Through this method Mondrian hoped to achieve "paradise," [138] just as Ernst longed for a "lost paradise." [139]

Mondrian shared with the neo Dadaists what he called their deepening of "feeling and thought" as the means to a "true life." [140] But only in his neo-painting would it be possible to secure that ultimate "purification" which the others had not achieved. Mondrian's expression of common interests with all the European arts of introversion strike his naive American followers as a "contradiction;" as "inconsistent" with his own work. To the contrary, Mondrian correctly saw all European art as seeking a "super-reality," and the further such art went beyond the imperfect world of "optical vision" the closer it came to achieving this "super-reality." It was only necessary to do what Mondrian had done to the "subject," "exclude it" [141] completely, after which one applied "destruction" to natural structure itself.

Thus neo-painting went "beyond nature," "surpassed" it, to achieve the supreme "universal reality," that ultimate "super-reality." Moreau sought such a goal with what he called "inner sentiment;" what Redon called the "inner vision;" what neo-Dadaists called the "interior world;" what Mondrian called "interiorization." [142] Mondrian was clearly and deliberately a part of the general European effort which he alone understood sought to replace the perception of the visible world with introversion as the new and absolute source of supreme reality.

During the turbulent years following Cezanne's death, when his work had a short-lived but explosive influence, there appeared to be two general directions in European art. One was the neo-mimetic direction of painting, dominated by neo-Dada; the other was the apparently non-mimetic direction for painting, dominated by the neo-Plasticism of Mondrian. Like all leading European painters seeking the new, whether neo-mimetic or non-mimetic, Mondrian was literally overwhelmed by neo-Cubism. He agreed with Breton in that both regarded Picasso as a "great pictorial artist." While Mondrian would follow the example of the neo-Cubists in many ways, his important difference from them was that when his own neo-Cubism approached the elimination of the "subject," he would not "recoil" and retreat as did his neo-Cubist predecessors. However, it is only the last phases of his neo-Cubism that concern us here; (fig. 36) that is, the linearization of form as shape or line. While he rejected what he said was the neo-Cubist concern with "volume," this was not because he was agreeing with Monet about "solidity," or with Cezanne on painting not being sculpture. For he adopted the neo-Cubist device of the "destruction" of form, but would not stop with the pseudo-plane destroying the structure of objects. Rather he went on to destroy the very appearance of objects until only an array of linear shapes surrounded by lines remained. Structur-

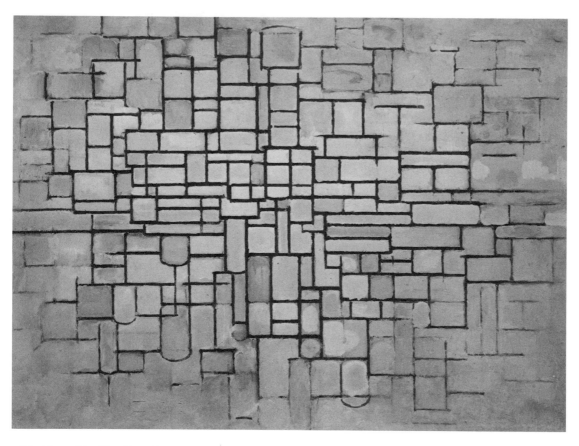

36. Above: Piet Mondrian, *Composition 1913*, Rijksmuseum, Kroller-Muller, Otterloo. 37. Below: Piet Mondrian, *Pier and Ocean*, 1915, Rijksmuseum, Kroller-Muller, Otterloo.

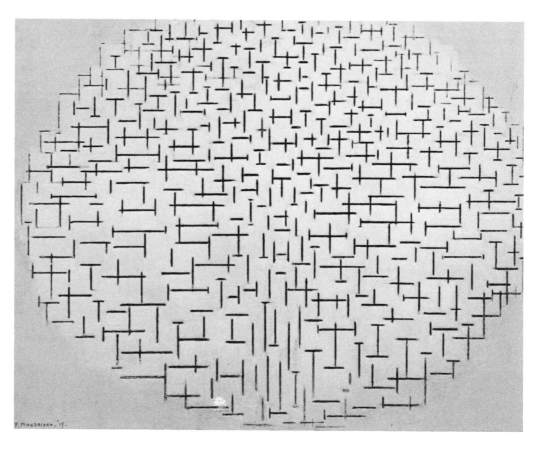

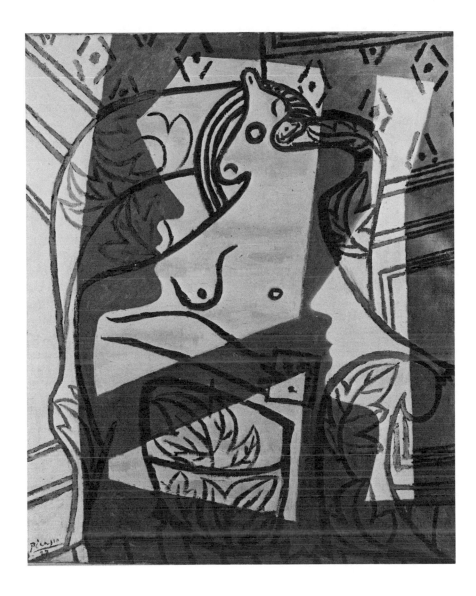

38. Pablo Picasso, *Le Femme Au Fauteil*, 1927, The Minneapolis Institute of Arts.

ally, everything was arranged in parallels to the picture plane. In between the largely rectangular array of grid lines were pseudo-planes, pseudo because the function of their structure was simply to displace space linearly. The destruction of form structure, as such, was reduced to the linear. This was a reduction of the old structuring of "volume," not its elimination. His problem remained.

His choice of the neo-Cubist method of "destruction" indicated that he, too, regarded the old perception exhausted while unknowingly remaining conditioned to such structure. Like all the other leading European painters he could not extensionalize the old perception. Therefore, he strove to destroy it and with the ensuing fragments paradoxically sought to create a new art. He called it the "decomposition" of forms.[143] If the neo-Dadaists sought merely the "dislocation" of the images of form, Mondrian intended the "decomposition" of any form of "natural" structuring.

Unlike his neo-Cubist predecessors Mondrian did not stop at the use of lines in conjunction with pseudo-planes as destructionist devices. He would now reduce everything to lines as in his seascapes, etc. (fig. 37) The most primitive representation of form introduced into painting by neo-Cubists, the line of drawing, for the first time in European art became the *sole* destructionist device in a "painting." This brought on an impasse; Mondrian seemed in doubt about the way to proceed further. For, in 1917, due to the influence of van der Leck, he sharply interrupted any further line painting. He returned to the perceptual character of rectangular planes all parallel to the picture plane. (fig. 39) For the first time since he became a neo-Cubist, an unequivocal representation of form and space appeared in his painting. But Mondrian was again unable to accept anything that was suggestive of natural structure. Again he was faced with the old problem of "volume" in which space was merely a "background."[144]

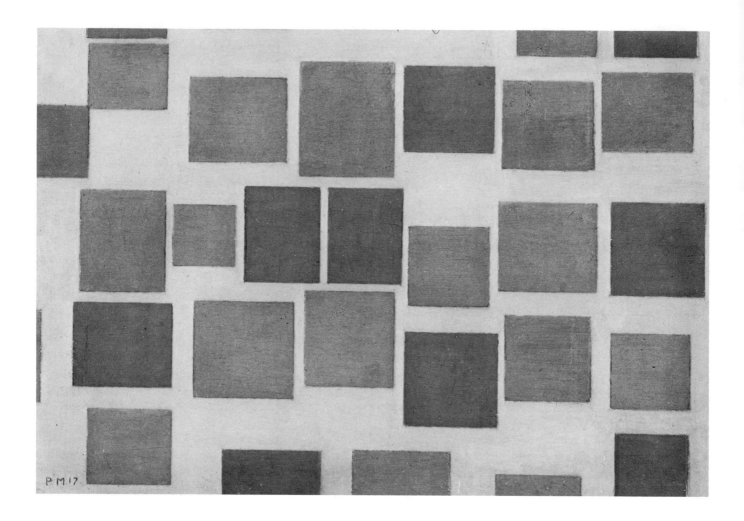

More to the point, the old space displacement of volume had simply been linearized. Given his perceptual prejudices he saw no solution and, as abruptly as he had left it, he returned to the use of lines as destructionist devices. He returned to his former grid solution out of which emerged the rigid paintings of 1918 and 1919. (fig. 40)

The plane which Cezanne perceived as a structural extension, not only of form but of space and light, represented for Mondrian but another variant on the rejected structure of the "natural." As such it must be subjected to "destruction," leaving structure reduced to lines. The result regressed the structure of art, for by no stretch of the imagination did line structuring go beyond the past's limited perception of form. To the contrary, the lines were regressing such structure. Under these circumstances it follows that in his very last work, and especially evident in that work, Mondrian was involved in a structural conflict as he occillated between lines and planes. His effort to destroy form only reduced the structure of the obsolete space-displacing form of the past, at the cost of destroying the very structural base which could be extensionalized to a viable means for achieving a genuine new art.

It is not surprising then, that at the end of his life, Mondrian was disturbed to discover that he had been "drawing" instead of "painting."[145] Not because he recognized the line as a structural regression, but rather because the old notion of painting had been lost. In fact, it was the method of destruction that had destroyed painting as such. He was unable to perceive that what disturbed him was the direct result of his relentless method of destruction. To the contrary, he concluded that he must further enforce the use of the "destructive element," contending to the very last that that method had been "too much neglected."[146] Compelled to give up his "line" drawing destructionist device, he had to set up a work that would permit him to exert his destructionist compulsions on a painting. (fig. 41) He enacted the ultimate "destruction" that was ever to appear in his work. All the former definitions of planes and lines now disappeared. There was only structural ambiguity, a confused structural interference of planes and lines with each other. If before the lines destroyed the planes, now the planes destroyed the lines, bringing destruction to both. This work reached the very brink of the "abyss" Mondrian predicted for art.

40

39. Opposite page: Piet Mondrian, *Composition 1917*, Stedelijk Museum, Amsterdam, 40. Above left: Piet Mondrian, *Lozenge With Grey Lines*, 1918, Haags Gemeentemuseum, The Hague. 41. Above right: Piet Mondrian, *Victory Boogie-Woogie*, 1943–44, Collection Mr. and Mrs. Burton Tremaine, Meriden, Conn.

Until this last work Mondrian's "paintings" possessed a spatial homogeneity even if limited structurally to the linear. But the paradoxical structuring that appeared in his last work would regress structure even further. The ambiguity of form in this work rendered space itself ambiguous. Structural conflict was everywhere. Indeed the diamond shape of the work struggled to contain the structural chaos within. There was a hammering at the diamond boundaries as if the turmoil within would seek release.

As structural extension inevitably carries with it its own unique unity, so too is the case with structural regression. For whatever one does to form, to space, to color, one does to all. The introduction of a single aspect of structural regression in turn regresses all aspects of structure. Hence the deceptive "unity" of regressive structuring. Where whatever kind of structuring is involved, there is always a structural chain reaction regardless of whether the artist knows it or not. The laws of nature are not a matter of our choosing to use them or ignore them. Thus, in spite of Mondrian's efforts to step out of the natural, he remained bound to it as any artist in the past.

In spite of Mondrian's assumption that natural space was "empty," that it must be "destroyed" into "space determinations," not merely "space expression," the spatial results were but "a background," a fact he considered a defect in his 1917 works. This was inevitable. Space cannot be manipulated in the same way as form. Form can be altered either by extensionalizing its relation with space or reducing its functional limit, thus regressing the structure of form to that of line and then reducing the function of space to linear limits. Mondrian, however, insisted that nothing but "relations" were left, as if form had been removed. The result presumed to be an art of "space determinations." The implication was that space is determined merely with structure, but structure can hardly appear in a work unless there has been something to structure, and, of course, in a Mondrian, "form" is present except that it has been reduced to the lowest order for structurally representing "form" — the line. And, given the "chain reaction," space has consequently been reduced also in its structural *function*, not in its structure as in the case of form. Space is confined to function solely in linear limits. It then becomes rather apparent that if one intends to go beyond the structuring of past art by the method of destroying it, one is bound to achieve the very opposite result. The art ends up in an even lower order of structuring than *ever existed* in past art. If Cezanne's last landscapes also tend toward the ultimate reduction of structuring to a parallel with the picture plane, they do so by extension from space displacement to spatial planes, in contrast to Mondrian's regressive reduction of form to line. Cezanne sought to achieve a structural transition to a new art of creation, not to Mondrian's mystical absolute whose future was an "abyss."

For all of Mondrian's neo-painting attempts to deny the "natural" state of "form" and "space," for all his denial of having any intention to "express natural harmony," [147] he never eliminated nature and its perceptual

reality. That was to attempt the impossible. He only eliminated for himself the opportunity to pursue and to achieve a new perception of nature's structure which was indispensable to securing a *genuine* new non-mimetic art. For nature supplies the *only* structural process available to the artist. To vent "destruction" upon nature's structure is to destroy the very structure essential to realizing art. One destroys art, not nature.

Therefore, the artist either seeks a harmony between nature and art or he finds himself in a state of conflict with nature that is certain to destroy his art. To "do battle" with nature is to "do battle" with art — the suicide of art. Mondrian would not allow himself to understand that his "drawing" works were progressively destroying painting. The attempt to return to painting in his last work, still with the method of destruction, only resulted once more in the complete destruction of painting. *When a medium becomes obsolete, the attempt to continue its use only leads the painter to achieve the "destruction" of that medium as art.*

As early as 1931, Mondrian conceded that nothing more of significance could be done except to produce variants on what he had already done.[148] The perceptual confusion and destruction of the ancient forms of art — sculpture, painting, drawing — which began with the original neo-Cubists was completed in the neo-painting of Mondrian. It is not surprising, then, that he predicted that art would eventually arrive at an "abyss." Is not his last work that abyss?

If Mondrian was the first to become disturbed by the confusion of "drawing" with "painting," he would also be the last to notice this confusion; still he never comprehended the problem as one of structural regression. All this was the direct consequence of the original neo-Cubist structural break-down of the distinction between drawing and painting. After Mondrian, no European would even suspect that a problem existed. This was one of the many problems anticipated by Cezanne. He called attention to the perceptual fact that there were no lines in nature; consequently he rejected the structural primitivism of the neo-Impressionist use of "outline." To the contrary, this structural confusion became a way of life and today we hear such contradictory expressions as "drawings are painted" and "paintings are drawn." Such observations exposed a problem, and were nonsensically understood as revealing an achievement.

Like all who were permanently blinded by the eruptive flash of neo-Cubism across the eyes of European art, Mondrian never suspected the fundamental perceptual significance of Cezanne's revolution. To the contrary, he saw Cezanne as merely achieving the "destruction" of the old "picture concept" and "not much else."[149] Of course Cezanne had never been concerned with the "destruction" of anything at all, and would have replied to Mondrian that it was the critical need for an extensional perception of nature, not the device of destruction, that was entirely "neglected."

Just as the neo-Dadaists had not fundamentally gone beyond Picasso's "visual habits," neither did Mondrian. He was as much a captive of visual conditioning to the past as anyone from Moreau to Ernst. The principle difference between all the perceptual introverters, from Moreau to Mondrian, was the degree to which they would use the method of destruction upon nature and past art in their futile effort to compel the old to yield the new. The case of Mondrian, however, was something special, for he took up the torch of neo-Cubist "destruction" with the zeal of a Savonarola. Santayana observed long ago that the mystic, by steadily destroying his base in the natural world, eventually immolates himself upon his own inflexible, relentless ideal.

The neo-painter Mondrian was, in his way, as much a neo-mimecist as all other European artists. The difference was only that he went beyond the object to vent "destruction" on the problem of structure itself. Indeed, he was logically carrying out to its ultimate destructive consequences the irrational goal of all European 20th century art. That is, he was attempting to destroy the very structure that characterized mimetic perception in a futile effort to compel the old to yield a new perception.

Unable to extensionalize his perception of nature as all the past great artists had done, thus enabling them to give extension to the perceptual horizon of art, Mondrian had no recourse but to assume that all past artists had unwittingly sought that epitome of art, the supreme and absolute goal of non-mimesis which Mondrian claimed to have achieved. Past artists did not share this goal he attributed to their subconscious. Moreover he destroyed that particular consciousness which would have enabled him to achieve the non-mimetic goal he sought early in his work. That was the price of his perceptual rejection of nature. "We cannot," observed Stendhal, "oppose nature with impunity."

10. *Sculpture As New*

Before considering the three-dimensional solution of sculpture, it is necessary to examine dimensional problems first raised by neo-Cubism as they later appear specifically in neo-painting.

In 1917, as already noted, Mondrian produced works using only rectangular planes. Since his own neo-Cubism it was the first (and the last) time he produced works based on extroverted perception. This effort erupted suddenly and was obviously not the result of any development out of his own previous work.

Such a drastic about-face indicated a crisis had arisen in his art. Yet before 1917 ended, this effort ceased as abruptly as it had begun. Mondrian then returned to the grid and pseudo-planes which had first appeared in his neo-Cubism.

In the 1917 paintings, however, the obsolete structuring of the past is still present. The planes simply displaced space. This space, Mondrian correctly observed, remained merely a "background" but was functionally limited to the linear structuring. This structural situation posed a critical problem he could not confront. That is, the 1917 works displayed the inability of painting's limited structure to encompass the further pursuit of non-mimetic form towards further spatial development. This impasse indicated the necessity for a new medium of more extensive structure, specifically a three-dimensional one. Mondrian, however, preferred to continue painting as perceptual introversion, i.e., structural "destruction," as the means to a new awareness of space. In doing so he chose to continue with the painting medium even when his own work could have indicated to him that it had become obsolete.

Mondrian was never disposed to comprehend the accomplishments of Cezanne, namely, that he had presented a new structure for the purpose of "creation" by giving extension to the ancient perception of form as space displacement to form as space plane. To the contrary Mondrian flatly stated, and this is more directly expressed in his preliminary draft for "Toward A True Vision Of Reality," that he saw the problem not one of achieving "new forms," but rather, of "abolishing them." That is, to abolish forms altogether, new or old. It is not surprising then that he arrayed his 1917 planes under the continuing sway of the old notion of form. To represent form linearly only limited, but did not "abolish," the old notion of form Mondrian had sought to eliminate ever since he felt the neo-Cubists had failed to do so.

Having doubts about his pre-1917 efforts to destroy form by unknowingly reducing its structure to the primitive line, thus giving a primitive structure to space and light too, and unable to resolve the form-space problem of 1917, he took the third and fatal step. He would go beyond the simple destruction of the forms of objects to rejection of all attributes of nature's structural process.

Just three years after the 1917 Mondrians, Rodchenko became the first to conclude that neo-painting was "dead." A year after that Doesburg found that painting had "ceased" to possess any further "meaning." [150] As in the photographic crisis of 1839, painting was again shaken with deep-seated problems, problems no European after Cezanne was willing to confront. For example, Doesburg, in spite of his discovery, continued to paint anyway.

Mondrian's response to the dilemma of his 1917 works took him on a course opposite that indicated by the now structurally obsolete medium of painting. He insisted that three-dimensional space had "to be reduced" to two dimensions. [151] Two-dimensional form or space, however, is a structural fallacy which originated in neo-Cubism. Parallelism of linear planes to the picture plane simply limits the use of, but does not reduce, the three-dimensional illusionistic structure of a painting to two dimensions. As noted earlier, unlike form which can be literally altered, e.g., with the line, space as such cannot be altered. Only the *function* of space can be altered, e.g., by limiting it to linearizing of the form structure of a painting. Even if we accept the surface of a canvas as apparently two-dimensional, the fact is that *whatever* a painter does on that surface, dripped or deliberate, cannot be *perceptually* confined to two dimensions. The painter cannot avoid producing three dimensional *illusions*. He can only *limit the use of structuring in three dimensions* by restricting himself to flat shapes parallel to the picture plane of the canvas; this then gives an illusion of being structurally in different three-dimensional linear layers of depth in relation to the position of the picture plane. (fig. 39) Therefore, it is not possible to reduce the number of dimensions in a painting, since anything the painter does on the canvas cannot escape having three-dimensional references. What one can reduce is the extent to which he will avail himself of the possibilities of three dimensions. Hence the "natural," so despised by Mondrian, cannot be eliminated. The three dimensions can be manipulated and regressed, but not eliminated. The perceptual reality of the structural world is three-dimensional, and nothing we can do will change that fact!

In recent years the two-dimensional fallacy of form was compounded by the effort to remove still another

dimension. The reference is to those who would "expunge" "spatial" illusion. Yet it is obvious that *any* mark placed on a canvas sets up an illusion of some kind of a representation of "form" in space and in color, since none of these structural elements is separable. Yet there are those who harbour the delusion they are reducing everything to a single dimension. There is good reason, however, why alleged painters involve themselves in the absurd game of dimensional roulette. Painting, as was noted earlier, is *structurally exhausted* for any further use to achieve a genuine new art. Unwilling to face that fact, painters desperately seek for any structural expediency that might feign painting's former viability. It is not an accident that, following the example of Mondrian, these structural expediencies take some form of denying ("expunging") the third dimension. Paradoxically, the painters felt if painting were to remain valid it would entail casting doubt upon the validity of a three-dimensional reality. The majority of painters were unable or unwilling to recognize the obsolescence of the painting medium until it was thoroughly destroyed by their own efforts to perpetuate it. As usual the majority were more concerned with conforming to the art fictions held by non-artist critics. The result was a complete failure to comprehend the reality of the structural transition that had taken place in Cezanne's work. That is, his structural transition from the three-dimensional illusion of past representational painting towards the linear reality of a canvas was just that, a *structural transition* and not a final goal. Structurally speaking, the transition was from the highly developed optical representations of structuring in painting to an even higher and new creative form of optical structuring in the full reality of three dimensions. In contrast, the majority were enveloped in the general flight to introversion which automatically lead to the general regression towards structural inversion.

It must be understood that the old mediums of art — sculpture, relief, painting and drawing — are in fact four structurally different perceptual forms of vision. Their order in the structural hierarchy of perceptual development is from line drawing to relief, to sculpture, and finally to painting. Now, to use a mixture of two or all of these extremely different forms of visual perception in the structuring of a single work, a common practice in alleged new art, is simply a case of confusing different *kinds and orders* of structural perception. Indeed, to mix together different perceptual forms is inadvertently to imply that none of the ancient mediums is considered as structurally adequate by the artist who is mixing them. It follows that if the artist takes two or more of the old mediums, which separately he regards as inadequate and therefore obsolete, he solves nothing by combining them. Mixing different obsolete mediums serves only to achieve still higher degrees of perceptual obsolescence and culminates in the most absurd visual confusion.

Since the example of neo-painting clearly indicates that it is out of the question to dispense with the structural presence of the world as three-dimensional, then what about sculpture? Here we will deal with the only sculpture that merits consideration. Namely, the Russian school of Constructivism. Just as the neo-painter sought to re-do past painting into a more perfect form of painting, so the neo-sculptor would re-do the past into a more perfect form of sculpture. According to neo-sculptor Gabo, art is a problem of "form" and "content." These two elements, he said, are inseparable and so must function as "a unity," [152] which fact past artists failed to recognize. Therefore past art was always a case of "form" determining "content" or vice versa. Gabo believed the pristine quality of form was lost when it was subjected to taking on the appearance of nature. He would, therefore, free form from the contamination of nature and thus obtain the absolutely pure state of form. This was, more or less, the neo-painting theory all over again. That is, the past artist was taken in by the superficial appearances of nature and thus failed to attain the supreme reality for art.

In the first place, no utterances by any of the great artists of the past expressed views of a dichotomy between "form" and "content." In fact such views appeared only after Cezanne's art began to undergo misinterpretations, one of which was the regarding of form as distinct from subject. To take one of numerous examples, the critic Clive Bell put forth the view that when one looked at a house, hill or whatever object, one could also see the object as just form, that is, as distinct from its object appearances. This was again the hopeless effort which insisted on compelling the old (objects) to yield the new. Thus a house or a hill was presumed to be transformed into a "form" that was not a house or a hill. The attempt was to reduce the results of the old perception to a new structural perception while not letting go of the familiar old object associations. The result was a total failure to give structural extension to the perceptual act itself. Thus arose the false notion of "plastic qualities" as something other than the object evoking such qualities. This view of the plastic became a popular mode of rationalization for all forms of neo-mimesis, in order to attribute all the qualities of non-mimesis, (the "plastic"), and all the mimetic qualities of the past, (the "subject"), to neo-mimetic art. Unfortunately at the time of his death in 1906, Cezanne had not completed, not "realized," the transition to a new art. It was that unconcluded state of his work, along with the discrepancy between his landscape and *Bather* paintings (figs. 25, 28) which invited misinterpretations of some contest between the combatants "form" and "content." A very bald example of this schizoid perception was advanced by a leading American art "authority." He stated that if the subject were removed from a "realistic" painting there would be "little left." Whereas, he continued, in an "expressionist" work, giving van Gogh and

Rouault as examples, the shapes, colors and lines could "exist without any subject." Actually, if the subject is removed from a realistic painting, the result is not a "little left" but nothing left. Similarly, if you remove the subject from an expressionist work, what is left is not shapes, colors and lines, but again nothing. The obvious fact is the subject supplies the structure whether we are dealing with realistic, expressionistic or any other form of subject painting. It is necessary to point out again there is no such *thing* as structure of itself unless there are things to structure. There is only one case where a painting can "exist without any subject," and that is when it was painted without any "subject" in the first place.

Gabo's structural dichotomy only appeared in modern art and never existed in the great art of the past. Both Gabo and Mondrian set up a non-existent past out of which they assumed to bring forth a superior art. After all, is not the "form" always the "content," whatever the content, as the content is always the form, whatever the form? How can one represent, for example, the human form without the latter being both content and form? It is Gabo himself who attributed structural separability to that which past artists saw as inseparable. Such structural fictions are found in Gabo's theory of absolute pure form, i.e., form uncontaminated by the subjects of nature.

Now there are in fact two general kinds of forms in 20th century art: those created by nature, and those created wholly by man. The former are appropriate to mimetic art, the latter to non-mimetic art. In each case, form and content are inseparable. The effort of both neo-painting and neo-sculpture to justify themselves on the basis of correcting and perfecting what past art supposedly tried to do only served to confuse the old with the new to the detriment of both.

Like Mondrian's neo-painting, Gabo's neo-sculpture erupted out of the influence of neo-Cubism. However, there is a single important difference. For the first time the effort seemed to be to engage the "plane" of neo-Cubism in the dimensions of spatial actuality as another form of neo-Cubism, this time as sculpture. For obvious reasons the sculptural version of neo-Cubism cannot begin with the landscape but with the only subject available to that medium, the human form. (fig. 42) Thus the neo-Cubist sculptor was immediately compelled to plunge structurally into the obsolete space displacement of the human form. But this problem was not recognized because the sculptor had accepted the neo-Cubist method of form "destruction." The planes are the pseudo-plane device of form destruction originated by the first neo-Cubist painters, only now this effort took place in the actuality dimensions of the sculpture medium. Again the "plane" is transformed into a destructionist device to break up the obsolete solidity structuring of the past instead of spatially freeing the plane from the limits of past structural perception. Now the past's convexity of form-displacing space is replaced with the concavity of form displacing space. This served to render in three dimensions what the original neo-Cubists structured in their paintings.

Gabo explained his structuring with the example of two cubes. The first was a solid cube, the old notion of sculpture as mass, that which we have been calling form displacement of space. The second was a cube with all the vertical sides removed and two perpendicular sheets passing through the diagonals intersecting in the cube's center. Although these structural distinctions do not seem to have been published before 1937, nevertheless, they are a description of the structural inversions of Gabo's neo-Cubism and characterize all his subsequent work.

Of the first cube, Gabo said it represented "mass," with no mention of space. The second cube represented the space said to be occupied by the mass, now "made visible,"[153] with no mention of form, as if access to space required the destruction of the barricade of form. Given the plenitude of space unoccupied by forms, why the concern with alleged occupied space? It becomes understandable, at least, when one observes that Gabo was following the practice of neo-Cubism; namely, to destroy and break-up the solidity of form in order to achieve what is taken to be a new sense of space. The neo-sculptor has no other alternative because, like all those around him, he concludes that the perception of the visible world is exhausted while remaining conditioned to that same limited vision. To escape that limited vision of the visible world he resorts to "destruction" of its structure. It is a paradoxical, irrational search for the new. The alternative of Monet and Cezanne, that of structural extension of the perception of nature, is closed to the vision of the neo-sculptor.

Lacking an extended perceptual orientation, Gabo regarded the neo-sculptor's concern with space as simply an additive affair, as if the old mass structures had nothing to do with space. That is, he did not consider the ancient mass structuring as obsolete, provided it was purified of any nature contaminations. In that sense he maintained that mass remained one of the (two) "fundamental attributes"[154] of neo-sculpture. Thus Gabo's works are of two kinds. There is the undisguised structuring of the obsolete, simple, space displacing of sculpture (convexity), or the disguised fragmentations (concavity inversions) of mimetic space displacing of form, the method of neo-Cubist "destruction."

In this way the neo-sculptor saw himself as simply adding space perception beside the continued use of the old mass structuring, as if such forms were deprived of space. That, Gabo said, makes available to the sculptor the "contrast" between the two methods,[155] both being considered as equally valid structures. In place of structural extension one is offered structural options, one of which continues obsolete structuring while the other is presumed

(a) The simple convex space displacement of sculpture form. (b) One does not make hidden space visible, one only reverses (a) into simple concave form displacement of space.

to be a new kind of structuring. Having erroneously criticized the past for its separation of "form" and "content," Gabo would consider the old notion of form and his presumed new space structuring as separable structures. Indeed, Gabo regarded space as so different from form that he contended space is defined "by space,"[156] while "volume" could only "define mass," as if unaware that mass also defines space. Space was wrenched out of form by destroying form's presumed occupancy of space. But artists must take care not to confuse art with scientific perception. In that case, past form structuring did not occupy space in the artist's *perception of it*, but simply displaced space in his *vision* of it. Contrary to the neo-sculptor, form not only "defines masses" but also gives a particular definition to space. Space cannot be used to "define space," unless there are some forms with which to define it. One is here confronted with structural irrationality, the direct and inevitable outcome of venting destruction on the old obsolete structure in order to compel it to yield the new.

The Aristotelian categorization of what is perceptually inseparable had its origins with neo-Cubism. For example, Picasso stated that when he concentrated on the object, space became "almost nothing," and when he concentrated upon space, the object became "almost nothing."[157] For Gabo, however, there is no "almost," mass and space are distinct entities from each other, each of which miraculously defines itself.

If space is perceived without verbally conditioned prejudices, it appears visually as an endless continuum unable of itself to evoke any perceptual definitions except its own ceaselessly, unchanging flow. Form has to be introduced into space: without it neither space nor light will define anything but a continuous homogenous spread of space. The homogeneity of space is transformed into the heterogeneity of perceptual variances by the structural actions of form. Similarly, on the question of space the neo-painter Mondrian concluded that "all is space," including form.[158] He would eradicate form from its occupancy of space, as would the neo-sculptor.

Because of the neo-painter's wish to be non-mimetic, his problem of form was distinct from that of the more apparent neo-mimecists. Unable to extend his perception of form structure, unable to extend the neo-Cubist destructionist device of breaking-up form, he then thought to eliminate form for the "spiritual" purity of space. This delusion was perpetuated by the final act of the destructionist device.

As is inevitable in neo-painting's use of the destructionist method, neo-sculpture eventually must reduce the structure of form to its lowest order of representation, the line. Indeed, the neo-sculptor Gabo uses the term

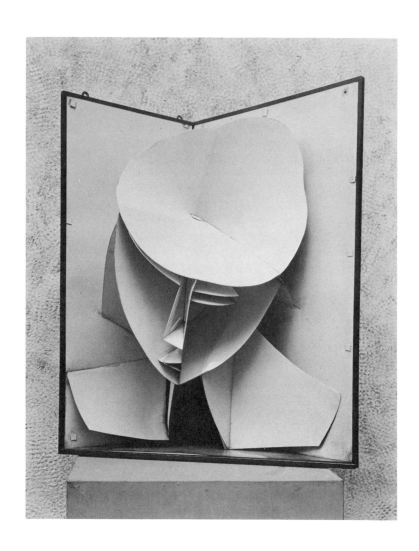

42. Naum Gabo, *Head of a Woman*, c. 1917–20 after a work of 1916, Construction in celluloid and metal, 24 1/2 × 19 1/4 in., collection The Museum of Modern Art, New York.

"linear" in the title of his works. (figs. 43, 44) The neo-sculptor Pevsner approvingly noted the neo-Cubists "gave importance" to the line,[159] and Gabo stated that it is necessary to return the line "back to sculpture."[160] Had the great sculpture of the past resorted to the drawing of lines? On the contrary, this is something peculiar to the neo-sculptors of our times. In any case, a recent follower of neo-sculpture refers to his own work as a "drawing in space" while another says much the same thing by putting the emphasis on "contour" lines from which it is presumed "form emerges." All strive to manipulate obsolete past structuring with the drawing of lines. Such attempts, instead of going further than the past, simply regress the structural form achievements of the past.

What about the neo-sculptor's attitude towards color? More than a half century ago Gabo expressed his disdain for the painter's color. He would "renounce color" as only an "idealized optical surface," "superficial" and a mere matter of "accident."[161] Similarly Vantongerloo, appealing to the "exact sciences" as did Gabo, concluded that color led to mere subjectivism. And a recent neo-sculpture manifesto stated that color led the artist into "subjective expression."[162] Both Vantongerloo and Gabo appealed to classical physics and its view of the so-called "secondary qualities" like color. Color was denied that physical reality accorded to tactile sensations, being considered a "subjective sphere" of perception.[163] Such speculations were not germane to, but often were fallaciously applied to, the very different perceptuality proper to art.

Such an assessment of color, implicitly denouncing color in nature, led the neo-sculptor to dismiss Monet's achievements as a "bankruptcy,"[164] and was an arrogant condemnation of five centuries of extraordinary European painting. The only coloration acceptable to the neo-sculptor was that apparently sacrosanct color already possessed by the material itself. Why that condition of color made it special was not explained. Asked to explain his views on color, Gabo reiterated his half-century old views, but added one new comment: i.e., there were times when past sculpture was colored and times when it was not. As everyone knows, all through the past *great* periods of sculpture color was applied over the material of the sculpture. Indeed it was the art of sculpture, not painting,

that first achieved a higher order of perceptual development in the use of color, precisely because it had the reality of three dimensions. Such sculpture had ceased to be merely tactile and had taken the first major step into the realm of color as the optics of light. Indeed, Greek and Roman painters would first have to achieve the ability to paint figures as if they were colored sculpture before they could then proceed to attain that even higher order of the colored optical image only possible to painting.

It was precisely during the last five centuries which Gabo considered the defunct, decadent period of sculpture, that sculpture was largely confined to the limited "colors" of the materials used. That was the very practice the neo-sculptor employed in his own work.

Discerning that the neo-sculptor is conditioned to the final efforts of sculpture when it is reduced to the color limitations of materials, it becomes possible to see through the naive view of materials as color. It is a view not unlike that of architect Mies. He regarded the "skin" as a mere see-through affair which thus allowed the "bones" to appear as the real structure. Similarly Gabo implied that applied color becomes a superficial skin which then hides the important structure of the materials as the forms. Yet the reality of structure, as given by nature, is far more interesting than the verbalism speculations of the neo-sculptor. As the cosmos is perceptually stratified from the macro- to the micro- to the super-micro, so it is with *every* object in the cosmos, be it a star or a human being. Whether we deal with the whole or the part, reality is stratified into various serial levels of structure, their individual significance being dependent upon the particular interest of the viewer. In art the particular level of interest is the perceptual, the visible of the skin not the invisible bones. All the great ancient sculptors were aware of this obvious truth of perceptual reality. Therefore, to apply the colors of the spectrum like a skin for the forms is to follow the greater structural reality of perceptual nature, to reject what is only the verbal speculation of the neo-sculptor.

Therefore, the color of neo-sculpture is not only very limited but also arbitrary, since it sets "no limits"[165] on the kinds of materials used, claiming that "any kind" is acceptable.[166] This arbitrary attitude not only prevails in the color and materials used, it also permits the use of any kind of geometry structuring. Finally, the supreme irrationality of neo-sculpture arbitrariness lies in the fact that it is also permissible to switch from the new concern with space or, when the mood beckons, to return to the old concern with obsolete form.

What about the new medium of the machine which the neo-sculptor adopted? It appears that, like space, the machine is merely an additive affair. Machine art, like obsolete handcraft forms, merely adds variance to the mediums open to the neo-sculptor. Thus along with his machine-made neo-sculpture, Gabo also admitted to practicing both the obsolete handcraft arts of painting and sculpture. Apparently it is not his belief that the new medium of the machine was to replace the ancient handcraft mediums and art which had become structurally obsolete for the purposes of new art.

It was because of its arbitrary attitude towards the use of the machine and machine materials that neo-sculpture fell heir to the worst possibilities of the new medium. In place of the perceptual world of nature, it was said that the new materials themselves aroused the "genesis" of a work. These materials were said even to arouse "emotional" and "aesthetical" responses.[167] By assuming such attributes for mere materials, arbitrarily used, the neo-sculptor was apparently not dependent either on nature or the possibilities which the past had opened up for art, but rather upon the arbitrary stimuli aroused by mere industrial materials. Indeed, Gabo insists the work was "determined" by the materials used.[168] There was the great danger of the new medium: namely, that the artist looked to the machine and its materials as nothing less than the very source of his work. Should not art, as in the past, dictate to materials? Should not the evolution of art, rather than the development of materials, be the determinations for an artist's work? Otherwise, will not art disappear in the tyranny of the mechanics of the machine and its materials? Is art to look like a machine, like some industrial product, simply because it uses the machine? Would not that result in non-art? Certainly neo-sculpture has had the most destructive influence upon the proper comprehension of the new medium and its materials. Never have the majority of artists exploited such an abundance of different materials and techniques as in this century. The inspiration of nature and the art of the past, which were the inspiration of all the great past artists, have been replaced by the shabby exploitation of any and all materials in any and all techniques, both old and new, as unbelievable substitutes for nature. Artists consequently continue wandering in a perceptual jungle of their own making. It is upon a proper understanding of the new medium and the new nature that efforts to achieve a genuine new art will stand or fall. The tragic consequence of falsely using the new materials has been to divert artists from the new and vitally interesting art problems that await solution. Assuredly the new art will not arise out of exploiting the machine and its materials. That can only lead to the ineffectual use of technology.

The new medium of the machine is an immense refinement over all the past mechanical handicraft methods and in that lies both its danger and its promise. Whether a new art will live or be still-born, perhaps whether there will be art at all, rests on our understanding of the new mechanical mediums as simply the means for creation. To

43. Naum Gabo, *Linear Construction No. 1*, 1942–43, The Solomon R. Guggenheim Museum, New York.

regard the means as the end will only continue the prevailing non-art course of neo-sculpture.

To make matters even more destructive the neo-sculptor not only does not appeal to the evolutionary achievements of art, which would determine the proper use of the machine, but instead adulates and appeals to science. It is important to note that neo-sculpture appeared and was formed shortly after the great revolutions in science took place at the turn of the century. Science was revealing startling information about the truly different world of unseen nature. Physicists were understandably overwhelmed by the dramatic view that was unfolding in the hidden physical recesses of nature. Unfortunately for art, physicists were overenthusiastic. They naively proclaimed that the non-instrumental world perceived by the non-instrumental senses was nothing more than a "fictional reality." Only Eddington seemed much disturbed by the consequences for art. The best he could offer, however, were rationalizations for a mystical sensory view of perceptual nature by the arts. The effect of his effort, in what was fast becoming a scientifically dominated view of civilization, was only further to rule out any perceptual significance for the arts. The whole perceptual climate was overwhelmed and confused by the instrumentally derived mechanical-mathematical knowledge of nature's invisible reality.

It was in this scientific climate that neo-sculpture was formed. These were also the years of the "crisis of the new" in art. Confusion reigned everywhere as "schools" proliferated one on top of the other, all seeming to go everywhere in a desperate search for a new art. Under these difficult conditions there was the temptation to substitute the authority of science for the authority for art.

Gabo was one of those who took seriously, even enthusiastically, the scientific condemnation of the perceptual world of nature and so of art. In this way he would rectify the backward behavior of artists in their pursuit of reality. Indeed science seemed to support his condemnation of past art as inferior to neo-sculpture. Artists and scientists, Gabo now discovered, sought to ascertain the "external reality," but only scientists made "great strides." The artists simply "stopped" at the "sensual world" as the "true reality."[169] Little did artists know, Gabo continued, "how shallow" their images of reality appeared to the scientists. One must deplore such statements which were implicitly, if not explicitly, directed against the extraordinary accomplishments of the whole past of European painting. The reality of that great past art will continue to live long after neo-sculpture is forgotten.

In these times, when the sensory experiences of human life have been denigrated by overevaluating the obsession of science with quantitative and/or mechanical inquiries into aspects of nature hidden from our senses, it becomes critically necessary to reinstate the unique and indispensable experience of human life in the world of

44. Naum Gabo, *Spiral Theme*, *1941*, Construction in plastic, 5 1/2 × 13 1/4 × 9 3/8 in., on base 24 in. square, collection The Museum of Modern Art, New York.

sensory nature. If some scientists have expressed admiration for the activities of some artists, this admiration is largely if not wholly directed to the most introverted art: art which is seen by the scientist, if not by the artist, as being one with the scientist's extra-sensory concerns with nature. It is such views that led to the devastating attitude of scientists and artists continuing a senseless and hopeless effort to be superior to sensory nature, this at a time when man's very survival depends wholly on his capacity to be in harmony with the inescapable laws of nature's totality.

The great error implicit in this confusing of art with science is the myth that there is some single paradigm of nature reality and it is the scientists alone who have found it. Happily nature's and man's reality is more creatively fertile than that, otherwise there would be no need for anyone except scientists in this world. Let the obvious be said then, that the reality of nature is no more confined exclusively to the unseen than to the seen aspect of reality. Nature consists of a hierarchy of related levels or orders of reality. It is precisely for that reason that there are such diversely centered experiences of reality for both nature and man. For that very reason not only scientists but artists and others engaged in various searches into the problem of reality. Science did not have the first, and very likely will not have the last, word on the subject of reality.

Therefore, the reality paradigm for art is not, and cannot be, that of science. If the artist confuses the two he will have to share the neo-sculptor's "shallow" view of art reality. In spite of all the attention given to art, it is not realized that art alone and not science has achieved a perceptual evolution for the visual reality experiences of man. Art too has made "great strides" in its reality perceptions, and the future may reveal them as more fundamental than those made by science, because art is centered in the individual, non-mechanical creative biology of man. Too often science sacrifices man and nature to its obsession with statistical mechanics. The supreme effort of art is ceaselessly to expand the creative sensory experience of man biologically within nature.

Gabo's attraction to science even colored his verbal descriptions of the original neo-Cubists. He found that neo-Cubism "sharpened" the possibility for "analytical thought," and achieved a "pictorial analysis" of what he called "cells."[170] This must have surprised Picasso who had a primitive belief in "magic," and Braque who regarded art as an "irrational act," not to mention neo-Cubism's associations with literary obscurities that could hardly be mistaken for "analytical thought."

In his own work, however, Gabo could more easily simulate associations with science. Asked where his idea for the application of space to sculpture originated, as if past sculpture were bereft of space, he replied that it

originated in those events that took place in science at the start of this century.[171] Such dependence on the authority of science seems hardly concerned with art. By the very nature of their great perceptual differences one would expect art and science to have differing concerns and differing perceptions of space.

Under the influence of science Gabo presented his view of perception. The five senses, he said, do not encompass the whole of nature and human life. Nature, he continued, "conceals" an "infinite" diversity of things "never seen."[172] Not to be left behind by science, Gabo would have his imperceptibles too. What this unseen aspect of reality specified for the *seen* aspect of art was never explained, except to refer to the "spiritual" to which all the European introvertors of perception appealed. It would seem that the scientific pragmatic concern with the unseen took on a most unscientific appearance as the "spiritual" in art.

In a similar vein, the neo-painter Mondrian distinguished between the "subjective" of past art and the "objectivity" of his art, claiming he was abstracting in a way that was similar to the scientific attitude. Art and science, he claimed sought an "abstract" reality,[173] and like science art found the "true reality" "veiled" by the "optical vision."[174] Each, he insisted, made the "invisible" become "visible." That is the sort of claim Redon made so many years before as a result of simply introverting the old perception. The "transitory" was rejected for the "permanent" as in Parmenides i.e., the perceptual "outside" was rejected for the "inside." In the same vein, Gabo made "visible" the invisible space presumably occupied by form. Hence the difference between Moreau-Redon and Mondrian-Gabo was that the latter also attributed unique spatial qualities to their presumed super-perceptual pursuits.

Neo-sculpture and neo-painting fail because both are without any viable perceptual relationship with nature which is so indispensable to any art. Thus, Gabo was compelled to conclude that the "medium" between the artist's "inner world" and the "external world" was no longer capable of extension because nothing "substantial" was left in the external world.[175] Like Mondrian, Gabo was one with Baudelaire, Redon, Moreau and Breton in believing the perceptual world was "deprived of all significance."

Since Gabo dealt with the problem of abstraction, it bears attention as being relevant to the question of perception. He began by stating that the term "abstract" made "no sense" because "any" kind of art was an abstraction.[176] Why something that applied to any art made "no sense" was not explained. However, neo-sculpture would seem to be included, since "any" art was an abstraction. To the very contrary, he insisted neo-sculpture was not "abstract" but "absolute" because it was not an abstraction from any existing thing in nature, for the "content" of such art existed in itself.[177] That was an extraordinary statement, the assumption being that the artist had conjured on his own the structural elements of form, space and light, and not abstracted these elements from perceptual reality. The source of knowledge and perception for neo-sculpture, Gabo implied, lay in "mental images," which remind one of Redon's "agent of the mind." Plainly this was perceptual introversion. As Apollinaire observed in the early years of this century, the artists of Europe were achieving "everything from within themselves."[178] Much later an American painter would put it even more arrogantly, claiming that the artist had become "his own nature," a nature that Cezanne called the "puny self."

In any case, the neo-sculptor is mistaken to assume he ceased to abstract from nature when he no longer abstracted from the appearances of nature. For that was to assume, as noted earlier, that he invented the elements of structure — form, space and light. Perceptually speaking, if the artist was not abstracting from what nature had already created, then he was unconsciously and therefore confusedly abstracting from the structural mode of nature. He had no other alternative, however much he totally confused his abstractions with the futility of "destructions." By introverting perception the artist inevitably must introvert his abstractions, abstractions which led him into a fictional world of structuring, e.g., regarding form or mass as "neglecting" or giving "little attention" to space.[179] Past perception of form had a particular and viable relation to space as space displacement structurally appropriate to the art of the past.

All artists, of whatever kind they may be, are involved in some inescapable form of abstracting from nature. Therefore it is false to claim, as Gabo did, that neo-sculpture made "its own laws"[180] for the laws were already there in nature; one worked in harmony with them or else opposed them at the cost of certain defeat, such as discovering that one's art often had more in common with some industrial product. And for the artist whose goal was non-mimesis, who also destroyed the obsolete form of past perception in place of seeking perceptual extension, the price was failure to achieve a structurally genuine form of non-mimetic art.

If the artist is in conflict with the laws of nature, meaning perceptual laws, nature's laws will act destructively upon the artist who deals with nature destructively. The key question cannot be whether or not an artist abstracts from perceptual nature, but only how he abstracts, whether or not he knows he is abstracting from nature.

In 1944 Gabo remarked that he had been "repeatedly" and "annoyingly" asked about the source of the forms in his work. Contradicting all his views on perception, science, abstraction, etc., he cited his sources as clouds, smoke, waves, stones, leaves, and other *fragmentary* aspects of mimetic perception.[181] Was not the "shallow"

reality that "external world" in which "nothing substantial" remained, which he and scientists looked down upon in the work of artists? For he was in effect now stating that he made neo-mimetic abstractions from that "sensual world" of nature which he deplored in the 1930's. Had he not denied that his work was "abstract," that it was "absolute" and pristine, uncontaminated by anything existing in "sensual" nature? In fact, as did any neo-mimesist, he now stated that he followed the "forms of nature" but "reforms them."[182] Like all European "innovators" Gabo was a conditioned captive of the past's obsolete vision. If he appeared to have overcome conditioning to the obsolete content of "subject," he remained, like Mondrian, conditioned to the obsolete structural perception of the past. That was true of all Europeans who sought a non-mimetic art and thus were compelled to resort to the device of destructions in the desperate effort to force the old to yield the new. The consequence was that every problem was laden with unresolvable dichotomies. For example, it would seem the source of Gabo's forms lay in obsolete mimetic perception while he claimed, as noted earlier, that his application of space originated in the events of science at the turn of the century.

In the 1920 manifesto of neo-sculpture, Gabo said of the then "recent past" that with the exception of neo-Cubism and the neo-mimetic art of Futurists, that past contained "nothing" of importance that was even "deserving" of attention.[183] Monet's Impressionism was dismissed as mere "bankruptcy." Neo-Cubism, not Cezanne, was seen as having made the major effort to open the way to the new art. As a recent follower of neo-sculpture claimed, the theories of Cezanne were obsolete.[184]

How different Cezanne's attitude was towards the past which neo-painting and neo-sculpture dismissed with contempt, claiming their own art was superior to both the past and to nature. For Cezanne the past was not a "barrier," but a world of art he wished to "profit" from, to be worthy of those before him.

It becomes evident that what the neo-painting of Mondrian and the neo-sculpture of Gabo had in common was far more significant than their differences. The old medium of painting vanished in the destructions of the "abyss," and the old medium of sculpture disappeared in the structural fragmentations of a machine-made non-art.

The collapse of the distinction between drawing and painting, which took place in the first neo-Cubism, was the signal that the medium of painting had structurally become obsolete. Therefore, the collapse could only continue in further fragmentations in the neo-painting of Mondrian and others, and the collapse was accelerated when the distinction between drawing and three dimensional actuality broke down in the obsolete continuation of sculpture by Gabo and others. Thus the two ancient mediums disintegrated in their regression of the structural coherence of all the great past art, leaving the remains in the bare bones of lines. Destroying the structure of past art which was based on nature did not make the neo-painters and neo-sculptors superior to the past, but made their art inferior to it. They also destroyed the structural possibilities of a non-mimetic art.

Cezanne had seen clearly many of the dangers that lay in the path to the future, for he saw those dangers having their inception in all the art around him. While reflecting on the extraordinary achievements of the old masters, he observed that they were certainly "not painters of fragments" and that *"something in the moderns breaks down,"* for the pursuit of painting according to nature "has been lost."[185] This breakdown has reached incredible proportions today. At the end of his life, Cezanne said, "I am the last of the painters." Indeed he was the last great painter that Europe or the world would ever see again. Mondrian was correct when he observed that the artists all over Europe were funnelled in the single direction of destroying the past and nature. This left them impotent before the challenge of a new art.

11. *Past As Colossus*

With Courbet, some 500 centuries of mimetic art came to an end after five centuries of extraordinary European painting. Only if one keeps in mind how colossal were the achievements of the past can one begin to appreciate the incredible efforts of Monet and Cezanne. They began to make the first fundamental change in the course of art. It is necessary to understand emotionally as well as intellectually why so many other gifted artists of Europe failed, if we are not to fail also.

In his last years Cezanne frequently expressed the hope he would live long enough to "realize" his goal. He knew he was approaching the discovery of a new kind of art. He was aware, however, that he had already "cleared a path" [186] to a "new vision," so that another might realize what he had "not been able" to realize. [187] But after his death not a single European was to continue the achievements that Cezanne left behind. No one continued his work in the real sense that Cezanne had continued Monet. This was not because Europe was not producing as many gifted artists as it ever had. Rather the link with the great European past was severed, thus freeing contemporary artists from the past, or so they thought. Everything that had always maintained the continuity of European art crumbled away. In time the artists came to interpret this extraordinary break in the continuity of art as meaning they were free of a totally useless past; had not the old perception of nature died out in an all-out effort at realism? It was assumed this meant, as Kandinsky, Picasso and others put it, that "everything was permitted." The great irony was the more Europeans thought they were free of the past, the more firmly they were ensnared in a terrible struggle within the perceptual limitations of conditioning to the past.

Each time Europe's artists appeared to be approaching the brink of the new, that brink that appeared in Cezanne's last few landscapes, those 500 centuries of mimetic conditioning descended like an avalanche crushing every effort to achieve the new. The "crisis of the new" revealed that the "crisis of the old" still reigned supreme. Some artists sought to make peace by offering a compromise with their "visual habits." Artists spent their lives weaving neo-mimetic images, going back and forth in the maze from realism to its demolition, from which they could not find any exit. Those who did not consciously mollify the past desperately sought to ward it off by hurling violent invectives against it, in particular against the last five centuries of European painting. It is not a mere accident that it was Leonardo, not Michelangelo, who was the focal point of the abuse hurled against the art of the past. His *Mona Lisa* was defaced with a mustache. Nor was it accidental that at the close of those five centuries it was not van Gogh but Cezanne who was abused. A toy monkey was stretched within a painting frame titled *Portrait of Cezanne*. Thus was mocked the one artist who had pushed European art to the "brink" of the new. Neither the infantile perpetrators of these defacements of art, nor those who were revolted by such behavior, understood the fundamental significance of these events, for both the radicals and the academicians were equally revolted by Cezanne.

Unquestionably a deadly struggle was going on with the past, as though it were the past which had failed, casting everyone adrift. When would the European cease weeping because of the "collapse" of the "old Temples?" [188] cried out Drie Rochelle just as the new was pressing for its birth early in our century. He felt he was witnessing the very end of the "earth's greatness." [189] The artist has to be "on guard," says Duchamp, because he might be "invaded by things of the past." Ernst considered his generation to be "victims of history;" [190] he accordingly could not tolerate the phrase "history of art." [191] In the previous century Artaud warned that the "logical Europe" of the past "crushes the mind," and must be swept away if man is to be rescued from the "corruption" of reason. [192]

None of these remarks should be taken lightly and dismissed as absurd, for they are inadvertent admissions that the problem of history had reached intolerable proportions. They are telling us that the European artist suddenly found himself torn from his moorings in the past, alone, adrift in a boat without oars or compass. All this was felt intensely in the previous century. Jullian reports Renan saw European civilization headed for "mediocrity." There existed a general "uneasiness," as if the "end of civilization" were approaching, as Europe was being pummelled on all sides by the "destructive forces" of socialism and the machine. Thus "escape" was sought in "dreams," "death," and "melancholy." [193] Renan felt that France was "dying," and everyone felt "threatened" by machines. [194] The Decadents felt that "disaster" was approaching. [195] Max Nordau, in 1893, saw a general mental breakdown taking place, the rise of a plague of degeneration, along with "artistic insanity." [196]

The Fauves, the "Wild Beasts," and the neo-Cubists, sounded a loud warning. Dada was the explosion. But Europe's artists could not confront the warnings and, instead of looking to the future, they turned their backs on it to "wage war" upon the past, as if determined to become the willing "victims of history." No artist so willingly

accepted that role as Ernst. He literally depended on assuming a "vicious past," [197] as an admirer noted. That enabled him to open wide the way to neo-Dada. Ernst had indeed sharply turned his back on the future as he yearned for what he called the "lost paradise."

Those who were not prepared to admit they were "victims" of the past rejected the past with the violence of those who felt themselves persecuted. Mondrian regarded the past as an "oppression," [198] and believed that a "fierce struggle" [199] must ensue with the past. Therefore, he concluded, the past must be "annihilated." [200] Gabo, in his 1920 manifesto, called the past "carrion." By this literal hatred of the past, painters and sculptors sealed their fate and became, as Ernst, "victims" of the past.

For the first time in 500 centuries, with the exception of the Dark Ages, artists were not only without a conscious link with the past, but also without a perceptual paradigm in nature, leaving the European to wander in the ambiguous, capricious darkness of his "inner self." We must appreciate this terrible traumatic isolation in which each European artist found himself. Each was compelled to consume his energy in a ceaseless and futile "battle" with nature and his past. Only when we feel the immensity of all that Europeans had lost, all that had been the very breath and blood of their art, can we understand the desperate measure they took to compensate for their loss.

Lacking all that once supported their vision of art, artists sought footing outside art. Neo-mimesists propped their art with a literature of obscurity, while those who sought a non-mimetic art tended to look to science and Hegel for props. Like scientists they foolishly turned their backs on the alleged "fictional reality" of the perceptual world. And like scientists, they too would delve into the extra sensory. Their "hidden," "veiled" world, however, was fabricated of verbal conjurations. All that had nothing at all in common with the scientist's instrumental perceptions of the unseen actualities of physical nature. When asked about the new condition in which the artist found himself, Picasso explained it this way: the "link" with tradition was broken by the Impressionists; with that all "rules," "order," "cannon" which all past art possessed, disappeared. Neo-Cubism, he contended, had tried to restore "order," but that was a "lost cause." Accordingly, he went on, there remained no alternative but for every artist to do as he pleased, to devise his own personal art. He, therefore, saw van Gogh as the "archetype" for the artists of our times, who are "tragic" and also "solitary." [201]

Ironically it was not Impressionism, not Monet, but Moreau, Redon, the neo-Impressionists and neo-Cubists who broke the link with the past; above all it was Picasso himself who managed the first totally decisive blow. It was thus a foregone conclusion that neo-Cubist attempts to restore "order" were bound to be a "lost cause." The die had been cast the moment Cezanne's work underwent the misinterpretations of neo-Cubists. It was then that Apollinaire saw that everything was becoming a "great subjective movement," that "subjective world" [202] Redon saw as belonging to the "future," where nothing could be defined, where everything remained unknown, [203] in order to "objectify the subjective."

This was also the time of the New York Armory exhibition in 1913, the content of which explained what had happened to European art after Monet and Cezanne. Monet was represented with only four works, Cezanne with eight. Seventy-four works were by Redon. Duchamp, whose work had achieved notoriety at that exhibition, when asked if he were influenced by Cezanne, replied that his "departure" [204] was from Redon. Cezanne, who but five years before had captured the attention of Europe, had been replaced by the introvertor of mimetic perception.

After Cezanne one can search in vain for a single European with any awareness that a "new vision," [205] literally a new perceptual vision of nature, had to "be born," "continued" and "perfected." Cezanne's very words suggest what could be seen in his works. How could it be missed? Because no one wished to see it. So with one voice Europeans concluded that with the exhaustion of the old vision in realism, the perceptuality of nature, too, had been completely exhausted. Europe had taken the transition to the new only as far as Cezanne.

What was not understood was that the artist could not instantly dismiss past perceptuality. That simply was not possible. The consequence of such an attempt was that one regressed the old image and/or structuring of mimetic perception. There was no other choice. The very serious problem was to become aware that one was conditioned to the old vision. The attempt instantly to dismiss the old vision had the disastrous effect of driving the problem further from the vigilance of consciousness. The result was to obscure further the possibility of perceptual extension which Monet and Cezanne had begun. One had to see the old anew to see nature anew, thus to achieve art anew. The perceptual defeat of modern art is revealed in the entire course through which such efforts have passed. As everyone knows, the great crisis in art occurred when it seemed that the realism of Courbet promised nothing further for the artist but to "ape nature." Since Moreau and Monet, the general attempt to avoid simply reflecting the image of nature has led to the fallacious belief that one was "re-creating" nature. Yet in the 1960's, and more so in the 1970's, modernism welcomed the very fabrications of realism that had previously been rejected so adamantly, a realism that was taken to the ultimate absurdity of plaster cast imitations colored with the mortician's skill. The original fight against realism inevitably led modern art to become the victim of the worst kind

of realism. It would appear Madame Toussaud had discovered the art of the future. Hence the decadence of 19th century realism was simply continued by the moderns to the ultimate regression; the pathological and/or primitive perception. That modernism returned to the very realism it departed from as decadent proved that modernism had not averted that decadence and was, in fact, but the continuance of the decadence of realism.

Nurturing a fallacious freedom in which "everything was permitted," Europe's artists buried in their collective unconscious the fact they were simply perceptual captives of past vision as no artists before them had ever been. Those who achieved the greatest repute for freeing themselves from the past's perceptuality were helplessly tied to it. No instant dismissal of 19th century realism was to have any effect upon 50,000 years of visual conditioning; that awareness of conditioning was to die with Cezanne in 1906.

How then is one to deal with conditioning? Artists must realize the perceptual failure they attribute to nature is only their own. They must realize they cannot terminate the old vision *at all*, and that it is futile and destructive to themselves to be *against* the ancient vision. Rather one must see the whole past anew, to strive *for* the perceptual extension of the old vision. Then one can begin to see that the past's vision was appropriate to past art, that the past has made it possible to further the perception of vision. Our predecessors, observed Cezanne, were "guarantors," they indicated the "way to follow," they were not "a barrier." [206] He was the last to see the tragedy of European artists denying their own past and nature too, a denial which emasculated their efforts to reach the new.

One must understand this primary fact: every artist — past, present and in the future — is born into the necessity of developing a mimetic vision. It is an indispensable, natural development producing images that appear actually to reflect the appearances of the external world. The difficulty, however, is that without knowing it we literally become visually conditioned to mimetic perception. So much is this the case that we are more apt to give credibility to perceptions said to be derived from some invisible extrasensory source (as has been done from Moreau to Mondrian and from Redon to Ernst) than we are to accept the possibility that our perception of nature can be given extension beyond the limits of mimetic vision (as has been done from Monet to Cezanne).

Even during the past when mimetic vision, as such, was never fundamentally challenged, conditioning to that vision, "visual habits," was a serious impediment. Each generation of mimetic artists assumed that the epitome of mimetic vision had been achieved. With each such conclusion, conditioning immediately began to operate. It always remained for the innovator — Leonardo, Giorgione, Poussin, Rembrandt, Courbet — to break through the conditioning and release the flow of the mimetic evolution of vision. Seeing the work of Giotto, Dante was convinced that the epitome of realism had been reached. Constable had to place a violin against a tree to prove that the tree was not the brown of a Lorrain. Contemporaries of Monet complained they could only see blobs of colored paint in his works. They were not exaggerating; their conditioning literally prevented them from releasing their "set" vision to the extended one required for a Monet painting. Even the "innovators" of 20th century Europe saw Monet as simply a "snap-shot" artist, as critic Sweeny put it. The late Read, foremost critic of Europe, upon noting that Monet had painted thirty-seven works from the same haystacks at successive hours of the day, naively remarked, "What could be more boring?"

With Monet, perceptual conditioning underwent fundamental changes. No longer was it a problem of what and how things were painted, whether the trees of Constable should be green or not, but of seeing what if anything at all had been painted. A new vision was needed. Mimetic vision could not have any further application to future art, since it allowed only for the mediocre revealed by all realistic art since Courbet. There were no more Leonardos, Titians, Tintorettos, Rembrandts, Poussins, Courbets. There never will be again. No more great painting can ever again flow from the old vision; the great ones of the past will forever remain the only significant representatives of the old vision of art.

The severity of conditioning is now so great that all the most gifted artists of Europe failed to survive its effect except for two French painters. All the others from Moreau to Redon, from Picasso to Ernst, from Mondrian to Gabo, were held firmly in the grip of "visual habits" upon which they would "wage war."

To switch off the ancient vision the moment one will have no more of it is impossible unless one goes blind. Vision can only be extended or regressed. Much European art was lauded for returning to the visions of earlier, more promitive, times, but all that achieved was to regress the truth of primitive art. There is no turning back. Primitivism was no longer possible regardless of Picasso's and Braque's talk of "magic." One could only regress primitive vision into a pathological form of perception, the only "turning back" there is. In that sense, Breton called for the only available possibility — a "psychopathic" vision.

The pathological degree to which the 20th century artist's abandonment of nature has been destructive to his perceptual life can be surmised by extrapolating experiments conducted in the early 60's. Individuals were submerged in tanks of water in such a way that nothing could be seen, heard or felt. In time, self-induced perceptions and hallucinations occurred. When the individuals were released from perceptual isolation it was clearly evident that a general deterioration of both emotions and perceptions had taken place, where forms and colors were neither

clear nor fixed. When deprived of the outside world, perceptual life rapidly degenerated. One can readily discern how far 20th century artists have retreated from the perceptual reality, becoming immunized to perceptual nature, their lives reduced to studio cells. Indeed the perceptual introversion assumed to be their volitional decision was, in fact, thrust upon them when they turned their backs to perceptual nature. It was Braque's view that it was necessary that the artist insist on "fighting against the habit" of painting from nature's subjects. Critics thought his view was a great "breakthrough" based in the "rational" and the "intellectual." Obviously Braque never ceased the "habit," as he correctly called it, of imitating nature's subjects.

If all the introversions from Moreau to Mondrian passed as a super-reality, it was because of the general failure to perceive the reality of nature more fully than did past mimetic artists. Left only with the ability of perceptual mimesis, such artists had no choice but psychopathically to pursue a super-reality, a reality superior to nature. Once that was fully understood, one perceived that the decadence of realism in art after Courbet was simply continued further by modern art into the total disintegration of realism, the delusion of super-reality. Beginning as a rejection of realism, modern art has come full circle by a return to that very realism, somewhat the worse for its Dada stance. What modern 20th century art has proved is not that a new art is possible, but that the old art is no longer productive to the further development of art.

Vache, who was to have considerable influence on Dada and neo-Dada, in 1917 correctly noted that the "continuity" of art had been broken. Around the same time Ball stated that Dada was both a "buffoonery" and a "requiem mass." Curiously, the only European school that named itself after the expression of a child, Dada, alone knew that the great era of European art was over. And for all the "diversity" of 20th century European art it was not its differences but its common interests that were most significant.

Since the center of art has temporarily moved from Paris to New York, the European decadence and confusion have not subsided. To the contrary, they have intensified, with New York now as the center of confusion. It seems the European defeat must be continued to its final psychopathic intensity before Americans can understand what has happened in the art of our century.[207]

When Dadaists repeatedly railed against the "decadence" and "disintegration" of culture and civilization, they of course were thinking only of Europe. Nothing beyond Europe seemed significant and the significance of Europe was slipping away. They could not know, although it happened often enough on the continent of Europe, that the future would find nurture elsewhere, this time beyond Europe itself. Nor could Europeans even suspect that for over a century American artists had been achieving a new future for art.

If America was an economic-political colony of Europe until 1776, it was not until mid-19th century that America began a process which would eventually release it from being a cultural colony of Europe. This began with American's accepting the new art of light, photography, without the equivocations or rejections of so many leading Europeans. With the opening of our century a further de-colonization took place, this time in architecture and soon followed by film art. Further in the century this process would be completed with the appearance of another new art of light to replace obsolete painting. That the majority of American artists and architects remain colonials, either imitating 19th or 20th century European art or architecture, is to be expected. Thus gradually during the last 140 years America has become culturally de-colonized, due to the efforts of a few genuine machine artists. It is to those artists that I dedicate the remainder of this essay.

12. A New Vision

In all the history of art, with the exception of the change to a new order of perception, there has not been a change as fundamental as that which led to the use of the machine as the new medium of art. It was so fundamental that it would be over a hundred years after the introduction of the camera before the art world was willing to grant photography a confused status as an art. Even then, as we shall see, it was accepted by some as an art for the wrong reason. The difficulty was that the camera gave the impression of appearing suddenly because we were not historically conscious of the extraordinary series of events occurring for centuries out of which the camera was destined to emerge.

The first mechanical device for recording images of light was the Camera Obscura. Some claim it was known to Euclid, at least in principle; still others credit the Arabs with its invention. There is no doubt, however, that Leonardo knew of it, since his notes indicate that fact.

Although focusing lenses had been available for a hundred years, it was not until the 16th century that a lens was fitted to the Camera Obscura. Another delay followed before the application of chemical and optical principles were used to give permanence to the image. This possibility of a permanent image existed for a century before the Frenchman Niepce achieved the first permanent image in 1824, the first known photograph. In 1839 the first practical camera with which permanent images could be produced was invented by a Frenchman, Daguerre.

The long delay in applying available means to develop the camera and "fix" the image was regarded by a recent writer as one of the "great mysteries" of photography. It only seems so because we are limiting our attention to the mechanics of the problem when, in fact, more important factors of higher priority are involved. It is necessary to look at the events that constituted the evolution of art; then the "great mystery" of photography vanishes.

The first concern with capturing the reflection of light images originated with those early humans who were the first to ponder the phenomenon of the reflection of their images in the water. That experience was later simulated when it was discovered that one could make a mirror. One could enumerate a host of events that followed, e.g., the Egyptian priests using mirror reflections in their magic rites. But it was only in the 19th century that the pace of development was accelerated to achieve a camera and finally a fixed image.

When Niepce fixed the first image in 1824, Courbet, who was to become the last great realist of mimetic art, was only five years old. When Daugerre perfected the camera, Courbet was 20 years old and already well on the way to beginning the last significant phase of mimetic art. Hence the effort to achieve greater realism was "in the air," as painting was arriving at its last significant achievements for the mimetic image. Certainly the time had come for the realization of a new medium with which to continue from the point where painting had ceased to be useful.

After Courbet the old art of mimesis remained available only for those artists who would be content with a mediocre image of perception, the only kind possible for an obsolete medium and art. All future realists would appear as mere technicians, mere performers, whose performances were divested of the vitality and purpose which characterized all the great mimetic past from the Aurignacian caves to the studio of Courbet. If there were any doubt one had only to place such a realist next to a Courbet, a Titian, a Rembrandt. It was the failure to do just that which perpetuated the reputations of all the mediocre mimetic artists since Courbet.

The urgency with which the new machine art was sought is apparent in the fact that photography, once it was achieved, was quickly put to practical uses and there was an impressive awareness of its many important future uses. Within the space of two months of 1839, without knowledge of each other's work, two English men (Talbot and Herschel) and a Frenchman (Daugerre) announced two different methods for "fixing" the image. Herschel christened the new art "photography," and coined the terms "negative" and "positive" for the new method of producing and fixing an image. It is no mere coincidence that it was the English and French who had also produced the last great realists of painting — Constable and Courbet.

The immediate problem seemed to be one of a mechanical medium displacing non-mechanical ones. That was a false and non-existent problem. The chisel and brush were no less mechanical; the important point was that a great refinement of the mechanical had been realized for achieving images from nature. In the process, however, the experience of nature would be transformed to another and new order of nature perception.

Naturally the new image had an immediate, impelling impact on artists of the old art of painting. Many abandoned the old medium for the extraordinary images of the machine with its chemically prepared "canvas" whose surface directly responded to the images of light. Among them were the first genuine artists of the machine, artists experiencing the most extraordinary changes in the very notion of being artists. For the first time in the history of art, the artist had no deliberate intention of adjusting or modifying the image he saw into the terms of

"art." To the contrary, he sought in every way to use and improve the function of the camera, always better to achieve what he perceived with his own eyes in nature. Like others, the American Samuel Morse understood that the new art could not be called "copies of nature." The new artist went beyond the obsolete vision of mimetic painting which was always transforming nature into "art." The "new vision" which the camera images literally produced was not the prejudiced images of the mimetic painter but images which no painter could ever attain.

The most extraordinary aspect of the new image of photography was that it achieved an enormously higher degree of image credibility than painting could ever hope to achieve. For that reason it was to have a major influence on all the sciences, indeed becoming indispensable to the further development of general science and to the future of man himself.

Major events such as photography had occurred only twice before. The first took place when the ancient arts evolved the formation of written language;[208] i.e., the visual structure of art led to a method that visually recorded the thoughts of human beings. The second event took place in the Renaissance, at which time a high degree of recording ability had been attained by painters. This resulted from the fact that rules of perspective had been worked out in a way which also led to "descriptive geometry," a method that became indispensable for the architect and came to be called "the universal language of the engineer." Just as important, the capability for accurate portrayal by the painter permitted the first accurate representations of anatomy, thereby greatly advancing the science of medicine. There were similar benefits also for botany, archeology and other disciplines, as exemplified by the works of Leonardo. Most important, such visually accurate information could be mass-distributed by means of wood or metal block printing. This mass image making would later be enormously extended by photography.

Perhaps at no time in history has it been as essential as it is now to recapture the excitement, the discoveries of the past which had literally prepared the way for our present form of existence. By not doing so, even relatively recent events become less effective due to our habitual responses to them. Lacking a vital response, we are not aware how the events of the past are, at this moment, shaping our lives for good or ill. Thus, surrounded as we are every day by an immense variety of photographic forms, few people can sense the momentous appearance of the new perception when first introduced by the camera artists. It was a form of perception which no artist before could experience, not even Courbet, for all his desire to see and paint only the real, realistically. For he, like all painters, in some measure had to transform the perception of nature into the mechanical limitations of painting's structure. There is a limit beyond which realism in painting cannot go, specifically when it attempts to compete with the camera, for that only allows for mediocre mimetic painting. Courbet's contemporaries were revolted by his art precisely because they saw it as but the realism of photography. This was not true except for his very late work. Until his last works his defenders were correct to point out that Courbet was not a machine like a camera, that he did not produce photographs.

There were, however, those who wished to compromise photography with painting as a means of gaining the status of an art. Genuine camera artists felt no need to compete with painting as they were not concerned with producing painting-like photographs. To the contrary, they insisted on the considerable distinction between painting and the new art of photography for the best of the camera artists succeeded in working their way out of being conditioned to the mimetic image of painting and the obsolete perception that went with it.

Free from the perceptual prejudices of painting, the camera artist was not only the first artist of the machine but, above all, the *first non-mimetic artist* to appear in the evolution of art. For he had no desire to imitate or manipulate imitation, or to manipulate the world of vision; he simply wished to achieve the reflection on his chemically prepared "canvases" of those wondrous images of nature reflected in his own eyes. Samuel Morse recognized the distinction between the old and the new when in 1840 he described the photograph as "painted by nature's self . . . what the pencil of light in her hands alone can trace . . . they cannot be called copies of nature."

How very badly mistaken were those who saw photography as but a despicable continuance of the decadence begun by realistic painting, a view held by too many even today. Realistic painting was the end of the great era of mimetic art; photography was the beginning of perceiving nature's reality *non-mimetically*. It was a momentous perceptual event.

Although easel painters had already begun to free visual images from the central control of society — from the government, from religion, from the censor, and from manipulators of visual information — it was the camera artists who really burst open the gates of visual greedom with an incomparably more credible kind of image. For the first time in history man could experience the world of sight untrampled by *a priori* assumptions or directives from above. For the very first time man had the opportunity visually to come face to face with nature, to experience a reality of nature such as no one had seen before, which brought him much closer to the reality he lived in and the reality with which he lived.

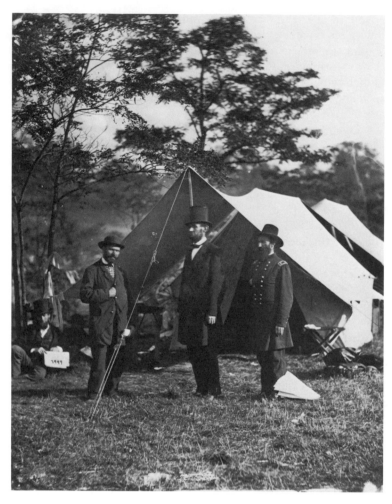

45. Mathew Brady, *President Lincoln at Sharpsburg*,
1862, Library of Congress.

If European artists failed to bring the revolution of Monet-Cezanne to its realization in a genuine new art, they did not fail in the case of photography. Indeed it was the one machine art to which Europe alone was prepared to give birth. In the long history of European image making, the new machine art was not as radical a change as were the later non-mimetic forms of machine art. Furthermore, the photographer, unlike later "new" artists, did not deny the great European past of painting, because he understood the new art was giving *extension* to image-making. He was achieving a logical perceptual change from painted images to chemically fixed images reflected directly from the visual world. Painting having become exhausted became an obsolete medium for what the camera alone could continue. As the French realist put it, "Painting is dead from today on." [209] This was felt so deeply by so many, for or against photography, that even the fact painting possessed the element of color, not yet achieved by photography, failed to minimize photography's attainment of greater image realism.

Even though Europe was the natural place for the origin of photography, leading artists, writers and critics reacted to the new art with hostility which was often of a very violent kind. In fact, the opposition which Courbet's realism encountered intensified with the development of the new art. Perceptual conditioning was at work here, denying the photograph as art. No one could escape responding deeply to the new art, whether for it or against it. So intense were the rejections that it was thought the new art should literally be banned. There were any number of well-known European writers, poets and painters who damned the new art as a "visual plague." It was called "French humbug," a "machine" that lacked a "soul," a "vulgar stupidity," a "rotten portrait painter," (though obviously it was not painting). Baudelaire and the Symbolists, (the former becoming one of the heroes of neo-art) saw the new art as an "indolence of spirit" which only confirmed their belief that the "exterior world was deprived of all significance."

46. D. W. Griffith, *A Corner on Wheat*, 1909, The Museum of Modern Art Film/Stills Archives, New York.

It is of interest to note that both Impressionism and photography were denounced by 19th century academics; the former for not being realistic, the latter for being too realistic. Not long after, both were dismissed again by the academicians of neo-art; this time both were equally accused of being "merely realistic." Not until 1948, well over one hundred years after the appearance of photography, was there a history of art that treated photography as a legitimate part of the general evolution of visual art. (See my *Art As The Evolution Of Visual Knowledge*.)

* * * * * *

The American response to the new art was far different from the European; due principally to two major conditions peculiar to the American environment. First, the transition from handcrafts to machinecrafts was already well on its way by the time the camera appeared. Indeed, by 1850, machinecraft had taken over in America as it had not in Europe. Hence, the advent of the camera fell quite naturally into the general effort of Americans to develop a machinecraft society. Second, the Americans did not experience the Europeans' cultural difficulties when the machine image not only took over the domain of painting but even claimed certain superior qualities over all past art. That was because Americans did not possess a great art past to interfere with their acceptance of the new art of photography. Indeed, photographers were the very first American artists to achieve world recognition from the Europeans. It was England that gave the first recognition to America's *first great* achievements in art. At the 1851 World Fair, in London, English critics gave the American contributors to the photographic exhibition "first place," at a time when the new art was a little more than a decade old. Their work was considered the "best," three of the five jury awards being given to Americans — Brady, Lawrence, Whipple.[210] Brady would become America's first, most recognized, *artist* of the world.

47. Above: D. W. Griffith, *Intolerance*, 1916, The Museum of Modern Art Film/Stills Archive, New York. 48. Opposite page: C. E. Watkins, *Cathedral Rock Yosemite No. 21*, published by I. Tabor, ca. 1886, The Metropolitan Museum of Art, New York, Whittelsey Fund, 1922.

One English critic, wondering why American photographers were superior to Europeans, suggested that it was due to the American "atmosphere." Another thought it was because the American sun shone "brighter," and that Americans possessed superior mechanical abilities. One, more perceptive, supposed that the new art was more "congenial" to Americans.[211] In any case, the Americans saw the plain truth of the new art and then utilized it without cultural fuss or frustration. The readiness with which Americans accepted the new art is reflected in the fact that the first photographic journals in the world appeared in America, the earliest in 1850, the year before the London World Fair exhibition; the second the following year.

Unfortunately, many of the first great American artists of the camera disappeared into oblivion their names are unknown and only some of their work has survived. Certainly the first great American artist, Mathew Brady, was not only a machine image maker, but he discovered the instrument of the camera had a social role to play; he saw the camera as the means of achieving a visual history. (fig. 45) To this end he recorded the images of numerous public figures. In this latter effort he gathered together a number of photographers who recorded the Civil War, often in the midst of battle. It is of interest that Brady quite naturally regarded himself as an artist and was so regarded, with equal naturalness, by his contemporaries.

The question of the subjects that appeared in photography is important. Europe, at the close of centuries of cultural development, had marvelous cities that tended to grow in harmony with the given terrain and vegetation of nature. Hence her major photographers concentrated upon the human form and the urban scene. The landscape of nature was more the concern of a new group of painters such as Constable in England, who died just two years before the appearance of the camera, and Michel, Corot, T. Rousseau, Courbet and others in France, all of whom were preparing the way for Monet's Impressionism. American photographers, however, recapitulated the order in

which subjects dominated in European painting. After the first flush of producing portraits and urban scenes in the 1860's, a change appeared,[212] a change made possible due to more advanced photographic techniques far superior to the daguerreotype. Interest now shifted to a passionate involvement with the untouched wonders of nature's landscapes. Often these early photographs were achieved with great difficulties; burdensome equipment was sometimes carried over long distances where only the photographer's own feet could take him. It was these truly genuine artists of photography — Watkins, Jackson, Muybridge, Russell and Carleton — rather than the painters of landscapes, who formed the first great American landscape school of art. (fig. 48) All the American landscape painters were hardly to be compared to the great landscape painters of France and England.

It was the extraordinary American landscape photographers of the New World who were properly acclaimed by the Old World. They responded to nature and photography out of a passionate experience with both. It was that passion for the landscape experience of nature which was to be the mainspring for still other American machine arts, namely, a new art and a new architecture.

*　*　*　*　*　*

The next development in the art of photography was as startling as its initial manifestation in 1839, photographic motion was achieved. The continued argument about art versus photography seemed to subside for the time being as pictures in motion swept across the screen. Motion picture artists soon were labeling the earlier motionless image, which was scanned by the motion of the eyes, a "still." With the new development it was no longer a matter of the eyes in motion, it was the image in motion.

In 1895, at almost the same time in America, France, England, and this time, Germany too, the invention of the motion picture was realized. Again, because they were not burdened by the European's great mimetic culture, Americans took the lead in the development of the new art of motion. David Griffith became the next great American artist in the field of photography. He not only adopted the achievements of others and refined them, but he also originated a host of innovations which brought motion pictures to their first great social expression, thus continuing the attitude adopted by Brady respecting the function of the new art. (figs. 46, 47) Griffith's first works were simple recordings of stage plays with a single stationary camera, using stage actors. He then developed the uniqueness of the film. As an example, he replaced stage actors with actors who would now orient to the special demands of film. When needed, the camera would now move as the film demanded. Step by step, Griffith set free the visual range of the silent motion picture. Not content with novelty or mere entertainment, he recognized the film as an immense social force. As the first great film artist he was also the first to use film to protest social injustice. Long before anyone else he took up the cause of the American Indian and the social evil of poverty in general.[213] Where Brady, with his "stills," wished to record human events for a visual history, Griffith saw that the motion pictures could participate in the formation of human events, could become an active participant in the making of history itself.

Griffith's achievements are too numerous to relate here. But this brief account indicates that he comprehended the film as art and also as a means by which it could instill greater vitality and meaning into human existence. He accomplished the transition from stage to film, from motion of form on a static stage with a static camera to the motion of image and camera on a static surface. Above all, he understood that the film was essentially an art of "light," i.e., was a further development of the arts of stage and literature. After Brady, Griffith was the next American artist of photography to achieve world recognition.

* * * * * *

When the new art of photography appeared in Europe and then remained, in spite of violent negative criticisms, painting sought to absorb it as a lower variant of itself — a mere camp follower. Hence the camera artist who had failed to work his way out of mimetic conditioning and had failed to achieve the necessary perceptual transition, set about to produce photographs emulating the subject and compositions of academic realist painting. This compromise with painting only served to destroy the uniqueness of the new art and regressed it to a neo-photography. Visual conditioning then proceeded on a further destructive course. Photography, which produced images whose credibility was incomparably superior to all past image-making, was now judged as a false and inferior reality, not by that form of perception from which photography derived, but by individuals who claimed to be privy to a super-reality. From the earliest appearance of photography the cry was raised, and is still heard today, that the photograph "leaves nothing to the imagination," when obviously the function of the photograph was not to evoke the imagination but to eliminate it for the most credible image of the perceptual world ever achieved by man.

Some three decades after the initial appearance of photography, the mimetic aspect of painting had ended with Courbet. The "crisis of mimesis" was in progress, which would soon bring on the "crisis of the new" which swept through European art with the opening of this century. In short, the "destructionists" were at work in the perceptual introversion of all the neo-arts. Therefore, the appearance of film art was subjected to the directive of neo-painting, i.e., an effort was made, which still continues today, to apply the destructionist method to the "subjects" of the film. The neo-mimetic rationalizations, unchanged from Moreau's first expression of them, surfaced in discussions of both film and "still" photography. Only recently the claim was made that it was necessary to be "rid" of films that represent nothing but "automatism of perception," as if it were possible for a mechanized photographer to be behind the camera machine. This would be accomplished by using "techniques," that is, "destruction," to manipulate the image so as to "defamiliarize," "make strange," the images of the perceptual world. Thus, it was said, the vision of the film would be "forced" into "new ways." This was, again, the all too familiar autistic rationalization for perceptual introversion which had remained fundamentally unchanged since Moreau and Baudelaire first expressed it. Thus arose the second wave of neo-photography, this time becoming part of the general regression of all the neo-arts. The non-mimetic camera having rendered the ancient ideal-real obsolete, now it was hoped the "purified ideal" would destroy and discredit the real altogether. The favorite view of the destructionists was that the real of photography or film was but a "lie," in contrast to earlier criticisms that the camera was merely realistic because it did not lie. The neo-idealists were anxious to discredit the credibility of the camera even though it had become a crucial instrument to the scientific search for the truth of nature.

49. Paul Strand, *Rebecca's Hands*, New York 1923. Copyright 1971 by Paul Strand.

We are possessed of this remarkable instrument which produces permanent visual records of an extraordinary variety of images, from the galaxies of the universe to the incredible world where the atom exists, along with all the images that exist all around us. Yet there are those who would emasculate the new art; those new provincials of art history who live in urban caves blotting out the truth of nature. They are of one mind with the obsolete handcraft mentality. A perceptual revolution occurred and their response was to abort it.

One of the many examples of that 19th century provincialism appeared recently in remarks made by the head of photography in a prominent museum. He began by admitting there is little "serious study" of photography. He said that the difference between photography and the "traditional" arts, (in our view the obsolete arts), has presented "theorists" with a "refractory problem" because camera art has not "submitted with grace" (sic) to traditional art history.[214] Our conditioning to the obsolete perceptuality of the ancient mediums of painting and sculpture makes it impossible to comprehend either the new art of photography or what has become the new history of art. It is we, not the camera, who render the new art "refractory". It is "traditional" history, "traditional" arts, the "modern" mentality, that have not "submitted with grace" to the new world of art in the making.

After more than 135 years of the new art, our perceptual conditioning to the past continues to dominate our response to and understanding of it. The energies of the art world have been misspent in obsessional pursuit of "invisible" perception. The viable problems of art remain where they have always been — in the perception of nature. We have become inverted perceptualists in the closed cave of the studio.[215]

13. *New Vision Of Creation*

In 1937, almost a century after the birth of the first non-mimetic machine art, my experience as painter and sculptor led me to conclude that the two ancient forms of art had become obsolete as the means to a new art. What was needed, it seemed to me, were precisely those unique three-dimensional qualities offered by the machine as a new medium for a new art. I called the new art *Constructionist*; its use by others eventually confused its original meanings. In 1952, I coined the label *Structurist* which suffered a similar fate and I discontinued its use in 1970. Since the last major schools of European art — Cubism, De Stijl, Constructivism, Dada, Surrealism — school labels seem to serve the destructive interests that are everywhere in art. For that reason I have refused to encourage the formation of any school around the art I have originated. Schools first distort, then destroy, all they initially set out to represent.

In the rest of this essay I will continue to refer to "new art" as a general label for the efforts of all artists who have searched for the new since Moreau and Monet. Accordingly I will present my own views of a new art by reversing the usual practice, i.e., adopting a label I will share with all the "new" arts that have appeared since the demise of mimesis. Such a general label has the important advantage of putting the emphasis upon the general effort, calling attention to the general problems, which all arts seeking the new must share alike.

It is precisely that condition of mutuality that has appeared sharply evident in the preceding chapters. Only Mondrian was deeply aware of this condition of art which all Europeans were compelled to share. Mondrian, however, discerned only one alternative when in fact there were two.

In making nature the victim of art, the neo-artists of the 20th century victimized only themselves. We have seen the consequences. Cezanne well knew whereof he spoke when he said he believed in "liberty," but that it could only come from the "study of nature alone."[216]

In the past, nature kept every artist on course, i.e., nature supplied the model and, at the same time, literally imposed the laws of evolution upon the development of art. That is, every single artist was compelled to begin as a "primitive" mimecist and gradually evolve to ever higher orders of the perceptuality of nature and art. No artist could possibly escape those demands. In short, there existed inescapable *natural laws of development*, perceptually and artistically.

These relations between the artist and nature were seriously affected once the viability of mimetic perception ended. This change appeared most sharply for the artist who sought to create his own art. Nature which no longer offered any models for art became just too much of a problem for most artists, who then returned to the apparently more secure domain of one or another variant on neo-mimesis. As a result, the perception of nature was damned and banished, along with the natural laws of development. The artists became victims of the laws of regressive perceptual conditioning.[217]

However, the particular new art to be presented here is a non-mimetic extension of the perception of nature and art, the new nature "model" being the process in which all structuring of creation takes place. Thus, nature remains the perceptual source of art. Nature is the only creative process available to the artist, and the laws of that structuring process prevail in whatever he does. His task is to perceive the structuring process common to all creation in nature, for that will become common to all he creates. Failing that, the artist falls into structural conflict with nature. As Cezanne well knew, the artist cannot create outside what he (Cezanne) and Poussin called the "boundaries" of nature.

Least of all, this problem cannot be averted by capriciously leaping into some advanced stage of the new art, such as might appear in an advanced artist's work, in the desire to be an immediate master instead of a student. This has happened all too often. Without a developed perception appropriate to the structure in which the artist involves himself, he cannot give the life of a sustained growth to such structure. Instead, in the effort not to be left behind, he is compelled to plunge ever further into the capricious exploitation of structure. If the new art is to be a genuine form of creation, there simply is no more escape from perceptual evolution than there was for the old life class student who wished to begin immediately with a masterful Courbet rendition of the nude figure.

It follows that the natural laws of development, perceptually and artistically, remain as much in effect as they ever had for past artists. But there is a change, an extremely serious change; these laws are no longer inescapably imposed by nature in the way they had been in the mimetic past. Today the artist must become more deeply conscious of these laws; nature will no longer keep him on course, even though these laws remain inescapable. Only through consciousness of these laws can the artist subject them to the realization of an art of creation. Failure to do so means the certainty of creative failure.

50 and 51. Above and Opposite page: two of twelve *Teaching Models*, 1951–52, suggesting to the student the possibilities of evolving from the old to a new perception for structuring art.

Granting the above, the artist then attains his first realization of the non-mimetic perception of nature which the genuine camera artist possesses. Then it becomes possible to give extension to the new vision of nature to that further order of non-mimetic perception necessary for non-mimetic creation. The artist then visualizes beyond already-created nature to nature's creative process.

For obvious reasons then, the organic forms that prevailed in past art will no longer provide the form structure for the new. The artist, *on his own* as creator, must now release that form of creation unique to man. It is the machine that provides just that medium most appropriate for releasing the artist's unique structuring potential as creator of his own art. We now make an important discovery. The particular structuring that thus appears in new art not only results in creations unique from nature, but also makes manifest creations that could never appear without man in nature. That is to say, the creations unique to man are implicitly dormant in the creative process of nature, but can only become explicitly manifest through the creative agency of man.

If the new art adopts the three-dimensional medium of the machine, it must not be understood as the outcome of sculpture but as a direct outcome of painting. After the great colored sculpture of Greece and Rome, when the sculptor pointed the way for the painter, sculpture ceased forever to be great and influential in the further course of art evolution. With the remarkable Italian painters of the Renaissance, painting dominated the future perceptual evolution of art as a matter of three-dimensional optics. Thus painting opened the way to a new kind of three-dimensional art beyond the space-displacement sculpture of the mimetic past, an art which gave extension to the structural engagement of space in the spectrum of nature's light.

A remarkable thing has happened. Once the artist ceases to lean on what nature has already created and creates his own art, the umbilical cord between nature and the artist has been severed. He has been born a completely new artist, he is now responsible for himself in his relations with nature. The art of the past has been a pre-natal preparation for the birth of an art wholly man's. Hence the post-natal period begins the evolution of non-mimetic creation, yet remains as ever subject to the laws of nature.[218]

It follows that the development of the new art will have similar-differences with the development of past art. For example, the past artist was not suddenly a fully developed mimetic artist. He had to begin at a beginning that would gradually allow him to evolve his mimetic capacity. Similarly the new artist cannot automatically become a non-mimetic artist, as all too many assume. As certainly as the laws of development compelled all past artists to begin as perceptually naive mimecists, so the new artist is compelled to begin as a perceptually naive creator. To achieve such a beginning, however, the artist must first experience a perceptual transition from the old to the new. The problem is that not just any beginning will do, but only one that permits a sustained evolution for a non-mimetic perception of nature and art. The new artist must gradually learn to create, as each past artist gradually learned to imitate.

Every past artist, every present artist (no doubt every future artist), is born into a mimetic vision. One cannot be born into a non-mimetic vision. That means that one does not reject the one for the other, but extensionalizes the one to the other. Thus the mimetic period constitutes a perceptual preparation without which non-mimesis would be impossible. Each future artist must recapitulate the past, as did all past artists, then experience the transition to the new, to be new.

Painting, then, as the highest developed order of past perceptuality, naturally accomplished the transition to the still higher order of structural perception that appears in new art. The goal is not a new sculpture — not sculpture at all — but an art of spatial optics. The higher order of optical development that was achieved at the end of useful painting is released into the full extension of the actualities of three-dimensional spatial structure. The new art is an optical art, an art of light, the art that Monet began. Only now has a truly creative art developed into the reality of real forms, in real space, in the full reality of light, as is the case in nature.

What began with Monet as the extension of perception beyond the limitations of mimetic "solidity," became the more specific extension beyond "sculpture" by Cezanne, i.e., going beyond form as space-displacement to the integration of form with space in the light. The realization of this goal, however, can only be achieved as new art by beginning at the beginning, if genuine creation is to be maintained.

Towards this end I proposed a theory of development in 1951, which I illustrated in three-dimensional "teaching models." (figs. 50, 51) Afterwards I discovered that, in principle, it had much in common with the course of Cezanne's structural development. There was, however, an important difference. From the very beginning the new art does not deal at all with the already created forms of nature. The beginning I suggested would be such that one would pass through the whole range of perceptual structuring; i.e., begin with form as simple space-displacement, but in non-mimetic terms, then progress gradually towards the ultimate goal of form-space integration as an art of light. Thus the student would have perceptually prepared himself to be fit to create new art.

Naturally the course of such a development would have to take place through perceptually experiencing creative structuring in nature. On what basis, however, is one to organize such perceptual abstractions from nature in order to apply such abstractions to the creation of art? By ordering one's perceptual inquiry into the creative process of nature with the fundamental order of symmetry, again structuring from the *simple to the complex*. The artist perceives nature in those symmetry terms common to the process structuring in nature according to those differences that reveal how structural evolution takes place in nature, from the simple to the complex. (See my article on symmetry.)

In suggesting symmetry orientation to the study of creative nature, that should not be confused with the symmetry inquiries of science in its study of nature, such as the crystallographer's mechanical-mathematical idealistic view of symmetry. The new artist must perceive symmetry as an artist, not as anyone else. Most important, he is not limited to the mechanical-scientific views of structuring. The new artist has not the intention of continuing mimesis by imitating the hidden aspects of nature which science reveals nor the wish to continue imitating the visible structures already created by nature. This permits the artist to focus just where science ends. That is, to see that symmetry is always asymmetrical and asymmetry is always symmetrical, as the perceptual experience of nature reveals.

If the problem is to perceive nature in terms from the simple to the complex, nature does not supply the particular structuring with which to develop art from the simple to the complex. How then is the artist to make the determination which will give him the simplest structural beginning? In Cezanne's mode of structuring, the basic geometry of nature is the sphere — a single circular plane. The sphere, as noted in the discussion on Cezanne, anticipates the structure of any form that can possibly exist. That is, there is no structuring in nature which does not have some parallel to the form of the sphere. No curvature (all nature having some degree of curvature) can go outside or beyond the boundaries of the spherical form. The genuine new artist, however, is not so presumptuous as to imagine he can begin to create with the full complexity of nature's structure. He must first learn to create. For that reason the perceptual complexity of nature must be structurally simplified to the maximum possible in three dimensions. This is done geometrically by simplifying nature's spherical complexity to the cube. That is, one begins with the last geometric form which Cezanne introduced into his work, as in the late Ste. Victoire landscape paintings.

The single highly complex plane of spherical nature, a plane that moves ceaselessly through all the complexities of constant change of form, space and light, is perceptually simplified to the three sets of parallel planes that form a cube. The artist, then, possesses the simplest structure possible in three dimensions, where everything is limited to the symmetries of simple right angle structuring and composing. Asymmetry enters at once since only five of the planes will have visible functions. With the solid cube, one takes the first simple non-mimetic steps towards achieving the new perception of art. Development can then proceed with the vertical sides of the cube compressing more and more towards each other, while the horizontal sides expand more and more away from each other, ultimately to manifest genuine spatial planes. One will then have non-mimetically experienced the whole structural spectrum of form, from simple space-displacing to the direct complex structuring of the space plane, finally to achieving the "new vision" Cezanne predicted; a vision that could be "perfected," to "free everything" into what he called the "meeting of the planes" in sunlight,[219] that art of light which Monet began.[220] There exists, Cezanne noted, "a space, an atmosphere."

Since the new artist will create his work with the machine and machined materials, what then is his attitude towards their use? He adopts a position the very opposite of the neo-sculptor's; materials are merely building materials and nothing more. The neo-sculptor's mythology about materials as the "origin" of a work is flatly denied. It is the art of color, the light of the forms in space that are his central, final concerns. (figs. 70 to 81) The new art responds to the colors of light, rejecting the muted and garish colors of industrial materials which emphasize the limited tactile vision. The new art is an art of optics, of light. Hence from the beginning, with the use of the cube, to the later use of the plane, the emphasis is not at all on materials; those can be whatever is structurally needed. Indeed, they will not be visible but completely hidden, because the form-space structuring appears as an evocation of light, as in the great colored sculpture of the distant past. The artist begins by employing the most primary order of color as the optics of perceived light, just as he began similarly with the most primary order of space-form-light; i.e., again from the simple to the complex. To accomplish this, one begins by limiting color entirely to white — white forms in the white light of space — the simplest structuring of form, space and color. One then gradually introduces each of the perceptual primaries of color, as the general structural development of creation requires. The nuances of the primaries will be enriched and extensionalized by the development of the evolutionary variances of form-space. In this way the artist will gradually pass through a transition that will enable him eventually to form a spatial art of light. When the space planes emerge in the work the perceptual complementary colors can each gradually enter the creative evolution of the work.

One has then gone beyond the limited structural optics of colored sculpture, and also beyond the limited optical structure of painting. For the new art now emerges in the full light of structural reality as a spatial art of light. Extension of the structure of creation now appears limitless, both in the perception of nature as creation and the creation of art.

It is now even more clear why the neo-sculptor was in great error to expect that an admittedly long dead art form, sculpture (its decadence regressing it to the tactile order of non-optical perception), could ever be "rejuvenated," let alone achieve a new art. All that was rejuvenated was the reactivation of the perceptual conditioning peculiar to the last and final decadence of sculptural art. It was inevitable that one could only further regress sculptural structure to the most primitive representation of form — the line of drawing.

Indeed, so conditioned was the neo-sculptor by the last and "colorless" period of sculpture that he was not adequately aware that the whole evolution of all the arts, — architecture, sculpture and painting, — always carried with it the evolution of the use of the color spectrum of light. Consider the great colored sculpture of the ancients, further advanced by the painters of Egypt, Greece and Rome, which finally burst into its full glory beginning with the Italian painters of the Renaissance. The long history of art is the history of color as the structure of light. Only when painting became the leading means by which to continue the perceptual evolution of art did sculpture try to maintain itself by denying the color of light for the muted appearances of building materials.

Again it becomes more clear why the neo-sculptor, in his 1920 manifesto, insisted he would "renounce color," considering it simply as "idealized optical surface," merely the result of "accident," denouncing Impressionism as a mere "bankruptcy." Nor have recent neo-sculptor remarks on color clarified matters except to concede there were periods when sculpture was colored and periods when it was not, leaving the matter there as if the differences apparently were a matter of capricious choice, not of value. It is time to become aware that it was during the birth of sculpture achieved by the cave artists, and during the decadent end of sculpture after Greece and Rome, that the color of sculpture was limited to the building material of which it was made. It was in the most highly developed periods of sculpture that the color of light was employed. As noted earlier, it was sculpture itself which took the first major steps out of the limited, non-optical vision of the tactile to the perception of color as the optics of light. Later, painting took color to a high degree of evolution. Finally Monet and Cezanne brought the perceptual structuring of light to its last stage of development in painting. It is that evolution which the new art now continues in a purely creative form.

Hence the new artist rejects the neo-sculptor's idealizing and technological romanticizing which fallaciously regard mere industrial materials as inspiring the creation of a work of art. Of themselves, materials are of no consequence *if* one is concerned with art. Their sole role is to supply the *evolutionary demands of art* for physically structuring the base for an optical art of color as light, and not for the visual appearance of materials in any respect. The neo-sculpture view that one is free to exploit the use of "any" materials is fallacious and leads to non-art.

New art as a gradual evolution of the structure of creation from a simple beginning (a beginning such as will allow for ever greater evolutionary complexity), rejects the neo-sculpture view that one is free to use any kind of geometric structuring, for that, as explained earlier, renders art contrary to the natural order of development. The artist's silent assumption that he suddenly burst forth as a fully developed creator who is able to create in any way, with any material or any form, leaves him without a beginning or goal that signifies. Indeed, it is that very arbitrariness which attracts the so-called indeterminists to neo-sculpture. It is necessary not to confuse the

machine and industrial materials with art.

The new art admires and respects the inheritance of 50,000 years of art evolution as light, the wondrous life of light with its spectrum of colors, the supreme experience of color open to human life. The new art does not claim to be superior to, but is inspired by, all the great art of the past, joining the past in giving extension to the creative experience of art as light. Hence the new art had no wish to "rejuvenate" either sculpture (Gabo) or painting (Mondrian), but rather to continue the efforts of all past great sculptors and painters, to bathe the creations of art in the living qualities of the color of light.

Understanding the necessity for resolving the neo-sculptor's conditioning to obsolete art and perception will not do away with that conditioning. It is necessary to resolve that problem through the perceptual experience of nature to achieve the "new vision." Even then one must be alert for the intrusion of conditioning. It is always ready to impose itself in the shape of painting or sculpture if not in a confusion of the two. The new art seen as "relief" is a case in point. It is not a structural compromise as was the mimetic relief, where the line of drawing or the method of painting was compromised and in turn compromised the actuality of sculptural form. That would be form-making compromised with image-making. Nothing of the sort takes place in new art. It is not a structural compromise in any form for the art is not a partial structural representation of itself since it exists in the full three-dimensionality appropriate to its complete realization. The art is fully represented and represents only itself. Just as the new artist does not presume to become an "instant" creator, neither does he presume to possess an instant ability to engage any and all the creative possibilities of three dimensions. The aim is creative growth, not capricious technology.

As noted earlier, line drawing, sculpture and painting are each a different kind and order of perception. Each has a different structure in which line drawing is the most limited and painting the least limited. The particular structure of each determines the particular structure of the artist's perception of the visual world. Hence the successive stages of the evolution of art reveal the successive orders in which line drawing, sculpture, then painting have each successively played the dominant role in the perception of art. Each has enabled artists to achieve the gradual perceptual extension of the act of vision and so the act of art.

In the new art there are similarities and differences with the old which, if not understood, inevitably lead to perceptual confusion. Obviously there is a continuance of the three dimensions, as in sculpture, and of color, as in the image of painting. Just as obviously, both the old and the new are involved in the structuring of form, space and light. There is not only the great difference between handcraft and machinecraft, but the greater difference between the spatial forms of sculpture and the new art; i.e., between painting's total color illusion and the new art's actuality structuring of the color image. Hence there is a great and significant structural and creative difference between the perceptuality of the old and new. In short, the new continues the perceptual evolution of art as did line drawing, sculpture and painting in the past.

It then becomes apparent that the continued use of the ancient mediums inevitably confines the artist to obsolete orders of perception which, therefore, has resulted in that perceptual state of confusion that has prevailed throughout our century of art. With the introduction of the new structuring with the medium of the machine, it becomes possible to materialize the kind of creative structure which the new perceptuality of art requires.

Artists and critics have argued whether I alone discovered the specific need for the "relief." It is worth noting that before my first published writings on this subject in 1948, stemming from a practice that I had begun some eleven years before, there was nothing published anywhere singling out the "relief" as the only structural medium for a new art. That is, a form of relief that I perceptually and structurally distinguished as the new relief from its use all through the mimetic era. Until recently those who used the relief in whatever way, including those who continued Constructivism and/or de Stijlism, used it with the perceptual attitude which characterized the mimetic era. That is, to use the method of painting or other linear illusionist methods, and sculpture or so-called free-standing structures, and the relief was not understood as unique from, but rather as simply one of, the three structural methods as of old.

Because of the perceptual conditioning involved in this whole problem, I hope my more recent remarks now make it clear that essentially I do not advocate the use of the relief (or the term "relief") at all, but rather an entirely new three-dimensional beginning for the realization of a new art; one that perceptually is optically oriented. This would be to continue the optical image attitude of past painting, but given extension into the full optically structured reality of our perception of nature and not a structural compromise of both painting and sculpture. Indicative of the continuing perceptual conditioning of artists, not to mention those who do "reliefs," (on which subject I have published material over the past thirty years), not a single artist has published a word on this crucial question of perceptual conditioning. Yet until this problem is confronted, all art, and all remarks on any form of art, will inevitably be the product of perceptual conditioning and perceptual confusion.

If the previous century saw the beginning of confusing visual art with the non-visual field of literature, our

century saw the beginning of confusing visual art with the non-visual field of science. Fundamentally science is not a visually centered field, not even in its pre-instrumental past. For example, the scientist is not concerned with the visibility problem of space as is the artist. Early scientists were concerned with whether space was "empty," "homogeneous," indeed, whether it was a case of "non-being" and/or "Supreme-Being." [222] Their curiosity was with the physical or metaphysical reality of space, not with the visual perceptual experience of space as such. The same is true today. Failing to note the distinction, artists irrationally appeal to science as a prop for their art.

Ever since the "crisis of the new" appeared with neo-Cubism, an obsession with time-space periodically appears in art and architecture. When Einstein was asked his opinion of Giedion's claim that modern architecture had "discovered" the fourth dimension of time, he replied that it was "simply bull" lacking "any rational basis." [223] When asked about the connection between "cubism" and realtivity, Einstein said they had "nothing in common." [224] How many times have scientists warned against the effort to visualize the four dimensions of space-time? Not even Einstein or Minkowski were able to do so. Only "mathematical analogy" permits discussion of the problem, a problem which cannot be visually represented. (p. 89, *Albert Einstein, Creator and Rebel*, by Banesh Hoffman, 1972 Viking Press, New York.)

Why do artists appeal to non-visual theories of science for what they do visually, rather than rely on the credentials of art, as the scientist relies on those of science? [225] If science had never put forth the time-space notion, would it have ever appeared in art? If artists were anxious not to lag behind science, had they left art behind? Because of his entanglement in science one would expect the neo-sculptor Gabo to deny any quality of "motion" to past sculpture, insisting that its motion "is an illusion." [227] But what of the physical motion of the viewer of any three-dimensional work? (figs. 70 to 81) That is not an illusion since the viewer's motion literally exerts a very real experience, akin to physical motion, upon the sculpture. Gabo cites the *Victory of Samothrace* as a sculptural example of the illusion of motion. He says the movement in that work is "static," therefore, "timeless," without explaining how any sense of movement can also be static. "Real time," he continues, exists only when "real movement" is present. [228] Apparently only when the work itself is in physical motion is there movement, there is none when the viewer moves. This is obsolete science, where the observed is everything and the observer is assumed to have no effect on the observed. Indeed this is to be ignorant of the most elementary aspects of modern science.

The effort to introduce time-space into the creation of art, beginning with Apollinaire, was to use a most impressive verbalism as the means to discredit the validity of perceived nature. Artists hoped to shake off their sense of uncertainty and confusion before perceptual nature, seeking security in the impressive fourth dimension notions of science. Time-space offered the would-be non-mimecist a super-reality. Accordingly, it was thought the image of reality was not only static but false. The reality of time was exemplified by the dynamic of the multiple view of nudes, banjos, bottles, tea cups and all the nonsense to follow.

The consequence of the neo-sculptor's confusing scientific notions of "time" with motion in art, is serious. One is then not aware of the most fundamental experience of motion in a three-dimensional work — the physical motion of the viewer before a work not in physical motion. That is the primary order of experiencing motion from which one can evolve a natural order of development from the simplicity to the complexity of motion. Thus one develops the structure of motion as he does with all other aspects of structure which comprise the totality of a work. To recognize physical motion only when present in the art itself, i.e., to be involved in the full *complexity* of the problem of motion, inevitably forces one to rely on exploiting arbitrary choices in geometry, materials, etc. It is as if we did not want to be left behind even by the future.

The problem of motion is of prime importance in the new art. Motion is the living, creative heart of reality and art. Motion, not time, is the true fourth dimension of the new art, the others being space, form and light. This requires perceiving space with the visual palpability we readily experience with form. Cezanne was the first to experience this palpability of space. Failing that (and all those after Cezanne were to fail), planes become decorative gestures in "empty space." To then speak of "spiritual space" is hardly a substitute for perceptual space. In any case, one does not automatically induce the new perception of space simply by using "planes." Form and space move in a continuing modification of each other with the ceaseless transformations produced by the motion of light. (figs. 70, etc.) The changing motions of sun- and sky-light recreate the work from moment to moment. Nothing will ever be repeated again. Thus the new art exists in the living motion of reality whether the viewer moves or not, for we are dealing with an art into which the motion of light flows. Form, space and light radiate their motions into each other; everything ceaselessly intermingles with everything else.

There are three orders of motion in the new art. There is the motion implanted by the artist into the structural movement of the work — the psychological aspect of motion. Upon that acts the motion of light and the motion of the viewer.

For the first time in all its long history, art has at last entered on a "parallel" with the full range of the reality

52. Peter Rubens, *Charles I as Prince of Wales*, The Minneapolis
Institute of Arts.

spectrum of nature, structurally, perceptually and creatively. The dichotomy of past vision, sculpture as form and/or painting as image, becomes one in the new art which has become perceptually parallel to our vision of nature. So long as art remains, it remains a response to the visual experience of nature; the non-visual notion of time-space is totally irrelevant to art. In any case, the question of time as such poses a false problem.

Understandably the scientist must constantly refine his particular mechanical needs for searching out the hidden structure of physical nature which he then measures with mathematical-statistical approximations. In any case, the scientist's perception of these recesses of nature are dependent upon instrumental extension of his natural vision, and it is such instrumentation that must be constantly refined in order to give extension to scientific modes of perception.

Contrary to 20th century European art which considered the perception of nature exhausted (which false understanding was abetted by the scientific desertion and denunciation of non-instrumental perception), natural vision is far from exhausted. Our vision has not exhausted the perception of nature but only exhausted the old art vision of nature, which then opened the way to a broader and deeper perception of nature as creation. Hence, the new artist seeks non-instrumental, non-mechanical refinement of his perception in order to give extension to his comprehension of creative nature in terms of art wholly the creation of man.

Science and art reflect different sides of man's perception of nature: the scientist mechanizes nature, the artist humanizes it. The former seeks mechanical measurements by means of mathematics, a highly refined mechanical mode of structuring and logic. The living motion of a work of art, as is evident in all the perceived world of nature, goes beyond the mechanics of measure. The scientist applies measure to creation in nature; the artist creates organically in the way nature creates.

Scientists do not create, they invent; they invent mechanical means for analyzing and measuring the creative order of nature's physical structure. The great scientist experiences creation, but only in his direct experience of nature as the remarkable creation it is. He devises ingenious mathematical and instrumental inventions that give extraordinary insights into the structure of nature. At present, science is limited to a rudimentary or mechanized perception of nature. Nature *is not* mechanical.

The new artist rejects mechanical perceptions of nature or art. This remains so even though he uses the machine to produce his art. He understands that a machine does not mechanize unless the artist becomes mechanized. He goes beyond the mechanical attitude, because the psycho-biological character of his perceptions determines the structural creation of a work of art. He recognizes the dangers of the machine, in that the mechanical and/or mathematical seem to offer such a tempting way to make everything final.

Science reduces space and motion to the mechanics of measure, not by discovering "time" in nature, as there is nothing of the sort to discover, but by inventing a measure called "time." Time no more exists in nature than do inches or miles. Time is an instrumental invention, now in many instrumental forms, for measuring space, motion, etc. Time is imposed on the natural qualities of space and motion for the convenience of mechanical measure. The strength and weakness of science rest in its reliance upon the mechanical. Time appears to be a quality of "natural clocks" only because one ignores the ceaseless similar-differences contained in what appears to be time pulsations in nature.

In any case, problems of "time" do not exist in art. The artist is not concerned with measuring space and motion, but is concerned with the natural perception of the natural qualities of space and motion *for only the human beings' perception possesses that acuity* of structure that parallels the exactitude of the similar-differences that form the organic variances of nature's structure.

With the machine becoming the medium of art, the consequence is that there are now mechanically-minded, as well as non-mechanically inclined, artists. The serious difference between the two can be shown in science itself where a somewhat similar conflict prevails. The reference is to the molecular and organic approaches in science.[230] The former is largely a mechanical-mathematical method where the idealism of statistics takes absolute precedence over individual divergences that arise in nature's structure. The molecularist dismisses the divergencies as indeterministic, thus preventing them from interfering with the convenience of his absolute faith in statistical mechanics. There are artists who aspire to a similar goal, insisting on a strictly mechanical-mathematical method for producing art. Such artists lack security in their sense of sight as the determinant for creating the exactitudes peculiar to a work of art. Having abandoned the perception of nature, substitutes are sought by looking to the machine and industrial materials, to mathematic and scientific props. The artists' vision then regresses to the tactile, hence their reliance on mathematics which, in sensory terms, is a tactile, not an optical form of perception.

To continue the analogy, the molecular method is necessarily non-historical. It concerns itself only with the repeatable, such as H_2O. To the contrary, the organic approach is necessarily historical and evolutionary, deeply involved with the individual aspects of the organic as process. The attitude of new art parallels the organic biological view. It, too, deals in historical, evolutionary viewpoints and, above all, is concerned with the individuality of creation. Like organic biology, the new art is concerned with the non-repeatable process of creation and/or evolution.

The conflict between the biology of the human and the mad technology which now forms the urban environment, has in recent years emerged in an even more bald form than is apparent in the biological sciences. There are those who seek escape from the mechanical madness by taking the art world's falsifying admiration for the primitive a step further back, by adulating the behavior of certain forms of animal life, over-evaluating such life to the point of absurdity. The opposite kind of escape is being taken by the learned and the ignorant who reach for paradise via the computer. The former seeks escape from the mechanically complex, confused world of humans, while the latter offers himself as an eager victim of the mechanical malady. Art, architecture, everything seems bent on circumventing human confusion in sub- or super-human flights of fantasy.

There is no doubt the literal use of science has done considerable harm to the efforts to achieve a new art. It has given the artist false assurance as he abandons his own source of visual life, the natural perception of nature and art. Thus, in the view of Vantongerloo and others, art is said to have no need to express itself in "terms of nature," but in that of the "exact sciences."[231] How much further can the artist wander from art? On one occasion the wife of Max Born, the physicist, expressed her disturbance over what seemed like the determination of science to reduce everything to equations. "It's conceivable they will," Einstein acknowledged, "but don't worry. It would forever be inadequate — something like representing a Beethoven symphony by air pressure curves. (From "Book of the Times," The New York Times, Oct. 16, 1962, by Charles Poore.)

Scientific laboratory perceptualists have made their contribution to perceptual confusion. Often they extrapolate simple tactile vision in a confusion with optical vision. They misconstrue visual illusions. The whole glorious

past of painting, with its paramount relevance to man's search for the truth of reality, is all illusion. Were perceptual illusion to somehow vanish from our vision we would be continually deceived by the reality of the world. Yet these scientists of perception continually delight in presenting illusion as deception by rigging their experiments to fool the eye. Their prime interest seems to be with the laboratory instruments and trick experiments, not with human beings. When will they discover that art alone has left a clear visual record of man's perceptual evolution? When will they leave the deceptive world of their hot-house laboratories, leave the tricks and learn to see and thus comprehend the human joy of natural perception of the visual spectacle of nature? A recent book by a scientist of perception informs us that the 19th century investigations of Helmholtz "still remain the most important work" on the subject of perception. Why does this last "most important work" correspond in time with the last viable days of the mimetic image in art? Too often it appears that recent laboratory perceptualists are under the influence of modern art; indeed the "findings" of the laboratory are often used to rationalize recent abberations in art. And like the neo-mimecists they too seem bent on discrediting perception with rigged tricks to trap the eye rather than studying the condition of human perception as the means to improve it and give it extension. No one disputes that everyone has to learn to read, but no one thinks we have to learn to see.

In criticizing the destructive role of pseudo-science in art, the intention is not to imply that the artist ignore science, but only to suggest he not substitute science for art. The life of art exists where it always has for 50,000 years, in the ceaseless extension of perceiving in nature the truth of art. The new art demonstrates that the supreme gift and significance of man is that he is primarily creative, artist or not. As new art reveals, the artist realizes creations that would remain dormant in the creative process of nature if man were not present in nature to bring such creations into being.

However, until the problem of perceptual conditioning is fully confronted, it will be of no use to pursue a new perception of nature if those who agree or disagree do so on the verbal level rather than on the grounds of the perceptual experiences of nature. For it is there in the world of perception, not in words alone, that the problem can be met in a significant way. Some artists, artists striving for a non-mimetic art while ignoring or denying nature, have concluded that my view of nature "seems to be based on personal insight" rather than "objective truth."[232] Since this conclusion was put forth without offering any perceptually arrived at evidence, the conclusion would seem to rest on perceptual and verbal conditioning. Again the underlying assumption is that the perceptuality of nature has been exhausted, leaving only the possibility of some subjective "personal" belief to be conjured, thus lacking any "objective truth." The fact is no work of art can materialize without resting on *some kind of visual abstractions from visual nature*, regardless of whether the artist wants to do so or not.[233] To assume, as Malevitch does, that the "creation" of a work comes out of "nothing," says nothing but that the artist has no notion of the source of his abstractions.

The more one understands conditioning, the more one understands it will always remain a problem. Each time we see what we never saw before, each time we think what we have never thought before, conditioning steps in to assert its domination. It can happen as easily in the new as in the old art. In the new, however, conditioning can play a far more destructive role than it ever could in the past, for the new art demands incessant renewal and ceaseless extension. No more can a whole generation concentrate on some innovation. In the post-natal period of art we will be aware of the ceaseless motions of the evolutionary process present in every day of our lives. We are no longer born into a generation; we must be born every day.[234]

14. *New Vision of Architecture*

Most if not all of us have assumed that architecture was unquestionably a non-mimetic form of art. By now that belief has become a form of perceptual conditioning which, in turn, wards off the possibility of this habitual view being questioned.

Contrary to general belief, architecture is no more a non-mimetic art than the other arts of painting and sculpture. Architecture began mimetically out of experiences with nature's ready-made shelters, and remains mimetic to this very day. If our conditioning prevents us from acknowledging the fact that all architecture has been some variant of nature's caves, we will have thrown away the key not only for perceptually understanding the old, but also for really grasping the creative possibilities of a new architecture. If we wish to create non-mimetic architecture we will fail unless we perceive past architecture as mimetic.

Just as nature supplies the "model" for sculpture and painting, so it supplied the model for architecture. This occurred with various ready-made shelters, but largely with the most complete natural shelter, the cave. The cave had a roof, walls, "door," "window," floor and fireplace. It offered the most all-around protection against the climate and animals, and a place for man to create his arts and evoke the animistic beliefs his art signified. It was in these experiences that man originated his architecture.

When, because of climate or other changes, man left nature's cave shelters to become his own architect, he strove to evolve some extension of the over-all fitness he experienced in nature's caves. In ceasing to rely on nature's ready-made shelters, man now turned to the ready-made materials of nature with which to build his own version of a "cave."

Among the Paleolithic arts there are line drawings which are depictions of man-made shelters very much like those that appear in Renaissance paintings. The question then arises why depictions of houses would appear in the natural cave shelters? Could it be that once the climate allowed man to leave the cave to live in a shelter of his own making, the ceremonial rites continued to be practiced in the natural caves? In that case the man-made shelters would be included among the depictions in the natural caves, and by dating the shelter drawings one could date the approximate origin of architecture.

Thus the natural cave which served both to express beliefs and provide shelter, now became simply a "temple," the first form of "church" — which to the present day still retains its structural origin in the cave.

Perhaps in this way man might have become an architect while sculpture and painting continued to function as before, in what now became the natural temple. As with later temples and churches the natural cave became a repository for man's beliefs, a place solely for worship.

Once the need arose of leading a more permanent existence as farmer, man learned how to build more permanent shelters. In this period of architecture the natural cave temples were gradually abandoned for man-made temples. Marshack's research, regarding the lunar concerns of early man, suggests that as man became a farmer and the creator of his own architecture, there was a transition from a lunar- to a solar-oriented civilization. Thus began the forming of urban life and architecture. It was then the architect began to use the more permanent of nature's ready-made materials, at first using naturally shaped wood and stone. Eventually these two materials would be functionally perfected when the mimetic architect became technically a full-fledged sculptor, i.e., he bcame a stone-cutter, shaping stones uniformly for more precise methods of building. In short, the "unit system" of building with nature's ready-made stones was greatly refined. This was a momentous event in the technological development of architecture. Stones were cut and shaped into precise, uniform rectangular units. The previous awkward and complex system of fitting together the nature-formed stones of varying sizes and shapes was replaced by the human-formed "machined" units of uniform size and shape, either in stone, marble or molded brick. Thus the *complex* and functionally *limited* older system of building gave way to *simple* uniform units which made possible a future, *complex* mimetic architecture.

Hence, in the second stage of man-made architecture the architect ceased to rely on nature-formed materials and reformed them as the figurative sculptor had been doing in his art. It was after that beginning the other arts of painting and sculpture gradually became a direct part of architecture itself, as in Egypt, even to the mimetic transformation of the columns originally abstracted from the column of a tree. Wall reliefs and wall painting were developed. Along with its continued function as a "cave" shelter, architecture became a grand staging area for the great display of figurative sculpture and painting. Where the figurative arts previously had been limited to the interior of the natural cave, now they also appeared on and around the exterior of architecture. Thus was formed the second grand unification of all the arts, this time in man-made cave shelters. The use of the term "unification"

is not meant to describe some static condition. Unification as used here indicates a process that ceaselessly moves in great waves of transitions, each crest arriving at some new unification. The latter is then followed by another transitional wave which eventually evolves another totality of unification. Thus the totality achieved in Paleolithic times was followed by a transition during the period up to the achievement of urban architecture, which then reached another grand totality in the incomparable genius of the Egyptians.

Eventually the unification process moved again into another transitional phase as Greek artists and architects took over the further evolution of mimetic art and architecture. The Egyptians' figurative sculpture was dominated by the severity of precise geometric-like structuring of form, bringing it into harmony with the geometric severity of architectural structuring. Therefore, in Egypt the great sculptures of the human form flowed into and with the general structural characteristics of architecture. The figurative sculpture of the Greeks, however, reached a very high degree of mimetic development, in which the geometry of form structuring became less and less apparent. The severity of the Egyptian pose was replaced by form rendered in the poses of motion. Figurative structuring became more and more organic and so more and more distinct from the structure of architecture which necessarily remained strictly geometric. Figurative sculpture was taking on a visual character all its own. In time then, sculpture appeared which was given a special and often largely extra-architectural role on a level with architecture itself. While there was a close working relationship between the Egyptian sculptor and architect, the new development was reflected in the fact Greek sculptors supervised architectural building, as Pheadeas did in the case of the Parthenon.

Changes in the transition were also appearing in the linear and/or painting arts. Egyptian painting was more or less outline depiction of flattened sculpture (as was the relief cutting), which outline was then filled in with paint. It remained for the Greeks to free the line of drawing from the silhouette of sculpture. By freeing drawing from sculpture, the Greek draftsman was preparing the way for the unique possibilities of figurative painting, making possible the perception of the image as optics, the image as distinct from the literal form of sculpture in terms which would later be called perspective. Greek painting did so by first imitating colored sculpture, for the sculptor from very early times had been coloring his work and thus was the first to move out of the limited vision of the tactile to make the first step towards perception as optical image. That sculptural step would then become the first image step of imitation taken by the painter, this time in terms of a differently structured medium which later made possible a further pursuit of the visual image as the color of light. Hence the efforts, both of the draftsman and the optically oriented sculptor, opened the way to painting perceived as an optical image problem.

Certainly the unification achieved by the Egyptians no longer existed as Greek painting and sculpture become independent arts *in* architecture. It is understandable then, that Aristotle would reserve the distinction "fine arts" only for the two mimetic figurative arts, as if the chief role of architecture were to achieve a proper setting for displaying the superior arts of painting and, above all, sculpture. Thus the transitional phase of the unification process was beginning to lead away from the formerly dominating sculptural perception of the Egyptians towards the higher perceptual order of the optical image.

Sculpture as an independent art reached its zenith in the realistic portrait. Though this effort began in Egypt and reappeared in late Greek sculpture, development had not reached the extent of Roman accomplishments.

Figurative painting as an actual three-dimensional illusion, also begun by the Greeks, developed tremendously with Roman painters. Painting was now playing a dominating role in Roman architecture. The very walls were pierced, seemingly replaced by three-dimensional figurations, land- and sea-scape illusions. Often the painter painted in his own architectural setting. Painting as optical, an extension of the limited optical renditions of sculpture, had developed enormously.

The transition revealed three major arts each distinct from the other, each with a special role. The mimetic arts of sculpture, painting and architecture were searching for a new kind of unification, but this would be held in abeyance during the thousand years when the Church replaced the Romans. The continuity of evolution from Egypt to what would become western culture was broken. In an eclectic search for an architecture that would evoke the view of Christianity, the Church architects borrowed from Rome, from the Orient, from the Middle East, and finally ended in the Gothic. The cathedral became the principal focus for architecture, becoming a drawing of lines sweeping everything upward, reaching towards another world. By contrast, Egyptian architecture seemed like the work of sheer pragmatists, planting sculptural architecture firmly and grandly in horizontal harmony with the earth. Past architecture had been aligning space more and more towards the exterior world of human experience. The cathedral, in its vertical effort to strive for passage to another world, abruptly closed itself off from the world of man, the whole structure making a skyward leap. Structurally there was a regression to the more literal cave mimesis of primitive architecture, with the exception that the walls now thrust the cave vertically into the sky. Until the late Gothic trend towards realism began the line dominated all the arts, structurally regressing what the great Greek draftsmen had accomplished.

With the Italian Renaissance, a revival of the impetus which had made the art of ancient Rome brought everything back to earth again. The Gothic, never favorably regarded by the Italians, was considered a "foreign" influence. Due to the fact that painting had replaced sculpture as the dominant art, architecture itself would now become dominated by the painter's perception, i.e., the architect would seek an optical image for architecture. After a period of imitating sculpture, painting had then gone on to develop the linear image proper, the illusion of the optical actions of color as light. In achieving this higher order of perception as optics, painting then asserted its perceptual dominance over all other forms of art, including architecture.

Consequently a most extraordinary event took place in the further creation of architecture, the significance of which remained unrecognized. Not only did the perception of the painter dominate architecture, but painters themselves were now among the leading architects. While noting the fact of this event, architectural historians then gloss over this really extraordinary occurrence. Surely if architectural works were now created by painters, and by others who began as painters, it seems worthy of considerable curiosity. Indeed, in the following centuries many an architect would originally have been trained to be a painter.

The change to the dominance of painting over all the arts was actually signalled back in Greece when the work of a sculptor or architect was completed by the painter who colored the work. To comprehend properly the evolution of architecture it becomes imperative to dispense with the myth of architecture as the supreme or fundamental art, not to mention the recent fallacy of attributing to it all the qualities of painting and sculpture. All the mimetic architecture of the past is the consequence first of the dominating influence of sculpture, then of painting, each in turn the "mistress of architecture" and not the other way around. As Pheadeas and other sculptors became the architects of Greece, so Raphael and other painters became the architects of Italy.

True there were sculptors who were also architects, the most eminent being Michelangelo. For all his extraordinary gifts, however, Michelangelo represented the demise of the sculptor-architect. A new architecture was being formed that went beyond the perceptual limits of a sculptor. It is no accident that Brunellischi was first a painter; that Alberti wrote studies, not only about architecture, but also about painting; or that Bramante began as a successful painter. True, Michelangelo also painted, but what he did only returned that art to the past when painters were confined to producing colored imitations of sculpture. That is essentially what Michelangelo painted in the Sistine Chapel, which was not a mere coincidence. While wishing to reduce painting to the limitation of painted sculpture, he took the opposite course with sculpture as he vainly sought to burst the bonds of stone. At a time when architecture had ceased to be dominated by sculptural perception, he reduced sculptural architectural efforts to false destructive roles. It is in the drawing of the human figure that Michelangelo left his greatest works.

Through the painters and painter-architects, architectural creation was expressed in terms of the optical image of perspective; it was becoming a pictorial form of expression. A new unification of all the arts was in progress. But where did one go after the Gothic effort which negated the spatial world in which man existed? The Italian temperament, the temperament that did not succumb to the Gothic "craze" of Europe — indeed found it "ugly" — would overcome the Gothic dead-end. The Italians would return architecture to the horizon of the earth, back to the spatial world of man under the inspiration of the very arts the Church would replace, the ancient arts of Greece and Rome. Once more interior space was aligned to the spatial experience of man. The ancient practice of using the color world of paint, both for exterior as well as interior, was resumed at the end of the Gothic period and became a frequent practice with the Italian of the Renaissance. The works of the most eminent painters, Titian, Giorgione, etc., appeared on the exterior as well as the interior of buildings.[235]

Those writers who spoke critically of the Italian architects' so-called "indifference to materials,"[236] were too hasty in their judgment due to their conditioned perception. The perceptual change from the sculptural to the optical vision naturally made materials subservient to the optical image sought in a work of architecture. In that perceptual climate, whenever the architect could not secure the particular building materials he needed, he felt no compunction about creating an imitation of the unavailable materials. Hence, various stones and marbles would be simulated with stucco-made imitations. When large stone blocks were wanted, the architect simulated them by hiding the joints of the small blocks in order to attain the appearance of large ones. In any case, paint, enamel, stucco, and other means of visual illusion were used to produce an architectural *image*.

Therefore, in these times of the perceptual dominance of the optical vision, materials were subservient to the optical goals for all the arts. We can then comprehend the sense of Alberti's observations of his architectural time, as one where the architect "takes from," and is "governed by," the painter's art. Accordingly, Alberti listed painting as "absolutely necessary" to the architect.[237] Indeed, using the very language of the painter, architects like Alberti spoke of the "composition"[238] of an architectural work as of first importance. The role of materials was simply to carry out the demands of "composition."

Italian figurative sculpture, however, was not able to respond as architecture could to the new visual order of painting, having reached the zenith of perception as colored forms in Roman art. Michelangelo, that undeniable

genius, was born too late to assert the sculptor's superiority over the painter. When he challenged painters with his bold extravaganza of the Sistine Chapel, he altered nothing except to regress the art of painting to earlier times when painters imitated colored sculpture.

Since both are basically sculptural arts, why was architecture able to proceed farther than figurative sculpture? Because the particular structure of the mimetic role in architecture was not limited to the particular mimetic function of figurative sculpture. The latter had exhausted its useful possibilities and was replaced by painting which alone could continue figurative mimetic perception. The mimetic structure of architecture, the mimesis of the cave, was a geometric not a figurative order of mimesis, and needed only to adjust itself geometrically to the image world of perspective. Thus, while others after Michelangelo would try to reinstate the value of sculpture, architecture in the following centuries would continue to give extension to an evolving pictorial structure.

The pictorial period of architecture reached its epitome in the Italian Baroque, where everything became completely subject to the painter's perception. Architect, sculptor and painter, Bernini would be a Rubens in stone and marble. (fig. 52) Indeed he insisted he would "paint with marble." His attempts were limited, however, to the few "colors" of materials, using gilding and such coloring devices which, of course, were not to be compared to the full coloration of ancient sculpture.

Actually the Baroque attitude struggled to make its appearance with Michelangelo's sculpture. But his consciousness of art resided in the great past of sculpture, a past gone forever. Fervently wishing to prove sculpture superior to painting, he strove to instill a life into sculpture. This was no longer possible. In doing so, however, he was torn between two poles. Thus he sculpted when he painted and, against his own will, wished to paint when he sculpted. Michelangelo was not to know that it was the colorations of the painter of light which had brought all the past great sculpture to its supreme reality. Yet he painted imitations of colored sculpture and sculpture stripped of the life of color. In any case, he could not admit that painters had taken perception beyond the exhausted vision permitted to sculpture.

Bernini, relatively free of Michelangelo's dilemma, deliberately set out to "paint with marble," with the limited colorations already noted. And indeed sculpture appeared to live again, as marble and stone seemed to simulate the very life of flesh. All previous sculptures, by comparson, were "stills" whether depicting motion or not. With Bernini, sculpture seemed on its way to instilling the very life of motion into the work. One forgets the marble and stone before this extraordinary attempt to evoke life.

Yet when we look again at Bernini and other Baroque sculptors, there is something missing. For it is mostly the form alone that has been brought to a high pitch of mimesis. What is lacking is the color reality of the original, a lack that is even more sharply evident in Michelangelo. When we look back to the sculpture of the Egyptians, Greeks and Romans, even though many of these works have lost their color there is still an aura of living motion, even in Egyptian sculpture, which the Baroque, for all its desperate energy and drama, only simulates. For all his wish to "paint with marble," Bernini emerged beyond Michelangelo's conflict only for awhile, because in the end he did not, he could not, "paint with marble." He simulated life with the sweep of a painter's brush but without its color. In contrast to Michelangelo, Bernini was aware that the difficulty of sculpture lay precisely in what he called sculpture's "deficiency" of the painter's colors. He tried to compensate for that deficiency, by not only adopting sculptural arrangements as much like painting arrangements as possible, but also by a constant and pronounced reliance on the flamboyant use of drapery. Hero-artist of his own 17th century, he was transformed into the corrupt one of the 18th century, due to the regurgitation of classicism and the moralizing that went with it. Winckelmann, however, did not accurately express his irritation with Bernini when he accused him of not abiding by the method of the classical, since Bernini specifically advised that procedure both for students as well as for himself. What he did, however, was to convert the classical method into one of realistic expressionism. Accordingly, in the 19th century, he again became a hero of art as writers from Stendhal to Zola expressed their admiration and the art of realism rose to the fore in the art world. The Baroque, as the third unification of all the arts, lacks the unity of the Egyptians, Greeks and Romans. The real issue remained between painting and architecture and soon frustration would lead to crisis even there.

The course taken by Baroque architecture was quite another matter. While the early Baroque was still held within the classical rectangle, it eventually went beyond this structuring to achieve further geometric possibilities. The result of this structural release was that architects became aware of the possibilities of unequivocale protruding and receding structural juxtapositions. This horizontal play into and out of space, so to speak, had been gradually developing since the Renaissance. But it was the Baroque architect who stepped boldly beyond the classical *closed form* with its simple exterior space displacement and its simple interior of enclosed space, thus breaking free of the classical limitation.

This release enabled the architect to extensionalize the action of form by setting it into new motions with space. Form was making a new structural relationship with space; space was brought into consciousness on a

greater structural footing with all other aspects of structure. That is, space displacement had been given extension beyond the simple classical relationship of excluded or enclosed space. The structural variants possible to space displacement went beyond the simple to the more complex forms of space-displacing structuring. This effort really had its first beginnings in Roman architecture, interrupted by the Church's "obsession" to shove the rectangle into the sky. With Baroque architecture, however, the Church now sought to regain its authority by extending architecture into the secular space of man.

Once the Baroque broke free of the classical either-or structuring — that is, space was sculpturally displaced or it was enclosed — the wall ceased to be limited in its structuring, for now it became the means of forming the spatial variances of the convex and concave, with similar results for ceiling, roof, etc., with form setting space in motion. The Baroque architect was reaching beyond literal cave mimesis by releasing the structural diversity of space displacement itself into new and startling perceptual encounters in the relations of form, space and light. The dark cave of the Paleolithic Temple was now bathed in rushes of space and light. The mimetic cave had been pierced with large dramatic openings letting in a literal flood of light.

Space now appeared as a wholly new and structurally diversified perceptual experience in the light, traversing all the geometric variances of space displacement and enclosures through the interplay of receding and protruding horizontal and vertical motions. The consequence of freeing space displacement was to release both the exterior and interior into new creations of form-space and light, structures never seen in architecture before. Light sprayed its variances across the new variances of form and space. As was noted earlier, cave mimesis was no longer a literal affair. The lunar cave of darkness was replaced by the solar cave of light. The new forming of the walls having made possible the new spatial structuring, the walls themselves became a place for rendering picturizations of form. The Baroque architect, having become a pictorial perceptualist, ceased to be sculpturally limited. That is what Bernini understood to a point, for it was the painter's more developed perception of form that had led to a new sense of space enveloped in a new structuring of light. Hence the architect Guarini spoke of the "effect on the eye," rather than, "blind obedience" to "rules" of architecture.[239] In his view, the experience of the "senses," i.e., perception, was not to be wholly controlled by "reason."[240] By rules and reason he meant those peculiar to the demands of limited tactile vision.

Baroque architects had ushered in the first steps towards a wholly new form of architecture. Their efforts had extensionalized perception of structure by means of the painter's pictorial vision. That is to say, architecture had been freed from the limitations of either-or classical space-displacement limited to sculptural vision, that is, form simply acting upon space to either exclude it (exterior) or enclose it (interior). The moment architecture began its first steps of transition out of the literal cave mimesis of the classical, that was the signal for extraordinary events to appear in all the arts. Here only it should be noted that in the case of painting, unlike that of sculpture, mimetic vision had not yet been exhausted and thus had not yet arrived at that point when, like Baroque architecture, it too would begin its first steps out of literal mimesis.

Left to itself, however, Baroque architecture on the European continent was unable to pursue the transition further. The architect was then left with one possibility; he began to smother architecture with pictorial excesses, the pictorial now reduced to the limited function of decorative elaborations. France replaced Italy as the new center for art, producing new great painters from Poussin on. French architecture, however, eventually produced the Rococo which served to continue to a final excess the last, or decadent, decorative period of the Baroque. The Rococo attempt to recover the life of architecture by a return to the rectangle of classical symmetry only resulted in neutralizing the best qualities of both the classical and the Baroque into an indifference to underlying structure. Unable to evolve perceptually, the Rococo architect hid his defeat by covering everything with flamboyant decorations. Structure, the very life of art, was smothered beneath facades of superficial surface gesturings. Walls dropped away beneath the rush of decoration, further heightened by large wall mirrors which fragmented form and space. The structure of space became so ambiguous that it seemed as though everything were about to vanish in a void of space.

In contrast to Egyptian unification, where architecture moved slowly in a silence of order, the great Baroque architects had set everything into vivid, swift motion, leaving behind not the slightest sign of the structural transition to a new unification of all the arts. Rather the very opposite was about to take place, the beginning of the disintegration of the unification process itself. All over Europe, pushed by a state of unacknowledged crisis, each nation sought to recover the former greatness of architecture. That effort would fail, because crisis had overwhelmed creation and the evolution of architecture fell into a state of caprice and eclecticism.

Piranesi, who worked in the third quarter of the 18th century, became famous all over Europe not for what he had built, but for the neo-Roman fantasies of his architectural etchings. Desperately he began to reach for a new architecture but, as Kaufman observed, concluded his efforts in a "tragic dissonance."[241] Boullee and Ledoux, Piranesi's French contemporaries, created on paper fantastic architectural projects that were regressions to

sculptural structure, projects they knew would never be built. It was as if architecture, smothered in crisis, sought escape on paper where anything could be built. Eventually the disintegration became all too apparent as those who continued to build began to pilfer the architecture of the past, turning their backs on an inscrutable future.

Everything began to disintegrate as art and architecture were dispersed between the force of the Baroque and the resurgence of both the classical and the Gothic. After the Italian Baroque, architecture seemed to have run its useful course on the continent of Europe, unable further to develop its evolution. Architecture had become sterile in the late 18th century, a sterility all too evident in the 19th. The art of painting, sculpture and architecture were each fragmented from the others. But more significantly, the parting of the ways between painting and architecture indicated that, like sculptural art before it, painting now appeared to have concluded its structuring role in the evolution of architecture. It was the era of easel painting which would now become the major form for painting, existing independently of an architecture disintegrating in its piracy of past architecture.

Towards the end of the 18th century the crisis of architecture was sharply signalled when rejuvenation was sought not by some architectural evolution or new relationship with the other visual arts, but by appeals to the non-visual art of poetry and literature.[242] Architecture thus became the first visual art to seek renewal in literature (as later painting would do with Moreau), through the idealized "ideas" and "thoughts" of romantic literature. The intention was to devise a symbolic function for architecture. As for writers of the times, the romantic appeal of the Gothic as "strange" and "mysterious" became the center of architectural focus. Literature became all pervasive in the seeing-thinking of architects. Inadvertently they admitted their visual poverty by denouncing the Renaissance as concerned "merely" with architecture.[243] The romantic architect, in the desperation of crisis, wished to find relief in claiming he was more than an architect.

A new interest appeared in the experience of nature; though not exactly perceptual nature, for nature too, was subjected to the romantic verbal yearnings for the illusive, fantastic and mysterious, especially when inspired by real or contrived architectural ruins in the landscape.[244] Architects whose work would never leave the drawing board, and others bent on contriving architectural ruins, spoke for the condition of architecture at this time. The stones of architecture, as ruins, were tumbling back into their original context in nature. Once the Baroque had achieved the extension of space-displacing structure, the continuity of architecture became obscure. This was evident in such views as those held by the 18th century architect Lodoli, i.e., his insistence that "functionalism" and the demands of materials must be the principal determinant for architecture.[245] Unable to deal with those demands which the evolution of the art of architecture would normally impose on materials, Lodoli reversed the problem, making materials the pivotal determinant for the art of architecture. Thus he charged that to shape stone as if it were wood was a "lie," that it was nonsense to deny materials their "own nature."[246] These are the very arguments we are to hear two hundred years later from architects and Constructivists when the evolution of both art and architecture again become obscure. Implicitly such views were a denial of the great sculpture and architecture of the past. For materials to determine the art of architecture, instead of art determining the functions of materials, is nonsense. It is to the credit of a 18th century Italian architect, Algarotti, that he rejected materials as pivotal. He preferred the view of Vitruvius that architecture was related to the perceptual experience of nature. The "Baroque dictum" correctly insisted that the "beauty" of architecture resided in the "illusion," not in the tactile perception of materials;[247] i.e., in the "effect upon the eyes," as Guarini put it.

In the 18th and 19th centuries a variety of attempts were made to ascertain the origins and structural developments in past architecture. The hope was that a return to sources might indicate how to resolve the dilemma of architecture. Great attention was given to researching the earliest modes of human hiabitation for clues to a future course for architecture. Various arguments arose concerning the respective merits of Egyptian, Greek, Etruscan and Roman works as a precedent for architecture. Just exactly such research was only recently resumed in our own century when architecture again began to fall into eclectic and pop art confusions of neo-Rococo.

* * * * * *

In 1850 an extraordinary event occurred which was eventually to reset the stage for an entirely new form of architecture. The mass production of iron and glass, and later of concrete and steel, became a practical reality. The use of these materials meant the machine became the new medium, leaving behind the old handcraft which the masonry method required. Only engineers, however, recognized that the machine and its materials were offering new structural possibilities. There were a varied number of related reasons why architects were immune to the new possibilities.

To begin, engineering had become a specialized field in 18th century France, where the first engineering school was established in 1747. Thus the fields of architecture and engineering were separated from each other. In their isolation, architects continued in the ancient method of handcraft masonry structuring. Indeed the 19th century

82

architect took considerable pride in regarding himself as an "artist" when really he was confused about the *art* of architecture. He saw himself as superior to the engineer who, he said, could have nothing to do with art. Therefore, not only painting and sculpture, but engineering too, were fragmented from their original roles in architecture.

Engineering had not developed as rapidly in England as on the continent; nevertheless, the architectural view of engineering is evident enough in the views expressed by Ruskin. He regarded art and construction as opposites. The new feats of engineering seemed to him just so much "humbug," so much "vile construction." Iron, he insisted, simply could not achieve "beauty."[248] In much the same vein as Aristotle, Ruskin concluded that architecture was art only when it included painting and sculpture, its sole purpose being to serve the two figurative arts of mimesis. When these arts were absent, he found that "mere building" remained.[249]

In the 1850's, however, when everything was opened up to the possibilities of a new architecture, Europeans were in despair over the "destruction" of "taste," claiming the machine had "poisoned" the handcraft arts.[250] The European's conditioning to the past great arts compelled him to subject the machine to imitating handcraft, and then to blame the machine for its failure to emulate the achievements of the past. The European was simply not aware that the handcraft arts, later including masonry architecture, could no longer meet the needs of future art.

After 50,000 years of extraordinary handcraft achievements from sculpture to painting to masonry architecture, the use of the machine to replace handcraft was a traumatic cultural catastrophe for Europeans, as had been the appearance of the camera only a decade earlier. By the 1850's the handcraft arts had sunk into decadence, the solitary exception being the art of painting. It alone survived on the continent in a viable way throughout the 19th century with some important help from English painters.

Given the architect's feeling of superiority as a masonry constructor coupled with his low opinion of the engineer, it is not surprising that the engineer became the first to put the new materials and medium to use. His concern, however, was not so much to produce architecture — which he was not fitted to do in any case, least of all produce a new architecture — but rather simply to utilize the extraordinary new structural engineering feats now possible with the new construction materials. It was out of this *engineering attitude* that there ensued such novelty structures as the Eiffel Tower in Paris and the Crystal Palace in London. Yet something evolved in the course of structuring these feats of *engineering*, which later permanently colored the structuring notions of European architects when at last they adopted the new materials and fabricating methods of mass production.

From the viewpoint of the *art* of architecture, the engineers' particular exploitation of the new materials was regressive, as could be expected from non-artists; it resulted in reducing the use of iron and glass to the lowest order of structural perception — the "line" of drawing. This was to anticipate by more than half a century the "drawing in air" of neo-painting, and similar efforts advocated by an engineer-trained neo-sculptor. Indeed the new material of iron came to be regarded as a "linear two-dimensional" means for structuring,[251] in contrast to three-dimensional masonry architecture. Here, too, we see for the first time the two-dimensional structural fallacy to which, much later, both neo-painter and neo-sculptor will also succumb. All such regressive structuring was to dominate European efforts to achieve a new architecture. This is clearly evident in both the art and architecture of Art Nouveau which was a regressive exploitation of Baroque after everything else from Egypt, Greece and Rome to the Italian Renaissance had been exploited.

* * * * * *

As with the photographic arts, the American response to the machine and its materials for the realization of a new architecture differed greatly from that of the Europeans. The unique conditions in America were to have a marked effect. It must be understood that long before the new possibilities for architecture became available, American utilitarian handcrafts had already been largely replaced by machinecrafts. Therefore, by 1850, when the mass produced architectural materials became available, the Americans were already well oriented to the machine and its materials as the new structuring medium. This was the time, as noted earlier, when Europeans were in "despair" over the "destruction" in "taste" which, it was erroneously assumed, was the destructive result of the machine.

The Americans simply were not frustrated by those cultural conditioning difficulties which faced the great handcraft arts of Europe, including architecture. The Americans were able to respond to machinecraft as a *natural extension* of handcraft methods. They were free of the deep conditioning to the handcraft mimetic past which colored the European's initial psychological response to the machine as destructive.

The American engineer's practicality was not about to lead him into constructing such structures as the Eiffel Tower, although an imitation was built in New York. Nevertheless, the American engineer, like the European, regressed structure to the line of drawing. It appeared everywhere in his giant bridges and huge railway terminals, and for all these years there had been profuse admiration for the purported artistic feat of the Brooklyn Bridge. Yet

as long ago as 1883, Schuyler clearly perceived that the Brooklyn Bridge was indeed a work of "noble engineering" but "not architecture." As a work of art it did not even remotely approach the artistic dignity of any number of Roman bridges. Unfortunately, the American too often mistakes the quantitative for the qualitative, as in recent American painting. For that failing America has paid an enormous price in false art and architecture.

The European historian Giedion found, beginning with the 1880's, that while European architecture was in a state of "muddle, indecision and despair,"[252] a new architecture was appearing in America. He was, of course, referring to the skyscraper. Historians usually make much of Richardson, then merely mention Root, if at all, and finally burst into raptures about Sullivan. Wright, however, was to have an up and down reception over the years, both in America and Europe. There is no doubt that Richardson was a gifted man, but his concern with the Romanesque left him with not the slightest notion of any new architecture. Root was quite another matter. He was passionately aware of the promise the future held for American architecture and art, and did his best to fire others with his remarkable insights. Sadly for the future of both art and architecture, Root died just as he was seeking his way to the new. He has since been unjustly and habitually neglected, but he will one day be recognized as America's first great architect of world importance. His deep devotion to nature, his extraordinary insights into the promise the future held for American art and architecture, allowed Root to look ahead with extraordinary hope. As a later discussion of Root will indicate, he was the first architect in the world to perceive that the future held the potential for an entirely new kind of architecture and art.

Both Americans and Europeans agree one American architect, Sullivan, was the chief contributor to a new architecture, if not its originator. Everyone is familiar with Sullivan's statement "form follows function," which continues to be repeated out of sheer habit. Nothing could have been more disastrous as a motto for the attainment of a new architecture. It still remains the false battle cry of the functionalists today. That destructive motto meant art must bend to the dictates of function, and was nothing but a rationalization for a blatant commercial theory of architecture which must have brought a smile from every real estate operator. It was the motto by which architects could avoid any significant confrontation with architecture as essentially a new problem of *art*. Thus they could conveniently apply themselves to the new gods of architecture — function, engineering, profit.

As each skyscraper reached ever higher into the sky, to just that degree shrank the old role of the architect; he became subordinate to the actual purpose of the building. Indeed, by the 1880's, engineering was already consuming 50 percent of the cost of "designing" the skyscraper.[253] The really important man was the engineer, for he held the key to realizing the wishes of the real estate speculator. The architect was tolerated as merely supplying window dressing for the engineering.

In 1891 the editor of *Industrial Chicago*, commenting on the new "commercial architecture" as a monument to Chicago's "commercial greatness," applauded the practice of "casting out art where it interferes with the useful."[254] That was just a more candid way of saying, "form follows function." Here we come upon the American's Achilles heel. Not burdened by the European's great cultural past, he was also totally unaware of his own cultural ignorance. So it mattered not to those commercial apologists that the art of architecture was no longer the indispensable necessity it had always been in most of the past. It was no surprise that the perpetrators of the skyscraper solved the art problem by tolerating those dubious forms of art most likely to keep art out of the way of the real business of skyscraping. At least such building received the art it deserved, the mediocrity that willingly "follows function."

No one, no one at all, is more responsible for the inevitable ugliness of skycraping architecture than the architects who perpetuated such structures even after it became evident that doing so meant the destruction of the *art* of architecture. They gloried in the grandiose quantitative, with lip-service to the qualitative. They filched their false art from the past and then had the temerity to call it new architecture. This filched art would be confined largely to the bottom and top floors, between which would appear the major portion repetitively giving height to the building.

This building nonsense is euphemistically referred to as the "tri-part system," which makes it sound impressive indeed. The fact is it was simply an opportunist system that spewed forth bad, ugly, deplorable buildings, which hypocritically dared to pass as new architecture. In any case, how could one expect a genuine new architecture to appear while capriciously garbed in obsolete art and structures ransacked from the past, and to be justified simply because of its spectacular size and amazing engineering? Do we dare condemn 19th century architecture, when all the skyscraper achieved was an obscene enlargement of such buildings? What America received, and is still receiving, is the ugliest architecture to appear in the whole history of art. If all past periods came to their worst by ending in decadence, modern architecture began with the greatest decadence possible. Our recent past in all the arts has followed a similar course. Modernism in art and architecture, however, was not the beginning of new arts, but rather, the decadent termination of obsolete mimetic perception.

From the very start, the "modern" building was certain to be a tragic failure for one reason alone; it began

with false art, thus a failure of *art*! Skyscraping was a perceptual regression, limited as it was to the past's obsolete mimetic structure. For form was simply displacing space as in the literal cave mimesis of the classical which had long before fallen into decadence. We are here confronted with neo-architecture not unlike the neo-artists' structural disguise of the obsolete mimetic past as representative of something new. Thus the skyscraper is the oldest obsolete cave architecture in the baldest sense. Instead of tunnelling the earth as did the cave man's natural abode, the sky was tunnelled vertically like some Gothic apparition. Hitchcock, who eulogized Sullivan as the first "truly great" modern architect, concluded his admiration of what he took to be Sullivan's "masterpiece," the Guarantee Building, by referring to it as being a "hollow cage," [255] without knowing what he was saying.

Sullivan, hailed as the precursor of modern architecture, consciously lived between two opposing worlds. One was of the city, the other of nature. He found the effect of the city was that "inspiration was killed." He saw nature as the "source of power," precisely the power that he saw "dissipated" by the city.[256] This schizoid conflict would appear in every skyscraper he was to build. Thus the structure of the forms was the obsolete one of the literal mimetic past, the literal cave. These urban inspired simple space-displacing forms were then covered and disguised, made palpable with art Nouveau-like weavings of stems and leaves, as if to picture the monster and nature in mortal combat. This schism was evidenced in other remarks of Sullivan's. He distinguished between the "mass composition," i.e., the building as if it had no ornament, as the "nude" of the building, and the "decorative system" as the "garment" or "poetic imagery" which comprised the superior aspect of architecture. Hence he described the skyscraper as "harsh," "crude," "brutal," "weird" and as a "sterile pile" to which the "garment" would impart "beauty." In short, Sullivan was far more perceptive than his adulators. Indeed his buildings prophecy the future fate of architecture and the city. He was not defeated by eventual neglect, as some would have it, but by his failure to resolve the terrible dilemma he so strongly felt between nature and the architectural ugliness of the urban world.

Decades later Sullivan's decorative nature imitations would be swept aside to leave decorative "lines" now dressed up in the surface glitter of new industrial materials, the Constructivist version of neo-architecture. The "lines" and glitter now functioned as the decorations over the cave volume of the building. The lines were not so much the influence of the engineer's regressive structuring, where the "frame" of a bridge or railway station remained the visible structure as well, as they were the structuring result of European architectural influence. The very opposite took place in the skyscraper. The engineer's iron or steel frame would remain hidden, enclosed by the obsolete literal space-displacing form of sculpture, forming the architect's regressive structuring of mimetic masonry. The eventual vertical lines that soon dominated the vertical surfaces were the influence of the ancestor of skyscraping, the Gothic cathedral. And just as the cathedral, builders vied with each other in their "obsession" to raise the highest edifice or raise still higher already built cathedrals often without concern for retaining the original disposition of the structure, so similar occurrences now take place with the mania for ever higher skyscraping. For example, not so long ago a new "monster" was built in New York City. It rose higher than the Empire State Building, thus depriving the latter of its sole claim to fame. Plans were laid to regain the former quantitative supremacy of the Empire State by adding to the height of the building, but in anticipation of such a move a crane was left in readiness atop the new monster.[257] Today "commercial architecture" not only mechanizes the places for work, but also the places for living, with calculated lables such as "Highrise" or "Towers." It is imperative to understand that the "art" of the skyscraper is a total disregard for the art of architecture: only then can we comprehend the terrible tragedy, the steady "destruction" of once beautiful European cities and the new cities of America and the world. It is no mere coincidence that the original name given to this monster was skyscraper. The word means to "scrape," to "rub harshly," to "rub roughly" on something — in this case the sky, the space, the visual being of a city. But what about the city? As an indisputable product of the mimetic era of architecture, is it obsolete, too?

It was inevitable that cave structuring would first destroy space and light, then destroy life also. This is all too evident in recent years. But there is no awareness that regressive perceptuality was the fundamental failure that led to destructive architecture. Indeed, nothing that has happened in the whole of art history reveals as emphatically as skyscraping does, *how catastrophic the neglect of art can be for the welfare of human life*. A deadly price has been paid for listening to the engineer instead of to the artist. The toll of human life in the working cages of skyscrapers, or the cages for living in tower apartments, is incalculable. The very sanity of the physical and functional aspects of architecture, depends on its being *based in the humanizing function of art*.

Meanwhile, nothing is more certain than the fact that we can never, never return to the past except by regressing the past. The present shiny, glittering facades only further falsify mimetic architecture as the new. Do we really allow ourselves to see with our eyes? Is it any wonder that an architect's report on Expo '67 concluded that the most important structures were the dome, tent and ziggurat space-displacing formation of apartments?[258] All such structures are to be found in the very earliest primitive periods of architecture. Does it not say something

to us when one of the glittering skyscrapers rises among a cluster of ordinary 19th century architecture? Are not the once shabby looking old buildings enhanced when contrasted with the sterile inhumanity of skyscraping? We discover that even the old ordinary architects were at least still using their eyes; again proof that any return to the past regresses that past. In fact the new architecture has become so sterile and ugly that now any old architecture, however mediocre, is being protected with fanatical zeal.

In one of his last works Root attempted, as much as that was possible, to render a skyscraper as a work of art. This work was the Monadnock Building of 1889. (fig. 66) In this work Root was still using the ancient method of masonry. He looked to the example of the Egyptians, eliminating for the first time any use of skyscraping decoration, laying bare the building as essentially the "sculpture" it was. Yet for all its superior qualities, (when compared to what was then passing as skyscraping architecture), next to the grand beauty of Egyptians' works the Monadnock regressed that past. Root came to understand this conflict between the *art* of architecture and the building of skyscrapers. He found the height of such buildings, which were not yet very high, not "at all to his liking,"[259] candidly concluding that the expression of "art" would "never be so high" in such structures.[260] His view has been confirmed by all subsequent skyscraping.

In 1895, one alert critic, Barr Ferree, noted that skyscraping had already become a "blot upon the artistic aspect of our modern cities."[261] As early as the 1880's, Chicago newspapers referred to the "monster office blocks."[262] Blocks. Simple space displacement. In 1890, critic Schuyler, to his eternal credit, noted the monotonous "uniformity of skyscraping everywhere."[263] In the same year he wrote an article, "To Curb the Skyscraper,"[264] in which he deplored the fact that Chicago had become a place of "dark canyons" of "Frankenstein monsters." This visual congestion was a plain enough warning of what lay ahead — the physical congestion which now exists in all the large cities of the world. That early warning, however, was a warning from art. But art cannot make its warnings known as long as we remain ignorant of its central significance to the humane welfare of life.

Future generations will look upon the skyscraping of the 19th century as the architectural disease that first destroyed cities, which then became centers for spreading the industrial disease into outlying nature itself.

* * * * * *

While Americans were desecrating the sky in their race to see who could hurl his Gothic apparitions the highest, the Europeans' course was quite different. Their "new" architects were working under the sway of their engineers' structural regression of form to the line, a "drawing in space," the fallacy of two-dimensional perception of structure. From the 1851 Crystal Palace to the structures of the International Exhibitions in Paris in 1855, 1867, 1878 and 1889, each time there appeared buildings of huge arched or rounded domes with the exposed iron work criss-crossed over the ancient arches and domes like spider webs of lines, to result in enormous transparency line drawings of the obsolete cave mimesis of the past. All the spaces between the lines were filled in with glass to complete the deception that the old space-displacing form had yielded the new. That disguised structuring of ancient space-displacement was precisely what engineers in their ignorance of art originated and what architects in their ignorance of art perpetuated. It was in such fallacious structuring that Europeans erroneously saw the promise of the machine and the new materials as a new encounter with space.

Consequently, Giedion saw the architectural task ahead as a "problem of vaulting,"[265] what was called, during the Paris exhibition of 1867, the "globe of iron."[266] Giedion made the structural assumption that from the beginning of architecture the "highest architectural expression" of every past period was to be found in the "vaulting problem," citing the early and later Renaissance and the Baroque.[267] So, thanks to machinecraft, it became common for even the more permanent buildings to be globed or vaulted, supported with the old handcraft masonry walls arranged on the literal either/or space-displacing classical rectangle. One is reminded of Wright's apt remark about placing the Pantheon on top the Parthenon.

Americans, therefore, went in for huge "blocks," while Europeans went in for huge domes of glass. Each regressed the past differently, as they were bound to do for reasons stated earlier. In any case, it was a contradiction to expect the new to appear in *any* form of what anyone considered the past's "highest expression." For what the view amounted to was to present in the disguise of glass and line the obsolete structure of ancient cave architecture. Disguising the obsolete old does not transform it into the new but instead regresses the old.

More than anything else, what was talked about in all the varieties of modernism in art and architecture was something vaguely designated as "space," usually said to have some sort of "spiritual" existence. Thus Giedion said of all the glass-iron vaulting-doming that it was inspired by a concern with space. Unaware that the old cave space displacement was disguised by glass, he concluded that as early as 1885 the new meaning of the new materials had been correctly "grasped."[268] In the first place, European architects rejected the new materials and left them to the engineers who, however, failed to grasp the new architectural significance of the new materials and

the machine. Yet in an earlier part of the same book Giedion spoke of European architecture 25 years later as in a state of "muddle, indecision and despair." [269] In any case, he contended that there had been an "opening up of space" in place of "walling-in" the volumes. [270] Was that all it took, simply making the old "walling-in" out of glass in the belief you can't see what is there? One sought in vain to detect where space had been "opened up," for there was only the same old cave space displacement, the old captive "volume" of ancient architecture disguised by glass perpetuating the old "walling-in." All that had changed was that the closed-in interior space, rendered in the primitive structure of form as line drawings, was visible from the outside of the space-displacement exterior. The old by making itself transparent, like the "x-ray drawings" of the Egyptians, would pose as the new. *As in the neo-arts the old was being compelled to yield the new*. The results was to regress the old obsolete structure of form to the primitive representation of the "line." Indeed, Giedion insisted that through "primitive" architecture "contemporary" architects could gain a "new depth." [271] Thus the architect was being urged to follow the regressive example of neo-painters and neo-sculptors. Yet how often 19th century European architects were denounced by the "moderns" for exploiting the past. Apparently their mistake was in not going back far enough to do their exploiting. Corbusier, at the end of his life, more than others, exploited the primitive with his ugly sculptural regression in the shape of the Notre-Dame-du-Haut.

A devotee of the eclectic confusion of modern art, Giedion indiscriminately urged the architect to emulate neo-Cubism, neo-painting and neo-sculpture. He saw architecture becoming sculpture and sculpture becoming architecture, which was supposed to be preparing them both for being "integrated." [272] All that confused speculation could achieve would be to disintegrate structurally, and so to regress, the integrated mimetic perceptual past. The regression to the ancient sculptural perception accounts for the current interest in Boullee, Ledoux et al. What this indicates is that once more, with a crisis in architecture on their hands, architects sought escape with the mistaken solution of sculptural structuring regressions.

What does it matter then, to indulge in these periodic arguments about whether the inception of the "new architecture" took place in the skyscraping of the so-called Chicago school? [273] 99 percent of such discussion by architects at their meetings is solely concerned with ferreting out the technological precedents for such structuring, as if architecture has become a mere problem of new technology, not new art. Some see these precedents in European sources, others regard them as an "Eastern importation" to Chicago. [274] Really, does all that speculation that so thoroughly avoids discussion of the *art* of architecture matter at all? Those who wish to take credit for false architecture are welcome to it.

What is certain is that Chicago building, led by Sullivan, compromised the art of architecture with the ambitions of real estate speculators and thus gave the big push to skyscraping. It is just as certain that both the Americans and Europeans took the new machine medium and materials and did with architecture what the Europeans first did with the other handcraft arts, i.e., they compelled the old to be new. The result was neo-architecture.

<p style="text-align:center">* * * * * *</p>

The post-Baroque period began with the return to the space displacement form of the classical rectangle, then fragmented by the decorative compulsions of the Rococo and historical eclecticism. In America there was also a return to the literal space-displacing form of the classical, pushed vertically after the manner of the Gothic. The creative Baroque structural extension beyond the limited space displacement of the classical ended in the debasement of regressing the classical.

Time and again architects have asked why the new structural means that became available with the machine and mass production of iron and glass in 1850 were not grasped immediately by architects and used to create the new architecture? To this very day this problem continues to be referred to as the "unanswerable" question. Although this subject was considered earlier, with regard to the new relationship between the architect and engineer, there is another aspect to this problem considered in the following.

Aside from the fundamental problem of perceptual conditioning, the answer escaped us because the evolutionary two-fold roles of sculpture and painting as the creative structural determinants of architecture were not even suspected, let alone understood. Painting as a perceptual determinant of architectural creation was not properly noticed and so its ultimate consequences in Baroque architecture were never discerned. Architects and historians alike vaguely noted the spatial quality which the Baroque achieved in architecture. They failed to comprehend the specific structural nature of Baroque spatiality because of their general failure to note and understand the specific sculptural determinant in preceding architecture. How then could they perceive what the Baroque later achieved under the perceptual influence of painting? How then could it be seen, that the arrival in 1850 of the new mass-produced structural materials and means did not, and *could not, automatically* arouse into being a *genuine*

new architecture? How then could it be seen that the new medium and materials would have to wait until further masonry developments in art would achieve a *transition* to lead into the proper use of the new means? That is, masonry architecture would have to conclude its evolution in an art transition out of the old towards the new, thus putting the architect in a position where he could properly use the new means for a new art of architecture.

The often asked "unanswerable" question we began with betrays its naive assumption: namely, that the mere appearance of the new materials should have automatically prompted architects simply to drop whatever they were doing and apply themselves at once to the use of the new means to directly realize a new architecture without delay, as if dealing with this most drastic change of all in the history of architecture were simply a matter of exploiting the new means and materials, as has been attempted and is being attempted to this very day. It was as though the architect did not need to bring this art and himself to the place where he would be artistically fit to deal with this most fundamental technological change.

In any case, European architecture collapsed in the Rococo failure to perceive the structural extension achieved by the Baroque. If the Rococo architect returned to simple space displacement he then proceeded to glut it with decoration. True, Baroque space seemed to be continued, but space and light, like form, were relegated to the decorative. After that, architects resorted to the expedient exploitation of all past architecture.

To follow the further evolution of architecture we must leave the continent for England. The English architect took up the further development of masonry architecture that would continue the transition to the new. The English, whose temperament is essentially classical, first reduced the Baroque structural extension to its essential simplicity. Above all, bereft of the decorative excesses that finally smothered Baroque then died in Rococo, the English architect took the Baroque achievement with form, space and light and cleared it away to reveal the underlying spatial extension of geometric structuring. Thus he not only recovered the structural notion Baroque instilled into architecture, that is, the *plurality* of space displacement, but gave it a visibility it did not have before by putting emphasis upon the new structure as essentially geometric. Therefore, it was not as some historians see it, that Baroque was short-lived in England: rather the influence of Baroque led the way for English architects to go further. If, after Italy, all Europe went Baroque, the English preferred to develop it.

The 18th century English architects, like Roger Morris, proposed to regard structuring as a matter of "horizontal" and "vertical" distribution of "cubes."[275] If post-Baroque Italians also sought the new by a return to basic geometric structuring, theirs was a retreat to the spatial structural limitations of the classical, a retreat from what the Baroque had accomplished. It follows that the presence of much figurative sculpture and ornament in European Baroque retains its old dominant place on the face of architecture.

If the French too, as in the case of Boullee and Ledoux, also returned to the cube with the addition of the sphere, it was to limit and regress structure to the ancient Egyptian perception. The Baroque had moved from the simple closed space-displacing classical structure of sculptural perception to the "pictorial" plurality of space-displacing visualization for architectural structure. Boullee did not, therefore, take the "old" to a higher degree of structuring, to a new "beginning," as Kaufmann believed,[276] but actually regressed the obsolete simple space-displacing structural practices of the ancient past. That was the "end of the old" in spite of Kaufmann's denial.[277] Boullee's emphasis upon geometric structuring as sculpture, without resort to the ornament of the Baroque, only emphasized that much more how his form structuring negated the spatial release secured by the great Baroque architects. Perhaps it was the presence of Michelangelo which prompted an architectural historian like Kaufmann to see the period from Brunelleschi to Bernini as the era of the architect as sculptor when, in fact, the sculptural mentality had been replaced by the dominance of the pictorial perception over all the arts. Nevertheless, the sculptural interpretation of the 18th century had the consequence of fostering the false structural attitude of sculpture for 20th century architecture.

The essential classical temperament of the English, evidenced in such architects as Morris, Paine, Thomas, Nash and others, thus sought an architecture of "repose," as one of them put it, in place of what had become the excessive and capricious motions of late Baroque structuring. They perceived the excesses of late Baroque, in both structure and ornament, approached the state of "monotony." By centering their attention on the structural extension of the cube, English architects made clear the essential spatial extension begun by Italian Baroque architects. Contrary to the course followed by the French, who debased Baroque ornament with Rococo, the English reconsidered the role of ornament that they might return emphasis to the essential structure of architectural form in order to continue the new encounter between the structure of form and space.

In this light, reference to the "frozen Baroque" of English architecture is a false perception, no doubt the result of conditioning to the capricious late works of the Baroque temperament; hence the failure to perceive the geometric achievement of the English temperament giving structural extension to Baroque accomplishments. Unlike Europeans who merely diversified and exploited the Baroque, mainly through Rococo excesses of ornament or the return of spatial structure to the closed classical absolute, the English literally brought to the visual

forefront of architectural works the new role of form and space as primarily cubical structure in terms of the plurality of space-displacement. Contrary to Kaufmann's "frozen Baroque" view of English 18th century architecture, which he assumed wrought destruction upon the structural achievement of motion in Baroque, the English not only sought a new geometric means for structuring, but in doing so achieved a further and a new sense of structural motion which gave compositional extension to Baroque accomplishments. Thus the English achieved a new perception of structural unification. As early as the late 18th century Robert Adams saw architecture as a matter of "movement," as motion expressing the "rise and fall, the advance and recess" structuring of "convexity and concavity" as it appeared in a landscape or a painting, to thus create the "variety of light and shade." [278]

Therefore, if the resort to "elementary geometry" was the prominent feature of architecture as the 19th century began, what Kaufman correctly designated as a "revolution" of "composing in bold masses," [279] it was the English architects alone whose efforts were achieving a perceptual direction out of which a viable future architecture could arise. Contrary to the sculptural attitude that prevailed in Europe, the English continued the Baroque extension of form as a plurality of space displacement, having retained the emphasis upon the Picturesque, as they called it, thus continuing that perceptual direction which had been the principal structural impetus since the Italian Renaissance. It was the geometric clearing-away that permitted English architects to continue the masonry transition with the perceptual clarity of symmetry structuring; that is, the "horizontal" and "vertical" distribution of cubes. Thus, from the Italian Baroque to the English efforts of the 18th and 19th centuries, masonry architecture was evolving a structural transition to a new *art* of non-sculptural architecture.

It is necessary to consider the term Picturesque as it originated with the English, not only to clarify its past use, but also to clarify its use here. Whenever something new appears in the arts and inevitably acquires a label, this label is just as inevitably subjected to a number of uses and interpretations. Hence an historian like Pevsner frustrates his inquiry when he asks the question, "What is 'picturesque'?", and then proceeds to seek a singular answer to this question by stating that the Picturesque must be that which "appeals" to a painter. To then inquire, as he does, into paintings of architecture leads to confusion and misses the point.

As previous discussion indicates, the real problem revolved around the painter's high order of perception as a perceptual direction for architects, not in order to imitate any particular mode of painting but to use the painter's perception as it could be applied particularly to the *unique* possibilities and needs of the art of architecture. Therefore, all interpretations of the term Picturesque that sought a sculptural solution, as in the case of such 18th century French architects as Boullee and Ledoux, constituted a perceptual contradiction. Sculpture as it was generally perceived after the Renaissance, i.e., without applied color, and painting were two different orders of perceptual development, each perceptually exclusive of the other. Hence any confusion of the two led to perceptual confusion and so to regression.

If we ask what was accomplished by 18th and 19th century English architects and, like Pevsner, conclude that while some works are symmetrically structured the really Picturesque works are asymmetrically structured in their composing, we then distort the facts. Without needing to go further into the rationalizations for this view it does, in any case, separate what is structually inseparable, since all structuring is an inescapable matter of some kind of symmetry, i.e., some kind of symmetry-asymmetry structuring. Symmetry-asymmetry comprises a structural spectrum which on one side has the appearance of what we call symmetry, the other side having the appearance of what we call asymmetry, but one is always present in some degree in the other. (See my article, "Symmetry, Nature and the Plane.") In that sense the earliest pursuits of the Picturesque would tend to rely on what is called symmetry, while later efforts would tend towards the complexity of symmetry which is called asymmetry. This is not to mention the romantic irrelevancies which Pevsner adds to his definition of the Picturesque, such as texture of surfaces. [280]

The 19th century English architect Adams is more correct when he cites the structural factors of "movement" and the "convexity and concavity" interactions of architectural composing. Without agreeing with all Meeks' subsequent interpretations, he comes direct to the issue when he puts the emphasis upon "visual qualities," citing two sources from the 1870's. One of these states that a building must appeal to the "eye," the other contends that in the early part of the 19th century a "new eye" was evolving in architecture. [281] Accordingly, the Picturesque achievements of English architects during the 18th and 19th centuries rested in those pursuits dedicated to continuing the emphasis upon the development and architectural use of the painter's higher order of perceptual awareness; i.e., the optical world of nature's light which Adams called the "variety of light and shade," in contrast to the emphasis upon the tactile or limited vision of sculptural mass as in Ledoux.

The English effort to build according to cubical relations is called, by Kaufmann, cubism. In doing so, however, he had in mind the structural confusions of neo-Cubism. Clearly the English architect had no such dubious concerns as the "destruction" of past structural practices in order to achieve the absurdity of something called "spiritual space," etc. Rather he was concerned simply with a straightforward mode of structuring which

53. Above: Sir John Vanbrugh, *Blenheim Palace*, Oxfordshire, England, 1705, photo Edwin Smith. 54. Opposite page: *World's Columbia Exposition in Chicago*, 1893, photo Francis B. Johnson, Library of Congress.

would continue the creative evolution of Baroque achievements. In that respect the great English architects of the 18th and 19th centuries were Cubists, in the way that Cezanne and the early Wright were Cubists. It is in that sense of Cubism that one perceives the works of Gibbs, Vanbrugh, Kent, Morris and others. Morris was among the first of the English architects to adopt the new and natural view of the landscape as architecture, a view that then became general in English architecture and spread its influence across Europe.

It was during the period of England's isolation from Europe that the English began to give special attention to the landscape.[282] This effort was called the Picturesque, a term coined by the painter Gilpin. Later the term was extended to the other arts, beginning with the theories of Price in the last years of the 18th century. In Price's view the qualities of "roughness" and "irregularity" were given equal value with those of the "beautiful," a term previously reserved for such painters as Lorrain.[283] In effect, through the example of painting, the English were freeing the perception of nature from the limiting classical one. The classical aspired to achieve what it was thought nature sought but did not achieve. In contrast, the Picturesque attitude strove to give extension to that perception given in the direct vision of nature. It was this release from the limited, absolute classical view that extended perception in all the arts, permitting English architects to continue the visual evolution of architecture.

During the 18th and early years of the 19th century the notion of the Picturesque, with painting as the guide, permitted the English to perceive all the arts as a unified effort with nature.[284] Thus, when first consulted about the building of Blenheim, Vanbrugh asked that a landscape painter be consulted.[285] According to Hussey, Vanbrugh was the first to see a parallel in the relationship between landscape painting and the garden as a unity with whatever architecture was placed in the landscape.[286] The Picturesque architect relied on landscape painting in particular. In the view of Pope, "regularity," i.e., the limited classical order, was rejected in order to follow the way of nature.[287] All through the writings of those who practiced Picturesque perception was the emphasis upon vision, painting and the "variety of light," as Adams put it.

It is important to note that in the English unification of the arts, sculpture had but a minor role. The unity was overwhelmingly between the two remaining viable arts of painting and architecture. England's past was not one of a flourishing art of sculpture, in contrast to the opposite case on the continent. From the earliest architecture of the Anglo-Normans, sculpture was not common even as ornamental works. Even in the case of ornamental works the result was more architectural than sculptural and "uncluttered." When the isolation of England ceased during the Italian Renaissance, even then sculpture did not come into dominance and what there was of it was largely the work of imported sculptors. On the whole, when the English architect used sculpture or sculptural ornament it was

90

subjected to the dominance of the architecture itself. In English Gothic there was not the great use of sculpture, nor was the architecture itself as sculptural as works on the continent. Thus from the 14th century until the Renaissance began to filter into England, English Gothic remained sharply distinct from such architecture anywhere else. When the transition began in the 16th century from church to secular architecture, when the great country houses began to appear, the English remained largely "disinterested" in sculpture. This disinterest remained even after Inigo Jones introduced classical and Palladian architecture. The English attitude toward sculpture, as opposed to that of all Europe, was an important advantage in that English architects were the least bound to the obsolete structural perception of sculpture. Architects, perceptually speaking, were among the great visual artists of England.

Therefore, once the unity between nature, painting and architecture was fragmented on the European continent, the English alone continued the evolution of the painter's perception of nature for the art of architecture. Contrary to the contention of some recent writers prejudiced by the false revolution of Ledoux and Boullee, that English architecture was placed in a secondary role to nature, English architects sought to amalgamate the art of architecture with the art of nature.

The new perceptual insight into nature of the English was further evidenced by the fact that they would produce the first great painters to open up new perceptions of the landscape; these were Constable and Turner, who would make way for the great landscapists of the Barbizon who would then lead to Monet and Cezanne. The influence of the English architects, however, would not fare as well on the European continent in spite of the enormous influence of English landscape architecture. For nowhere in Europe would the new unity between nature, painting and architecture come into being. On the continent, a desperate effort would be made to secure architectural certainty by appealing to the false grandeur of sculptural monumentalism. Only painting lived on in Europe to the end of the 19th century.

Just as mimetic art was achieving a transition to the new, through Monet and Cezanne, that would eventually leave behind the ancient handcraft method of painting to become a new three-dimensional non-sculptural machine

art, so masonry architecture would move through a similar transition. In both cases the new technology had appeared long before art and architecture had developed to the point where the machine and its materials became appropriate for the new needs of art. It was during that transitional interim, for both art and architecture, that the new means were being destructively exploited by the engineering mentality on the European continent. As a result it was the engineer who determined the structural future of European architecture, and not, as in the case of the English, the necessity for a masonry transition to the new.

It is important to note the general attitude that prevailed throughout the Italian Renaissance and the great period of Italian Baroque architecture; i.e., the ''effect upon the eye'' (Guarini), the priority of the perceptual, art as pictorial ''composition'' — the particular form-structuring for creating a work. This attitude was abandoned once the Baroque had run its course, and was replaced by the priority of materials and function. It was then there arose ceaseless disputes over the priority of ''design'' or that of materials and function, disputes that continue to this very day. These disputes were essentially over the problem of whether art or materials and function are the formative determinants of a work of architecture. This underlying problem reached a hazy consciousness early in our century with Loos and others who saw the role of art lessen as the engineer became the artist-hero of a new architecture.

When the Italian Baroque had concluded its evolution, the art of architecture became confused, a confusion

which continued to the present so-called International Style. A perceptual breakdown between nature and art existed, which architects sought to circumvent by seeking salvation in materials and function as a substitute for creating architecture. This effort was most blatant in the constructivist architecture that began with the engineers in mid-19th century and continues today along with the constructivist art in our country.

It was the great English architects of the past two centuries who reinstated the Renaissance-Baroque perception, who alone would continue the evolution of architecture as requiring a "new eye." The English, however, would not complete the masonry transition. As the creative evolution of architecture left continental Europe for England, it left in turn for America. In this respect it was significant that the Picturesque attitude was making its influence felt in America just about the time America was moving ahead of England in technological development during the mid-19th century. In the last years of the last century and the first decade of the 20th century, the fundamental nature of the masonry transition would come into focus. This was the achievement of one American — Frank Lloyd Wright.

The drama began in 1903 with the Larkin Building (fig. 55). In that work, Wright said, he was first conscious of going beyond the "box," that is, simple or literal space displacement. It was then that the English geometrical, symmetrical clarification of the Baroque was brought to an even greater geometric simplicity. Wright directly acted upon the classical rectangle by introducing primarily horizontal motions into and out of the rectangle, in his reach for further structural development. The importance of the Larkin was not that it was essentially a new structure, for the inception of such structuring began to appear in Baroque and then more definitively in English architecture. In fact, there was even the continued use of figurative sculpture, though its role in the work was minimal. For what we see in the Larkin is the horizontal and vertical distribution of "cubes," as the English architect Adams had put

55. Opposite page: Frank Lloyd Wright, *Larkin Administration Building*, 1903, Buffalo, New York. Rear facade before removal of sculptural decoration, photo The Museum of Modern Art, New York. 56. Below: Frank Lloyd Wright, *Unity Church*, 1904, Oak Park, Illinois, photo The Museum of Modern Art, New York.

57. Frank Lloyd Wright, *Unity Church*, Oak Park, Illinois, 1904, photo Hendrich-Blessing, Chicago.

it; that is, the "rise and fall," the "advance and recess," the "convexity and concavity," as that English architect had expressed it. What Wright had done, however, was to give perceptual clarification to past efforts to pluralize space displacement by letting such structuring appear in its stark and almost its simplest symmetry geometry. In continuing the English achievements the crucial point was that Wright was the first to perceive in his Larkin experience the possibilities which would eventually lead to the discovery of a structurally new, non-masonry machine architecture.

It was no accident that as Wright steadily neared the new perception of architecture, he found himself returning to the original impulse of architecture — the single goal of achieving human shelter, the house. In his effort to achieve the transition to the new, however, non-skyscraping commercial structures like the Larkin and Unity Temple would participate in his concentration on the house as the most amenable structure for realizing a new architecture. (fig. 55 to 57) In so doing, Wright became the means to a most extraordinary event in the history of architecture. Through Wright, man would discover that he could become a complete creative architect; that is, no longer dependent upon imitating the cave structure of nature. Once more a new beginning would be made in architecture by concentrating anew on human shelter — the house.

As noted earlier, early man had to learn how to create imitations on the structural theme of his earliest experience with shelter, the natural cave. Only after long and varied structural experiences was it possible for man to achieve highly developed public architecture. In the times of the Sumerians, Babylonians and Assyrians, the layout of the temple "differed little" from that of the house.[288] In Egyptian cities, there were special areas for the

94

58. Frank Lloyd Wright, *Robie House*, 1908, Chicago, photo Henrich-Blessing, Chicago.

workers and others for the elite. This practice continued in Greece and Rome and is still with us.

In Rome, however, a change took place similar to one that would occur on a tremendous scale in 20th century America. In order to absorb the fast increasing population, the Romans were compelled to build houses vertically for several stories. The use of concrete made this possible.

In any case, the house would be the prototype for the future evolution of architecture. For example, the Aegean house became the prototype for structuring the early Greek temple. Thus the house was the first structure developed in the first stage of human architecture. Many forms were evolved like the tent, hut, and dome, using the geometry of the cylinder and cone and combinations of these. In the West, the rectangular structure survived to become the form for human shelter and, in turn, the prototype for subsequent public architecture. Later on, other forms of geometry would reappear as aspects of the mimetic evolution of architecture. It seemed, therefore, that as architecture was about to embark on a new era, the prototype for a new architecture would again make its appearance in the house, but in a new kind of house.

First it is necessary to note what previously took place in America, specifically the Chicago Fair of 1893 which was to have a devastating effect on American and world architecture. With Root's premature death, New York architects took over the control of planning the Fair. As a result, they would take the lead over future skyscraping from the so-called Chicago School. The neo-architecture of the skyscraper now regressed to the ultimate of neo-Roman and neo-Gothic decadence which included house architecture as well. (fig. 54) New York, already the center for American art for more than two decades, became the center for American architecture.

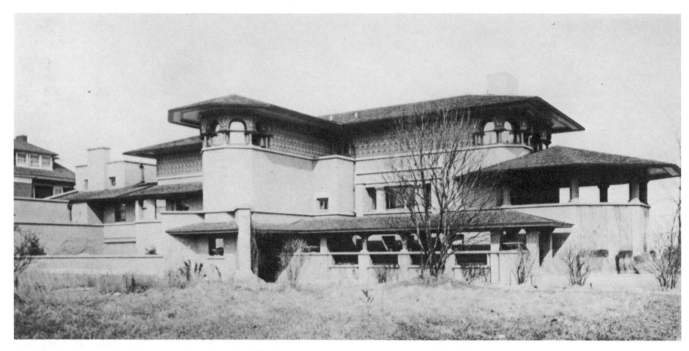

59. Above: Frank Lloyd Wright, *John Husser Residence*, 1899, Chicago, Illinois, photo Henry-Russell Hitchcock. 60. Opposite page: Frank Lloyd Wright, *Municipal Bathhouse*, 1893, Madison, Wisconsin, photo Henry-Russell Hitchcock.

It was during this period that Wright began working on what would be a unique mid-Western development, devoting himself almost entirely to the house. In contrast to the arguments over whether the Chicago School was the originator of skyscraping, Wright's architectural achievements indisputably originated in the mid-West. All references to the work of Wright, in the remainder of this essay, will be confined to his architectural achievements up to 1908, along with those of Wright's views which shed light on his early works.

In the fifteen years from 1893, when Wright began his own practice, he achieved with the house nothing less than a prototype for a genuine new architecture. He did so in the only way possible, by realizing the first *perceptual* steps out of the obsolete mimetic cave past to reveal a *new vision* for a new architecture. He, and he alone, took the first steps out of what Wright correctly called "cave" architecture. He freed form into a new sense of space, space into form, to make space a more viable, pluralistically conscious structure in future architecture.

Wright achieved what all the American skyscraping and European doming had utterly failed to do, namely, *an extension of the perception of structure as the means for achieving a genuine new architecture*. Achieving structural extension beyond mimesis, Wright exposed the futility of compromising the machine and its materials with the obsolete structuring of the past which falsely simulated a new architecture. The new structuring that finally emerged out of Wright's houses would be totally unlike anything done by anyone before him. Gifford expressed his disturbance over the differences which Wright's early houses introduced into architecture. He observed the "subtle and nagging" different directions between the large scale works of Sullivan and Wright's preoccupation with the house between 1890 and 1910. In all my reading on architecture, Gifford was the only one who regarded this "divergence" as indicating a "deep-rooted discord" in the architecture of our times. Unfortunately he did not amplify his reactions.[289] This "discord" revolved around the use of obsolete perception disguised in the new technology, in contrast to using technology to free perception from past conditioning towards a new architectural perception.

Writing in 1912, European architect Berlage observed that all one heard about was the skyscraper, not the "real modern" American architecture.[290] He was referring specifically to Wright's houses, noting that concerning such architecture there was "nothing like it" in Europe.[291] He also observed that Wright's Larkin Building "had no equal" in Europe.[292]

What Wright accomplished, however, was not the immaculate conception some adulators and even some detractors assumed. Nor was his early work the product of anything but the evolution of Western architecture, for he completed the transition begun by the English — the masonry transition towards a new architecture. It was an extraordinary accomplishment for one man to make. As Cezanne must be discovered again to perceive the real revolution of Cezanne, so Wright's early work must be discovered again if American and world architecture is to

cease its eclectic mimetic futilities which allow architect Johnson to rejoice in the "murky chaos," i.e., to continue the chaos.

American and European architects believe they have moved swiftly past Wright, leaving him scarcely visible behind them. Hitchcock, for example, wrote that Wright had "little to offer" architects today.[293] To the contrary, I will show that Wright's work, which Europeans viewed in the 1910 and 1911 European publications, was never really seen.

In 1894, Wright gave a talk entitled "Architecture and the Machine." He was the first artist to discover that the machine and its materials became the new means with which both a new architecture and a new art could be created. The future of art, he insisted, lay in the machine,[294] giving "new life" and a "new purpose" to *all* the arts.[295] That was some 70 years before even a small number of American artists accepted the machine medium. He also warned of the dangers of the machine, when not in the hands of a creative artist who alone could grasp the "significance" of the machine.[296] He warned, as had Root before him, of the destructive stupidity of "machine worship,"[297] of subjecting art and architecture to the mechanical, for the machine could only supply the means, not the end. He particularly warned against "prostituting" the machine by subjecting it to past forms, forms the machine could only "destroy."[298] He understood the machine could be our great "hope," or it could bring human disaster; it could be man's "glory" or it could be his "menace."[299] As an example of the "deadly struggle" between art and the machine, he singled out all the skyscrapers which, he said, put the head of art "upon a pike." He pointed to the skyscraping as a "warning" to artists and architects "the world over."[300] Architects, however, were too immersed in the power of skyscraping to listen to words about the machine and art. The architectural disaster which Wright warned about more than eighty years ago is now with us.

<p style="text-align:center">* * * * * *</p>

Again events took a very different turn in Europe. In stark contrast to Wright's warning about the machine,

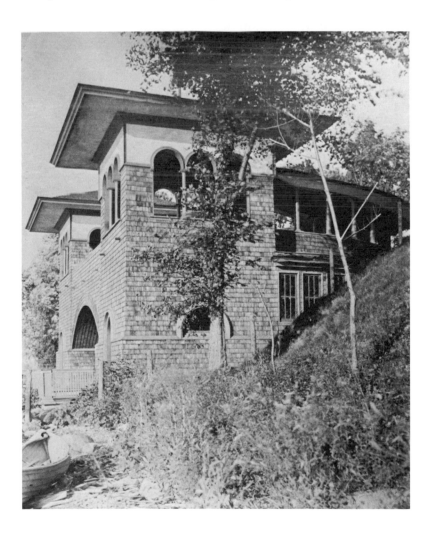

European architects were now entranced with the engineer who had been the first to use the new medium and materials for building. The formerly downgraded engineer now became the preeminent hero of architects seeking the new. Banham points out that the engineer was regarded as the "noble savage" of the machine age. It must have been beyond Wright's belief to hear such views, not to mention van de Velde in 1899 conferring the title of artist on the engineer, who was now regarded as the instigator of the new "beauty" of architecture.[301] In 1910, the year Wright's works were published in Europe, Loos insisted that art was "only a small part" of what now constituted a new architecture, revealing how much the engineer had become almost a complete substitute for art. Others were of the same mind.[302] (Remember the Chicago editor who, in 1891, was all for "casting out art" when it got in the way of the "useful"?) In 1897, Loos referred to the engineers as our "Hellenes."[303] For Loos, as for Sullivan, the engineer was a "hero." Today there are still those who believe that the best architecture emerges out of "great engineering."[304] Hence the Italian engineer, Nervi, insists on being called an architect.[305] Together, American skyscraping and European doming praised the engineer as the great benefactor of new architecture.

In order to resolve the confusion over the *art* of architecture, the engineer was irrationally confused with the artist which left art as a "small part" of architecture. Certainly architects did not elevate an engineer into an artist merely by stating he was "uninhibited" by the "constraints" of so-called aesthetics.[306] That only revealed the architect's dilemma over the problem of art in architecture, for that indicated that the highest goal of architecture, its status as an art, had reached the confusing proportions of crisis. It was naively hoped to circumvent that problem by considering art a constraint to be abandoned.

After a period of simple adulation of the engineer, Europeans turned their admiration directly to the machine. We then began to hear about the "beauty" of the machine, how the machine would liberate man. No heed was taken of Wright's warning that art and man could be reduced to being slaves of the machine. To the contrary, Europeans were contending that it was the handcrafts of the past that had reduced man to a machine. Such views were stated by Doesburg[307] and other de Stijlists, by Bauhaus people, Futurists, Constructivists, etc. Any American worker on the assembly line could have revealed to Europeans that the opposite was the case.

Hence the mechanical destructiveness of the machine was not long in asserting itself. Nowhere does that appear more sharply than in the machine adulator's attitude towards nature which ignored Wright's admonition, and Root's, that nature was the source of the new reality of architecture. To the contrary, Doesburg and others insisted on an "independence from nature," preferring to look to the machine which was regarded as a "mechanical aesthetic."[308] Prampolini, writing in Doesburg's magazine, *de Stijl*, saw Europeans as having "hymned and exhalted" the machine. Like Doesburg, he called for a machine "aesthetic" which he believed would evoke a "mechanical cosmogony."[309]

In contrast to the Americans who had *gradually* experienced the machine as a natural extension of ancient handcraft methods, the Europeans and Russians were suddenly shocked into a naive acceptance and adulation of the machine. The Americans, however, falsified the machine due to their naive awareness of the significance of art. Yet it was only in the American climate that it was possible for architects like Root and Wright to emerge, architects who properly understood the future possibilities of art and the machine. They had not abandoned art or nature!

Wright had warned plainly enough about "machine worship" and the "machine god." He insisted that he had never been "ambitious" to become an engineer, and deplored the fact that engineering was the only kind of formal education he received.[310] To the very opposite of van de Velde and Loos, he insisted that the engineer was "not a creative artist."[311] He rejected Corbusier's view of the engineer as "virile" and other such contentions, insisting that architecture need not become a machine simply because it was made with machines.[312] To regard the house as a "machine for living," as Corbusier did, was hardly a humanizing aspiration in Wright's eyes. For him the machine was a "mere tool."[313] In spite of Wright's deploring that his education was limited to engineering, he had been offered the opportunity, which he wisely refused, to attend the Beaux-Arts in Paris.

Europeans were to pay a heavy price for their abject "worship" of the engineer and the machine: they were confusing the end with the means. Where it had been natural enough for the 19th century American to take the machine in his stride, it seemed unnatural to the European conditioned to his great handcraft arts. When Europeans finally recognized the machine as an inevitable necessity, they simply capitulated. Unprepared by their cultural conditioning to accept the machine, they now put unquestioning hope in it as an absolute salvation. The direct consequence was the desire to be "independent" of nature. Like all the neo-artists of Europe, architects regarded nature as perceptually exhausted. The consequence was to leave them conditioned to the obsolete mimetic cave vision out of which they were hopelessly grappling for a new architecture. Denying nature, not to mention the past, they closed off the only avenue to a genuine new architectural reality. It was not, therefore, that Europeans simply refused to comprehend Wright's insistence upon a "natural architecture," an "architecture of nature;"[314] the fact was they could not, even if they wanted to do so. Americans, however, as Root knew in 1883, were free to achieve

the new without the European's frustrating burden of a great cultural past. The European was in the desperate position of concentrating all his energy in an unsuccessful attempt to escape instantly the burden of his past. It was precisely the impulsiveness of that attempt which led him irrationally to hope to achieve instant liberation from the hold of his immense past. While European artists were not aware of their own hopeless effort to achieve "instant" release from the old to the new, they correctly perceived that after World War II the Americans in New York were attempting to secure "instant culture" out of their less than great art past. Both were acting out of a sense of desperation, as some New York painters will later admit, but that admission was simply to show us how their genius had suffered before it burst into its full glory.

In place of nature, then, Europeans saw the machine as a "spiritual discipline," to use Doesburg's expression. Is that what Wright was referring to when he observed that the Americans were free of "sacrificial mysticism"?[315] Like Root, he understood the Americans were uniquely free to realize the new. The great past had left an immense burden on the conditioned European psyche which led both neo-artists and neo-architects to seek escape by introverting obsolete mimetic perception. They sought substitutes for nature and there were none.

Among the factors that placed the European psyche in conflict with the machine in art and then resulted in the opposite extreme of complete capitulation to the engineer and the machine, the powerful emerging role of science was crucial. Since the Renaissance, the question of nature and science gradually divided into the separate attitudes of "natural philosophy" and "natural science." The latter became the sole concern of instrumental-mathematical measure as the means to deal with nature, while the former dealt with the "interpretation" of nature becoming the concern of academic philosophers.[316] However, beginning around the time when glass and iron were finally mass-produced, the field of "natural philosophy" rapidly lost its capacity to act as a counterbalance to the "mastery *over* nature" attitude of science, as Leiss made amply clear. Thus was let loose anew man's old wish to be superior to nature, an attitude that had been forming since Francis Bacon and which, in our time, now means the enslavement of man by science. Hence the whole climate of Europe, from mid-19th century on, gradually introverted man's relations with nature. It was then that the scientist's instrumental laboratory and the artist's closed studio took precedence over the perceptual experience of nature. One can then understand the overpowering dominance of the engineer and the machine over the efforts of European artists and architects, many of whom appealed to science or even claimed to be scientific by absurdly assuming they were depicting the non-visual fourth dimension.

The fact that the masonry transition took place outside continental Europe, (first through England and then across the ocean to America), left European architects in an extremely desperate situation. They had no awareness of the necessity for a masonry transition. What they perceived was that a sharp break had fragmented the present from the past, leaving them empty-handed. Without any preparation to deal with the new problems, the architect eventually literally collided with the engineer and the machine and, on the instant, had to make a decision. He was like a drowning man reaching for the new means for instant salvation. Understandably then, the Europeans accepted engineering structuring without question, in place of structuring evoked by the demands of a new *art* of architecture. It followed that many like Loos concluded that art now played only a "small part," and like van de Velde found that the new "artist" was in fact the engineer, the hero of modern architecture. It was as if both nature and art disappeared together, leaving behind a maze of iron lines clogged with glass.

This resulted in another traumatic situation. Without the advantages of the masonry transition, architects were suddenly brought from their former perception of structure as simply space displacement to a head-on collision with engineering structuring which appeared *as if* the structure of form had disappeared leaving only lines strung across the indifferent flow of space. Hence the illusion arose that somehow the new space could only be achieved at the expense of form. In seeking an answer as to how to exploit engineering structuring, architects now turned to the form confusions of neo-Cubists, the line drawings of neo-painting, and the confused space of neo-sculpture. Architects in Europe searched such arts for a prototype to solve their own problems of form and space. In the midst of these structural confusions the works of Wright began to be generally known to Europeans, but that did not really alter the European structural course of events which had begun in the last decade of the previous century. It was not surprising then that Europeans were not much concerned with Wright's understanding of his own work. Instead, they set about comparing his structuring with neo-Cubism. That explains why Europeans were ambivalent towards Wright. Oud, for example, admired the great influence of Wright on European architecture, as a "revelation." He noted what he called the "horizontal development" and the "shifting planes," in Wright's houses,[317] but instead of relating the planes to Wright's realization of a *new perception of form and so of space*, he related Wright's structuring to neo-Cubism's fragmentation of the past's obsolete notion of form. It was inevitable, then, that he would find Wright's works and words short of the mark, concluding that it was incorrect to ascribe everything to Wright. Oud neglected to note, however, that Wright had already laid down the structural principles in his work before there was any "cubism" to talk about. In fact, Wright was making plans for the Robie in 1906,

the very year of Cezanne's death — two years before neo-cubism, let alone before neo-painting and neo-sculpture. Instead Oud concluded that Wright's innovations were already the concern of European art and architecture through neo-Cubism. At best, he said, Wright simply reflected a goal similar to that of neo-Cubism, except that the latter more consistently followed the goal which Wright "preached" rather than "achieved." How different all that was from Berlage's observation, that there was "nothing like" Wright's houses in Europe, that the Larkin had "no equal" in Europe.

Oud described neo-Cubism as the "breaking up" of forms, then "recombining" them to attain new structure; again the wish to compel the old to yield the new. This was the rationale for the irrationality of European art since Moreau. It was the Redon recipe, except that what Redon would do to the particular form of objects or "subject," Oud would do to the obsolete structure of form as such. The "breaking-up" and then "recombining" the resultant form fragments had the purpose, said Oud, of reinstating the importance of "mass" with space acting as its "complement."[318] This is an example of one side of the problem with which European architects struggled. That is, the old obsolete perception of space-displacing mass, in spite of the "destruction" of the "breaking-up," somehow reclaimed itself with space as some obscure "complement." At best this was a theory silently rationalizing elaborations or variations on the obsolete structural theme that had characterized past cave architecture. On the other side of the problem were the spider web lines of the engineer, where it seemed a new sense of space had been secured. It was the confused oscillation between these two structural extremes that was to characterize future European and world architecture.

Wright's early work had nothing at all in common with neo-Cubism. He, like Cezanne, was not concerned with "breaking-up" anything whatsoever. He wished only for form, in the new form of planes, to be free of being limited to the solidity structure of the space-displacing cube. The plane became spatial in its function and this led to a new encounter of "form" with the elements of space and light. This was not the European struggling with the old form structure, but rather form evolving to a new perception of form structure and the structural function of space and light. Structuring with "groupings of masses," as Oud described it, was precisely what Wright's works and words rejected. Simply to multiply simple space displacement was not to go beyond the old, but to fall below it. Wright understood that the obsolete "cave" structuring, however used, whether as "boxes beside or inside other boxes" — what he called "cellular sequestration"[319] — had to be rejected for a new perception of structure. Oud was circled by conditioning; Wright had taken the first step out of that circle.

Wright was certainly not another regressive neo-Cubist, he was a Cubist in the sense of Cezanne. This is evident in Wright's 1903 Larkin work, done five years before there was a neo-Cubism. (fig. 55) In this work, as noted earlier, Wright says he first became "consciously" aware of going beyond the "box" to seek a space no longer "walled-in." Space, he said, must be "free to appear."[320] Certainly he was now taking the first steps out of simple space displacement. The singular classical "box" was being extended into multiple motions, the motion of a plurality of forms moving in and out of, and beyond, simple space displacement. There was then a multiplicity of space displacement which first appeared among the Italians and then more clearly in the "new eye" of English architecture, that architecture of "repose" which the English of the 18th century sought through the "horizontal" and "vertical" distribution of cubes. The exterior was no longer a simple, single massive rejection of space; exterior space began to move in and out in horizontal directions. Interior space, the "walled-in," contrary to Wright, remained the enclosed, captive space of old. It was necessary first to free the exterior if the interior was to be freed, and not the reverse, which was the great error of the Europeans.

In the following year, in the 1904 Unity Temple, the spatiality of the new form now began to assert itself on the exterior, in the roof horizontals. (figs. 56, 57) For the first time space planes began to emerge. The planes extended beyond space-displacement seeking a new structural amalgamation *with* space. Two years later, Wright made the plans for the Robie House to be completed in 1908. (fig. 58) It was a great realization as the horizontal thrust of the exterior spatial planes strove to free themselves from the spatial limits of simple cave mimesis, from the space displacing of the "box." But as one moved away from the house, the slant of the roof appeared, a remnant of the cave, and the spatial experience was altered, subdued. This is not the true space plane that began to show itself in the Unity Temple, nor has the interior been freed from its ancient bondage to the cave. It stands there in the disguise of glass. There are no space planes; there must be space planes just as had been necessary to free the exterior. In any case, there was only the need to make a few more developments and the exterior and interior would mingle in each other's space in the light. For all the problems that remain to be resolved, no one has dared to go as far as Wright went with the Robie. It is a grand work opening the way to the future, and Wright was indeed correct when he referred to Robie as the "corner stone" of modern architecture.

If we look back at the Larkin, with its largely four-sided symmetrical interior, the interior walls still hold in the motion of space — space remains enclosed, "walled in." In the Unity, however, space begins to move through the variances created by the individual connecting interiors as well as by the exteriors. This first Cubist step of

100

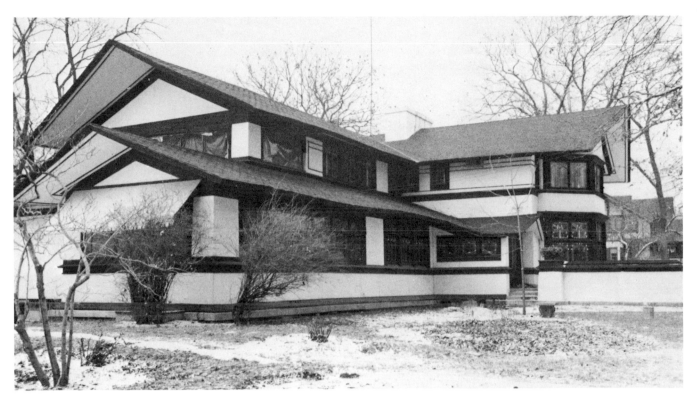

61. Frank Lloyd Wright, *B. Harley Bradley Residence and Stable*, 1900, Kankakee, Illinois, from *The Architecture of Frank Lloyd Wright*, copyright 1974 William Allin Storrer.

structural liberation, which first made its appearance on the exterior of the Larkin, now appears in both the interior and exterior of the Unity. But it is with the Robie horizontal planes, in spite of their incompletion, that one experiences planes literally sweeping out into an amalgamation with space. It was that great, daring thrust into space that set the stage for the kind of spatial freedom that already existed on the exterior, and which was indicating the viable future for architecture. Cubism was beginning to become Planism, just as had occurred a few years earlier in the landscape paintings of Cezanne. It would be well to think again before setting that down as mere coincidence.

Writers on Wright have failed to note the three principal directions through which Wright strove to release architecture from the obsolete cave form limitations of space displacement. The first direction began almost from the time he set up his own practice in 1893, as revealed in his perceptual attention to the sharply peaked and extended roof. Whether his interest in the roof stemmed from the influence of the Englishman, Voysey, is left to Hitchcock and others who think it is the case. Simply to state that influence is to miss the enormous difference in Wright's structuring of the sharply peaked roof. For Voysey such a roof served simply as a cover for a cave that happened to have a peaked roof. The considerably different structural perception such a roof took in Wright's hands was sharply evident in the two Kankakee Houses of 1900. Although the cave remained, the two planes of the roof (figs. 61, 62) sought to be just that — planes. The planes asserted themselves beyond the limited structure of the underlying cave, seeking to announce a new artistic principle, structurally to insert themselves into a new sense of space for the creation of new architecture. The solution, however, was not structurally complete, for the two planes joined to make a "form" still tied to the past. But there had been the beginning of a release from obsolete structuring, in that the limited simple rectangle had been parted in half, a structural development also apparent in Cezanne's Cubism. Hence the planes were not totally free as spatial structures. In the Unity Temple, three years later, the next development became apparent. The planes, incipient though they were, were strictly horizontal thrusts into space well beyond the limits of the underlying cave structure. If the planes were not limited by past structuring, their projection was not sufficient to assert a full encounter with a new structuring of space.

Two years later, in the Robie, the effort was made to resolve the problem posed by two different efforts to attain spatial release, to go beyond the incipient planes of both the Unity and Kankakee houses by literally compromising both. For the very first time in architecture, the thrust of the form of the roof became decisive space planes achieving a new sense of space structuring. However, this held true only for the underside of the roof plane, for its top side was released from obsolete structuring only to the limit a slanting roof permits.

For the first time in architecture, Wright was beginning a concerted perceptual effort to achieve new spatial structure as an integral aspect of the structuring motion of form and space itself. Planes were beginning to amalgamate with and into space, the new forms revealing a new structuring experience of space. It was now possible to take the final step and completely exclude the contained motion of enclosed cave structuring, finally to go beyond the excluding exterior space and locked-in interior space. The creative motion of structure could now be set free from the limited perception of the mimetic past, allowing space and form to move in and out of a work. As Wright put it, space "moved," space was "leaking" into and through the work. Contrary to Oud, Wright insisted that architecture must cease to be treated as sculpture, as cave, as Cezanne before him had observed that the new painting was being done in "caves" where "there are no planes." Wright would, in "terms of space," find what he called the "new forms." [321] There it was: no neo-Cubist nonsense about destroying the old form structuring, but simply giving extension to structure to realize "new forms." A new perception of space, Wright noted, had "to be realized." [322]

It is imperative to cease confusing Wright's structural achievements with the perceptually introverted and structural irrationality of neo-Cubism and all that flowed from it in neo-painting, neo-sculpture and neo-architecture. Yet even those sympathetic to the work of Wright claim he not only anticipated "cubism" but de Stijl and neo-plasticism as well. Indeed, Wright came to agree. Whether his work ever influenced such painters or not is left for others to determine. Nevertheless, it seems likely that Oud's theory of "cubism" was influenced by his misunderstanding of both the Larkin and Unity works, which were built several years before "cubism." We do a disservice to Wright's unique early achievements, which opened the way to a genuine new architecture, by equating anything he did up to the Robie with anything achieved up to that time, or since, in European art or architecture. What he accomplished was incomparably more important than anything any neo-painter, neo-sculptor or neo-architect could have even imagined. Wright alone in architecture, as Cezanne alone in art, opened the way to the genuine new.

Consider Wright's enormous accomplishments: with a few small buildings and a number of houses that evolved into the Robie, he all but realized a prototype, a "corner-stone," for a truly new architecture. Until Wright, there had been some (who knows how many) 50,000 years of architecture as mimetic evolution out of the original human shelter of nature's caves. Wright alone began to move out of that long period of limited perception, to commence a new and non-mimetic life for future architecture. However, that liberation from the cave would require rejection of the futile freedom of neo-sculpture arbitrariness which would simply dissipate the possibilities of a new architecture.

By concentrating on the house structure, Wright began the opening to the new according to the *natural order of perceptual development*. Putting aside the many varied early man-made shelters, concentrating on the single geometric form of the enclosed rectangle — which was to prevail in the western world and elsewhere — man's first imitations of nature's cave shelter could have begun with the roof; i.e., the lean-to as a one-sided roof later become two-sided. Eventually, with the need for more lengthy stops either by hunters or cattle farmers, there would occur the literal "raising of the roof" by placing a box-like shape underneath it. Thus, the early roof structure that simply sheltered man became the structure to shelter the shelter of man. In some such way the rectangular structure of the house could have evolved.

Wright's creation of the new house followed a similar-different perceptual development. The new structuring did not begin with the prevailing myth of the "open plan" for the interior. That procedure was not possible because you cannot "open" the interior without first opening the exterior, as Wright's development confirms. The last step that realized the mimetic house, the final cave enclosure, would comprise the first step for the new house. That is, it was the exterior, the roof as spatial plane, which released itself from the confining determinations of being locked in by the box or cave. Wright's various efforts to achieve this, as in the Kankakee Houses and the Unity work, have already been noted. The moment the exterior was released it became possible to release the vertical planes of the enclosed box. One could then begin releasing the interior space providing he did so with spatial planes. Thus the roof was released from being structurally locked to the walls and the walls were released from being structurally locked to each other and the roof — all would be space plane structuring. In short, the Wright development began on the exterior and then worked towards the interior. Both mimetic and non-mimetic architecture began with the structure of the roof: the former was completed with the placing of the roof by building up the planes to achieve a locked-in man-made cave; the latter began by releasing the planes from the cave into a new spatial world of architectural form.

When first confronted with Wright's work in 1910, Europeans, as their subsequent "boxing" indicates, were compelled to see him in terms determined by their perceptual conditioning to obsolescent space displacement, now fragmented by the neo-Cubist fallacy, inevitably resulting in the confusions of neo-architecture. It was this conditioned boxing that some American labelled as the International Style. Wright would have none of it and stood

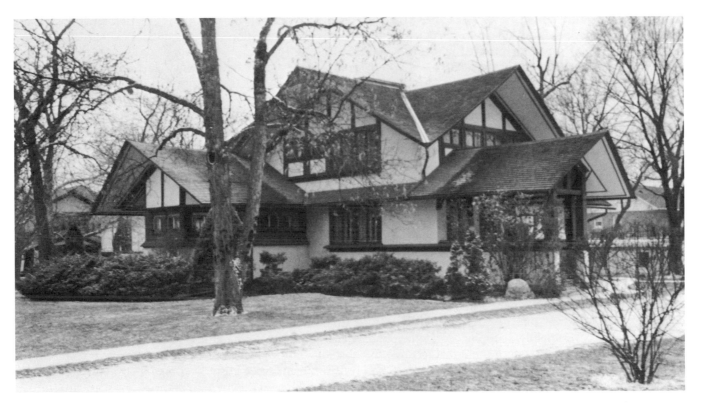

62. Frank Lloyd Wright, *Warren Hickox Residence*, 1900, from *The Architecture of Frank Lloyd Wright*, copyright 1974 William Allin Storrer.

alone in properly condemning it. He rightly saw that his influence resulted in a fallacious exploitation of his own work. No European was ever to comprehend Wright's evaluation of the International Style as being slavishly caught in the "traditional restraints" of the "box." [323] For the European innovators to suspect they were captives of the traditional seemed beyond belief. It was so in painting and sculpture, too. The European, unknowingly conditioned to his great past, was *perceptually unprepared* to comprehend what Wright built and explained as representing a new architecture. Indeed it appears that no European ever felt the necessity to respond publicly to Wright's criticisms.

Consequently, Holland, where Wright's work first met with so much interest, produced architects like Oud, Rielveld, van Easteren and Docsburg, who were to enforce the conditioning grip of the box more than any other European architects. One of Doesburg's 17 points on architecture refers to the "open ground plan," which Wright had first spoken of a quarter century before. Doesburg was never to achieve such an architecture, because he began with the interior. He tried to free planes in a box or boxes, and nothing was or could be spatially freed. Hence all his interior planes remained spatial captives of the exterior of the mimetic boxes, "planes in caves," as Cezanne put it, confirming Wright's correct procedure of first freeing the exterior. Thus, if Doesburg saw new architecture as "anti-cubic," no longer "one closed cube," he then contradicted himself by asking for "space cells." [324] Irrationally he was saying that one replaced closed forms with closed space. Calling space "cells" did not release space, but only emphasized that space continued to remain cubically enclosed. After all, you cannot achieve "space cells" with space alone, that is impossible: one must have closed cubes to make space cells. Structurally, Doesburg was reverting to a solution already dealt with by such English architects as Morris and Adams in the 18th century, a solution brought to a correct perceptual consciousness in Wright's Larkin work of 1903. No doubt he, like Oud, misinterpreted the Larkin, etc., with the confusions of neo-Cubism, for all he was proposing was simply to break up one cube into a plurality of connecting cubes for the exterior as if that were the final solution, as his architectural models plainly attest. Again that was the futile European solution, i.e., to compel the old to yield the new. Consequently, all of Doesburg's interior planes were "boxed in" by the space enclosing exteriors that Wright had called "cellular sequestration." Space was enclosed inside and displaced outside as in all past mimetic cave architecture. Wright had described the open ground plan as the development from "box," not to "boxes," and then to what he called the "free plan," as the means by which to arrive at the "new reality" of space. [325]

The great difficulty was that Wright was raising *perceptual issues* which were not recognized as such. European architects, like painters and sculptors, had lost their awareness of nature as perceptually indispensable,

indeed, inescapable. Wright never ceased to stress the necessity that nature was the "great teacher," [326] while Europeans, in the words of Doesburg, proclaimed that impossible condition of being "independent of nature." Wright knew the European neglect of nature assured they would "dedicate" the "box" to the "machine god," sometimes placing "flat boxes" on "stilts." [327] The last, of course, was a reference to Corbusier who regressed obsolete space displacement to the sixth side of the box.

Certainly the cave of ancient masonry architecture continued its conditioning role of sculptural structure in the International Style. As noted earlier, Giedion saw the new architecture as sculpture, as simple space displacement which was the most ancient of all forms of structural perception. A leading architectural critic wrote of "structure as sculpture" in reference to Breuer's architecture. Corbusier and Oud saw only the structure of "masses" as an "opportunity for sculpture." [328] Obvious as the old structural notion of sculpture was, literally staring one in the face all those thousands of years, yet it was hoped the old would yield the new. Not only did the evolution of the art of architecture, from England's architects to Wright's Robie work, indicate the necessity for a masonry transition to reach the new, but the failure of European architects to do so left them wandering in a confused effort to convert directly the art of masonry into the new. Consequently this left architects perceptually adrift with, at best, an 18th century perception. Like Picasso, architects "waged war" on nature. Corbusier saw the house as separating humans from the "antagonistic natural phenomenon." [329] Indeed he referred to nature as "hostile." [330] He saw architecture, even the city itself, as "directed against" external nature. As for his so-called indoor-outdoor solution of the 1920's and thereafter, all this was simply the old box structure and, contrary to his adulators, did not "suggest" a spatial or any other form of "advance" over Wright's early notion of the open plan. The reference to Corbusier's "hollowing" out the cube reminds one of the Constructivists' 19th century spatial fallacy, i.e., making visible the space presumably occupied by a solid cube. All this was part of the common perceptual irrationality of European art and architecture in the effort to force the obsolete old to yield the new. Bereft of a transition out of masonry structuring and experiences derived from nature, Europeans were literally compelled to conjure perceptions stimulated largely by *verbalistic* speculations in order to rationalize the manipulation of obsolete structure.

The telling clue to the perceptual failure of the International Style is to be found in the roof. It has been called the "modern European roof." The practice was, and still is, to lock the roof to the cubical walls like the cover on a cigar box, locking it more completely than any architect in the past would have done. Even the most humble of ancient houses was never so severely locked in the cave. Hence the achievements of the past are again regressed: it is a law. The only alternative to evolution is devolution. That is the price of perceptual failure, of introverting perception.

In 1933, Kaufmann titled a book *Von Ledoux bis Le Corbusier*. Hitchcock believed that Kaufmann would have revised his opinion if he had lived to see Corbusier's subsequent work, work that Hitchcock believed went beyond Ledoux. [331] What Corbusier eventually did, however, was to render the simple, sculptural space displacement of Ledoux into a primitive rendering. This is all too evident in such architectural abberration as his Chapel in Ronchamp and Notre-Dames-du-Haut. If ever there was a cave builder, on the order of Ledoux, it was Corbusier. In going from the stark mechanical to primitive, rough-surfaced structuring, Corbusier's life work ranged from a compulsive attraction to the stark mechanical to the opposite extreme of Gaudi's hysterical reversion to Rococo decadence of the Baroque. The frequent lapse of so much alleged modern architecture into the use of rough or non-mechanical structuring was but a confession that the attempt to use the machine to achieve human qualities in architecture had failed completely.

Like Gaudi's reversion to Art Nouveau, Corbusier's primitivism was structurally reducing the swirling lines into the bulky forms of sculpture. According to Hitchcock [332] and others, Art Nouveau was the beginning of modern architecture in Europe, when obviously, it reflected the dying spasm of Rococo. Indeed, from the swirling staircase of Horta to the work of Gaudi, such work only carried the Rococo decadence of Baroque to its final senseless extreme. Neither Horta's Art Nouveau swirls, nor Sullivan's skyscrapers and their swirling ornaments, constituted "landmarks" in the beginning of modern architecture, as Hitchcock believed, [333] unless we are speaking of landmarks of decadence. It is of significant interest that just as Italians had rejected the Gothic in order to take architecture further, so the English and, even more, the Americans were diffident about Art Nouveau. It was, as Hitchcock points out, primarily a concern of continental Europe. [334]

In these times of blatant confusion in architecture (and art), critics and historians circumvent the discrepancies and contradictions among the heroes of architecture by attributing all the contradictions to the "great" and "proud" individuality of architects, as if the discrepancies were the goal of architecture. Obviously, in spite of the style implied by the label International Style modern architecture was lacking any coherent direction in the sense always present in the great architectural periods of the past. Instead, we had eclectic high-jacking of the past by 18th and 19th century architecture in a capricious attempt to breakout of obsolete handcraft structuring by retaining the obsolete perception of the sculptor. So much is this the case that Kaufmann saw the whole era from Brunel-

lesche to Bernini as an era of sculpture when, in fact, architecture was dominated by the pictorial attitude of the painter's vision, not the sculptor's. Unable to account for the inconsistencies of all the attempts at a new architecture, one must respect Hitchcock's candid remark, that it was much easier to explain what architects were moving "away from" (is it?), than what they were "headed for."[335] Since this chapter was first written, the architectural scene has begun to fragment as the heroes of modern architecture are being denounced by former adulators. Not understanding why they were so mistaken, the adulators now would hasten us to the slogan of "post-modern" variants on once-despised 19th century architecture.

One European architect seemed correctly to have perceived the art of Wright — Mies. His work from 1912, just two years after Wright's work became known in Europe, to his 1929 house architecture was influenced by a combination of the Larkin and Unity works. Then, with no previous development in his own work to account for it, as was the similar case in Mondrian's 1917 works, Mies seemed suddenly to have discovered the Robie spatial planes — his 1929 Barcelona work. (fig. 63) He appeared to have grasped the essentially non-mimetic space structuring that first appeared in Wright's Robie work two decades before, but after a few more works in this direction further efforts became more and more structurally awkward and he abandoned this direction for good. The failure of Mies to sustain the influence of Wright was due to the fact that Mies was perceptually conditioned to obsolete structuring. Consequently he lacked that kind of structural perception which enabled Wright to achieve his extension of form and space in the Robie work. *Without the appropriate perception, such structuring could not be sustained and inevitably had to be abandoned. That too expresses a law: namely, you cannot sustain with one form of perception what really requires another order of perception.*

Mies had no alternative but to return, as Mondrian had in his own way, to his previous perceptual conditioning practice, i.e., return to the "traditional constraints" of the obsolete perception of the box. He was to do so to a degree beyond any boxing that had been done before, to the ultimate possibility — a single box. (fig. 64) Even admirers of Mies referred to his glass houses and buildings as "glass cages." The 19th century engineers who had led European architecture to the iron "line," to glass globing and doming mounted on the simple space-displacing of the box of a cave, had led finally to the "glass cage" of Mies, only now the walls of the box were glass, with the opaque roof sealing in the box. The cave now had glass walls instead of a glass roof.

Mies's glass cage was of a piece with the neo-sculptor's cube theory that space was purportedly "made visible" by dismembering the old form structure of the cube. As noted earlier, however, the problem was never one of whether space had to be "made visible." In the first place, there was all the unused visible space you could want. Then, too, space was quite visible in all past arts and architecture, including the neo-sculptors' solid cube. The real problem was not simply one of space, but rather of giving the viability of space a perceptually new structural significance. That could only be accomplished by giving the whole notion of form a new perceptual structure which would allow realizing the new space structuring a new architecture demanded. It would not do to take the old obsolete structural notion of form and simply render its opacity transparent with glass. Replacing an opaque cave with a transparent one solves nothing: it further obscures what really needs to be done. The neo-architect follows the neo-sculptor in that both simply give a reverse twist to ancient space displacing by substituting apparent form displacement for space displacement. However you view it, the old space displacing perceptuality is playing tricks on itself. In the impossible effort to dispense with form Mies was led to the irrational assumption that he could "refuse" to give recognition to "problems of form."[336] That could only be achieved with a presumably invisible work. In any case, the "glass cage" consisted of a combination of neo-painting and neo-sculpture. Where once the side corners of the cave existed, form was reduced to the primitive representation of line, while the roof and floor represented remaining undisguised fragments of the old space displacing box. If the globers, domers, vaulters of 19th century architecture disguised the top of the old box with glass, Mies similarly disguised the sides. When form is regressed, space and light are regressed. It is a law of structure — extensionalize or regress.

The 19th century engineers who were the first to exploit the new means for structuring were, in fact, the first neo-sculptors of Europe. Later the neo-sculpture attitude was adopted first by neo-architects, then by Futurists, and finally by Russian Constructivists. Hence the practice in both art and architecture of not visually concealing the new means and materials, (out of which Mies made a career), dates back to Eiffel and Paxton and even earlier. It was assumed the new materials automatically possessed the "aesthetic" visibility that would characterize the new art and architecture; by analogy, as if the bones would better represent the depiction of the human figure. Instead of a new perception determining the creative structuring of art, i.e., the art determining the use of materials, the new materials merely offered new structural means in which the new art was not automatically present. Europe's artists and architects of the machine, like constructivists, looked to industrial materials themselves arbitrarily to arouse the formation of art. What would we have thought if painters claimed their brushes, paint and canvas inspired the formation of their art? Was that the claim of the so-called abstract expressionists? It seems, after all, Ruskin was not entirely mistaken when he scorned the use of iron for the art of architecture and

regarded engineering as so much "vile construction." Yet even now we still hear architects talking about "innovating engineering," "engineering aesthetics," not about the innovating art of architecture.

For example, Mies had the peculiar notion of the "bones" being visible through the transparent "skin," the European neo-architectural error of making the old space displacing transparent. This is of interest in connection with his outline for an educational program for architectural students, in which he proposed a progressive introduction to the use of materials from wood to stone to steel. (Note that wood and stone are the old handcraft materials.) In any case, like a Constructivist, he insisted it was impossible to "design" a building before one completely understood materials. One need not point out the historical evolution of the art of architecture was not one of understanding materials first, but rather the *creative evolution* of the *art of architecture*, which then determined the evolutionary use of materials. It was the creative understanding of art which determined the proper understanding of materials. Mies usually spoke of materials, function and creation, in that order, the last being the subject on which he had practically nothing to say.

In fact, the teaching method of Mies was one taught more than a century earlier by Durand, professor of architecture at the Ecole Polytechnique,[337] and also by even earlier advocates of this method when the Baroque cycle of architecture was closing. Durand, too, insisted one must first understand materials and construction; then one could deal with the forms he would construct. The form, however, was then based on the sculptural attitude of Boullee, an obsolete practice continued to this day. About Mies, however, we can say he reduced Boullee's sculptural attitude to the primitive geometric minimum and then encased it in glass. Reliance on materials was also the error of Perret. He, Hitchcock reports,[338] sought to convert concrete in the way those before him had done with masonry, i.e., the material would supply the "expressive" means for a new architecture. Was not that the task of art? To seek salvation in materials, as such, was the characteristic alternative chosen in times of crisis ever since the demise of Baroque architecture; i.e., whenever the evolutionary development of the art of creative architecture became obscure and confused, the dilemma was circumvented by seeking arbitrary "creation" with materials themselves, both new and old materials. The resultant confused diversity and contradictions, that "murky chaos" of our times, was then given substantiation by rationalizing it as the product of "great" and "proud" individuals. Thus art and architecture were literally centered in the artists and architects themselves; the artist, not art, was the hero.

63. Opposite page: Mies van der Rohe, *International Exposition 1929*, Barcelona, Spain, German Pavilion, photo courtesy Mies van der Rohe Archive, The Museum of Modern Art, New York.
64. Above: Mies van der Rohe, *Lake Shore Apartments*, 1951, Chicago, photo Hendrich-Blessing, Chicago.

Mies' emphasis upon materials led to his emphasis upon function which, in turn, led to a peculiar conclusion. Namely, the function of all buildings must no longer be definitive but "universal." Thus, a work of architecture would then be amenable to any possible future function. Such an installation of what is, in fact, an amorphous function permitted Mies to conclude that such a work of architecture could be a work of "pure art." This is not possible if a work is to be architecture. To be "pure art" demands the work be free of any utilitarian demands, even the amorphous capricious ones of so-called "universal" function.

Perhaps no material promised so much, yet did so much damage to the realization of a genuine new architecture, as did glass. It has been used either to give transparency deception to obsolete structuring or simply to perforate the same old squares or horizontal slits in the same old boxes. More than anything else, glass has been used to perpetuate the fallacious notion of structure as "formless." This has gone so far that Doesburg's followers now claim they do not "use form" in their architecture. Of course they are compelled to use form if their work is to be visible. However, they refer to their rectangular structuring as simply "describing space areas," as if form had been perceptually neutered along the lines of the perceptual myth of neoplasticism. Form is supposedly shorn of its capacity even to "describe" itself but, without form, there cannot be space expression. That would be obvious but for perceptual conditioning. Such apparent contradictions result from the attempt to jump in one leap from obsolete masonry to structuring with planes. The latter option, however, is chosen on the basis of wholly verbal rationalizations not resulting from perceptual experience based on the vision of nature and architecture. Consequently spatial attributes given to the planes are not the result of actual space perception, but of rationalizations with words. Thus we hear a prominent architect speak of space as "more important" than what he calls "structure itself." But there is no such thing as structure unless there are forms to do the structuring, just as space is without structural significance unless there are forms to structure it.

Was the Doesburg-Mies myth of the "formless" born in the Eiffel Tower? In his recent book, Banham went into rhapsodies about the Eiffel. He believed that architecture had not yet "equalled" what he called the Eiffel's "space machine," where he found space reaching to "infinity." But what is the Eiffel except an engineer's transparency line drawing of what is obviously obsolete space-displacing form? Erected on such a large scale it gives the impression of space simply passing through it. No wonder that Banham was able to experience the space "flowing away" and spilling through the structure to infinity. Space was simply passing through a mere sieve,

structually unaffected by the Eiffel.

In his essay on the "Three Revolutionary Architects" of the 18th century, Kaufmann saw Boullee, Ledoux and Lequeu as the precursors of modern architecture.[339] But of what were they the precursors? Blondel, the teacher of Boullee and Ledoux, thought of structure in the terms of a sculpture-architect,[340] which resulted in regressing an obsolete form of structural perception. He flatly rejected the painter-architectural attitude which had carried architecture to the close of the Baroque. Indeed, Blondel rejected the English Picturesque attitude as a form of insanity.[341] For him, the natural no longer meant nature, but merely the functional nature of materials themselves.[342] Materials were the source and directive for the inception of a work. This constructivist attitude among artists and architects has become a form of fanaticism in the present century.

In effect, nature was replaced by the artist who presumed to become his own nature. Eclecticism then stemmed from the overrated importance given to the architects' individuality, rather than from the unique individuality of the times determining the art of architecture. True, at the 1927 Stuttgart Exhibition there actually existed a unified style which permitted the label of "International Style," but the unifying factor was one of boxing everywhere, so much so that viewers were depressed by the monotony of the visual result. If a similar exhibition had been held 30 years later, once more displaying the grouping of works by Mies, Corbusier, Gropius, etc., and this time devoted to their later works, it would be hard to find a unifying label for it. Viewers would then be disturbed by the chaotic disparity, the lack of any unifying effort. Obviously the *art* of architecture had ceased to be a unified expression of a particular time as was characteristic of the great past. To the contrary, architecture had become the expression of would-be autonomous individuals. In late 18th century Europe, as in the present, architectural chaos reigned. Then, as now, it was thought the past was "exhausted" and altogether useless, and, as Blondel assumed, only "novelty" and the "extravagant" would suffice.[344] Similarly our century confuses fashion with creative innovation. Is it any wonder Blondel's pupils, such as Boullee, looked upon the works and knowledge of past great architects with contempt, wishing to sever themselves from the past, (something impossible to do), and believing the real business of architecture was about to begin?[345] Our century harbours the same delusion. Recently an architect expressed the view that architecture now "transcends history and culture," that it is a "force in itself." In such a view the present is disposed of along with the past. However, as Robert Penn Warren understood, "History is what you can't resign from."

As the 18th century approached its close, the chaos of architecture divided architects into those who despaired at the absence of continuity with the past and those who saw this absence as an open sesame to "unlimited freedom,"[246] an attitude still prevalent today.

It is no mere coincidence the Baroque period, the last unification of the arts on the European continent, was followed by the period of functionalists like Lolodi and Ledoux,[347] a period when the very necessity of art in architecture was called into question, as with functionalists like Loos and others in our century when a similar kind of confusion reigned again. Thus architects in our time believe that the more perfect the function the more "beauty" is gained. As Taut saw it, if a building functions well, "it looks well," because utility arouses its own aesthetic laws.[348] In that case, the engineer dispensed with the need for an architect.

The architectural times of Ledoux, which Kaufman erroneously understood to have "anticipated" the future,[349] certainly had similarities with the present; i.e., the lack of a unified direction of architectural development which characterized all the great cultural periods of the past. Consequently the work of such as Ledoux would range from Baroque to classicism or mixtures of both to the "revolutionary" work Kaufmann attributed to him. The revolutionary works, however, were really the result of Egyptian influences and do not, as Kaufmann believed, have only "insignificant similarities" with the past.[350] Similarly alleged revolutionaries of today wander in different directions from work to work exploiting the "murky chaos." In that sense, then, the French revolutionaries of the 18th century were indeed the precursors of our times. The architects today simply continue a further regression of the obsolete sculptural perception. In recent years architects have sought to manipulate the space-displacing structure of the box by resorting to all sorts of inane projections and recessions with a capricious exploitation of geometry in order to be noticed in the "murky chaos" of cities. Thus a leading architect speaks of using "voids" to "break open" what he calls the "volume" in order to displace what he calls "mass." What this amounts to is again to disguise the continued use of space-displacing form by resorting to the destructive method of neo-Cubism and the neo-sculpture of constructivism.

Similarities abound. For instance, it is no surprise that Blondel's teaching led his pupils eventually to become "disillusioned" and then turn "reactionary."[351] This was not a consequence of social conditions, as Kaufmann wished to believe, but rather because the obsolete sculptural perception ended in a cul-de-sac, as is happening in our times. In a recent article, Huxtable reports on a conference called "After Modern Architecture."[352] We learn that not a single architect at that conference had a solution to offer for solving the mess of modern architecture. What seemed to emerge was a state of "confusion," "uncertainty" and "fear" accompanied by a "rising recanta-

tion'' of modern architecture, the latter having led architects into a state of ''anxiety,'' ''frustration'' and a sense of utter ''crisis.''

Kaufmann having correctly observed the gradual evolution of 18th century English architecture then all too quickly turned his attention to the French ''revolutionary'' architects of that period. He then observed, again correctly, not the gradual but the ''sudden,'' the ''spectacular,'' the ''radical'' changes of the French architects. The contrast should have given him pause for reconsideration. He might then have seen that the ''sudden'' changes made by the French were not the result of an evolutionary development, as with the English, but were the result of desperation, of crisis, which could not and did not lead to a viable future. Modern architecture has similarly emerged from a state of desperation and crisis. Is it then surprising that we see telling similarities with the 18th century? Just as Blondel's pupils, following his regressive return to *simple* sculptural space displacement, were led to a dead-end, thus turning ''reactionary'' in place of ''revolutionary,'' so too a similar reversal is taking place in modern architecture.

The confusion that has characterized modern architecture from its beginnings to the very present is revealed in the fact that the machine and its new mass-produced materials were used to disguise as the new the old handcraft space-displacing structure of masonry, while in recent times those like Mies, lacking adequate comprehension of the new means, resorted to all kinds of fussy and expensive handcraft methods to simulate the machine-made. Basic to the failure of modern architecture has been the loss of a coherent historical understanding of the evolution of architecture. Hence, among the overly anxious radicals of the present are those architects who indulge in the absurd effrontery of thinking they ''transcend history and culture,'' under the wish-fulfillment belief that architecture is an autonomous ''force in itself.'' As Santayana observed long ago, if we ignore the past we are ''condemned to repeat it.'' Actually something much worse happens. We are condemned to regress the past. The works of Ledoux and Boullee never realized beyond the paper on which they were drawn. Our century has not been that fortunate and our cities are being visually-physically polluted with architectural monstrosities.

* * * * * *

It is important to consider the European architects who lived the latter part of their lives in 20th century America. Not a single one ever freed himself from his European cultural burden, in spite of the very different environment of America. An admirer observed it did not matter to Mies where he lived in America; it was probably a coincidence he lived in Chicago. Mies, he continued, saw little of the city, confining himself to cab rides between his apartment and his office. In that way, it was explained, Mies ''preserved his insularity.''[353] Did he feel his Europeanism so intensely that he felt it essential to insulate it from the influence of the American environment? Yet America gave him all that Europe had denied him, all the ground he wished to build on, but it follows that what he built could just as well have been built if he had never left Europe. One has only to look at his unbuilt European projects from 1919 to 1928 to see what he wished to build in Europe — much the sort of thing he would build three and four decades later in America. European architects could not do other than remain European-oriented. It is just that fact, however, which was to have a disastrous effect on the course of American architecture. The problem of the European architect migrating to America was already understood by architect Vaux in mid-19th century. Noting the majority of architects were not born in America, he observed they had much to ''unlearn'' before they could produce an architecture inspired by the new conditions of America. Vaux's observation is equally valid now: there were ''buildings'' in America but, he asked, ''Where is the architecture?''

As for the position of Wright during the time when established European architects came to live and work in America — after becoming famous among the younger European architects of 1910, his influence was all too soon replaced by the boxing of the International Style. His influence on American architects vanished with the demise of the so-called Prairie School around 1914, for which school Wright had little enthusiasm. Thus American skyscraping went on its way, and house architecture became as mediocre as possible, with Wright's achievements all but forgotten. Writing to Europeans in 1925, Wright remarked that in his country the term ''artist'' was literally ''shunned'' by the ''commercial field.''[354] According to a Museum of Modern Art catalogue for an exhibition titled ''Modern Architecture,'' the 1925 ''Paris Exposition of Decorative Arts'' did not include a single American architect because their work was not modern enough. Wright, as modern as anyone else, had been completely ignored. However, between the two world wars modern architecture was generally rejected in America.

Into this vacuum of the 1930's, leading European neo-architects came to fill the place of Wright and to teach young American architects. This was disastrous, for the Europeans could do nothing more than to brainwash the naive American students with their own unconscious conditioning to mimetic perception. By the 1950's, American architecture was dominated by these Europeanized neo-architects. Thus the obsolete sculptural and cave perception prevailed while the Robie House was forgotten.

65. Piet Mondrian, *Salon de Madame B a Dresden*, courtesy of The Pace Gallery, New York.

That being the case, does it matter what originated in Europe or in America since the 1950's, as some have asked? What is significant is what became common to both. Americans were unnecessarily sharing the Europeans' cultural burden as neo-architects. While it was extremely difficult, if not impossible, for Europeans to comprehend Wright, it was quite easy for the young Americans to succumb to the particular regressions of their European instructors. The price was that young American architects ignored their own uniqueness. Willy-nilly they joined in the tragic defeat of Europeans, whether artists or architects.

The indisputably American achievements of Wright were all but forgotten, at best receiving lip-service. His marvelous adventurous works of 1893 to 1908, which addressed themselves to the unique reality of a genuine new architecture, were now tragically ignored. No one seemed to listen to Wright's appeal that the American discern his own unique potential to realize new architecture. Wright had protested the influence of the European teachers, because he found architecture in America speaking in a "foreign accent." [355] The accent was that of European neo-architecture which Wright correctly characterized as "still 19th century." [356] Architecturally speaking, American students had their eyes and ears "boxed" by Europeans.

* * * * * *

In the very midst of this division between what Europeans had to do and what Americans could do, lies the art

110

of painting. The problem is of such importance that the future of architecture rests on understanding the relation between painting and architecture.

Wright achieved his great discoveries before the appearance of neo-Cubism, neo-painting and neo-sculpture, all of which were to have such a devastating effect upon European art and architecture. Apparently Wright was the only one not influenced by such art. After all, nothing of significance was taking place in American painting and sculpture. Wright held Renaissance architecture in very low esteem, and blamed its failure on what he considered the decadent influence of painting. In his view, painting since the Renaissance had been "getting nowhere." [357] He believed the Renaissance "picture triumphed" over the art of architecture. The consequence was that for five centuries the "art" of architecture "declined." [358] It had been "dethroned" by the decadence of the Renaissance. He was certainly correct about the dominance of painting, just as he was incorrect about its decadence. [359] His admiration for the Gothic, that period when the flow of western art and architecture was interrupted for a thousand years, led him among other things to prejudice his judgment of both Renaissance art and architecture.

As for the 20th century, Wright concluded that European architecture was inspired by the "surface" and by "mass abstractions" of French painting which repudiated the third dimension. The result was "surface" rather than "depth," as if the architect were making a painting. [360] As noted earlier, however, it was the 19th century engineers whose work first introduced the fallacious structure of the "line" and two-dimensional structure which prepared the way for the European architect to succumb to similar structuring fostered by the neo-painting of de Stijl and the neo-sculpture of constructivists.

Wright saw European architecture as lacking any "architectural principle," as "mere decoration," "still 19th century" in its effort. The influence of neo-painting, aside from neo-Cubism already discussed, takes a most obvious form in a "room" and a "Stage Set" by Mondrian, along with the architectural works of Doesburg — works which took place some two decades after Wright's work became well-known. Walls, ceilings, floors, inside and outside, all became surfaces for making paintings. "Planes" appeared inside, "boxes" appeared outside, some surfaces were broken into a division of two primary colors, as if to paint away the forms with illusion as a substitute for the reality of form. There is a perceptual conflict between the illusory structure of painting and the reality structure of form. (fig. 65) The two-dimensional fallacy is carried to the extreme. A year before his death Mondrian was still insisting that architecture was a two-dimensional experience. He saw both exterior and interior as an "impression" of one two-dimensional plane followed by another two-dimensional plane, [361] but planes, however, could not escape the third dimension of form or the third dimension of space. Unlike Renaissance painting, painting itself had become structurally obsolete for the new art as well as for the new architecture.

In acknowledging their debt to painting the neo-architects of Europe were correct in principle. Their error was in responding to destructionist painting. Wright, while he was correct in denouncing the destructive painters, was incorrect in denouncing all painting as not relevant to the problems of architecture. Hence there are the common goals he shared with Cezanne, and these are most marked. Cezanne saw the need for a "new vision," and Wright maintained such a vision had "to be realized." Both insisted their respective arts were "not sculpture." Both found the source of their art in perceptual nature by achieving perceptual extension for the structure of creation. Both found their contemporaries limited to the "cave." Both "translated" their perception of nature geometrically into the new spatial needs of the new arts. Cezanne designated the geometry of the sphere, cylinder and cone, and later of the cube. Wright designated the cube, sphere and tripod. [362] Both achieved a Cubism by which to reach the Planism of the new. Clearly neither Cezanne nor Wright are to be confused with the confusion of the neo-arts and neo-architectures of Europe or America.

The world of art and architecture has paid a horrendous price for distorting the work and theories which Cezanne left in 1906, and for doing the same to Wright's achievements up to 1908. It has meant that American artists and architects continued the defeat of Europe instead of continuing the perceptional evolution of art and architecture open to the American alone.

If architects both in Europe and America failed to recognize the painting which could determine the particular creative nature of their own art, instead of following the example of destructive painting, more recent development should help to clarify this problem because the perceptual transition to the new had arrived at a form of structuring common to the architect. The transition begun by Monet and Cezanne has been completed. The consequence is that the "new art of light" has become three-dimensional and thus structurally similar to the structure of architecture. Reference is being made here to the new art presented in the previous chapter, a non-mimetic art created in the full three-dimensional reality of form, space and light. It offers a clear base for continuing the new architecture which Wright alone began. The new art offers the young architect the creative and artistic principles with which he can continue the work of Wright so that architecture can free itself completely from cave architecture that was obsolete long before this century was born.

The new art will teach the young architect as Wright taught; that nature is the supreme teacher, that architec-

66. John Root, *Monadnock Building*, 1889–92, Chicago, photo Richard Nickel.

112

ture is nothing without the artistic principle as its supreme reason for being, that function is only invention applied to mechanical problems and must not be confused with art and/or creation, that when the art of architecture submits slavishly to function it commits suicide. *Art is the function* to which all other functions must submit if they are to be *humanely functional*! The artistic principle determines function, reversing the motto of skyscraper Sullivan.

It is possible to cease that alleged architecture whose god is function, that architecture which is fast forming the madness of *The Brave New World* Huxley warned of more than fifty years ago. (figs. 64,65,68) It is possible to cease machine architecture which makes man a machine, which has visually glutted our dying cities everywhere. Cities now condemn millions to work and live in "cages," where air, light and space are monotonously maintained, where all the variances of the natural reality so essential to the creative variances and health of human beings are absent.

The new art of light opens the way to a new architecture of light. There will be a new creative forming of space in the light. The new arts of light can be sustained perceptually and creatively into what appears an indefinite future of evolution. It will become possible for all the visual arts to join with past three-dimensional artists, the great sculptors and architects who did not ignore color, who recognized the supreme goal of visual art as optical. Once Wright's artistic principles are secured again, the young architect will no longer be falsely urged to beat the drums of functionalism and primitivism. Wright was the first to meet the new problem of art and technology. Banham tells us that Wright was the first to use environmental technology as a natural part of architecture;[363] he cites the Baker House of 1909 and the Robie House of 1908. He points out that Wright did not allow technology to dictate; to the contrary, he used technology to liberate the structural creation of architecture as a "new art." As opposed to 19th century architects who pirated everything from the past, modern architects arrogantly claimed to be free of any influence from the past. That claim sealed their doom. Like modern sculpture and painting which are both obsolete forms of art, which began by denouncing realism only to come full circle to the most despicable realism possible, so modern architecture is coming full circle to bald variations on the once despised architecture of the 19th century.

* * * * * *

Richardson and Sullivan should be replaced by the truly great American architects, Root and Wright. Almost ninety years have passed since Root's death. He still has not been recognized as America's first great architect. Wright knew of Root's worth; he said that Sullivan taught "me nothing,"[364] and spoke of Root as a "genius,"[365] who would have been the "greatest" of his time if he had lived.[366]

A most extraordinary event took place a decade before Wright opened an office. It was long before anyone had heard of modern art or modern architecture. At that time only one American, Root, understood the significant for art and the art of architecture of a new kind of painting being formed in both England and France by such painters as Turner and Corot. On the basis of the little that was then possible to see, Root envisaged nothing less than a "new art" and a new architecture.

In 1883, Root published "An Art Of Pure Color." This was more than three decades before de Stijl painters and architects sought to recover the ancient practice of coloring architecture. Root, however, did not have in mind either the neo-painter's or the neo-sculptor's notions of color, but an art of light; an art that was to be realized more than a half century later in mid-west America.

Root felt that in the "new light" he saw emerging in European *landscape* painting, artists had begun a search for a "more truthful art."[367] This discovery could only be made by an American who was free of the European's cultural burden. He was not advocating some version of neo-mimesis, as others in Europe interpreted the new painting, even when it fully emerged in Monet's Impressionism. He made clear that what he meant was an art consisting specifically of "pure color" which would form a truly "new art."[368] Amazingly, he was anticipating a non-mimetic art, not from the vantage point of Paris, but in the raw cultural environment of Chicago, 1883, a city barely rebuilt after the devastating Chicago fire only a decade earlier. This "new art" of "pure color," Root explained, would create forms "scarcely dreamed of," and art that would be "similar . . . to music." Like music, it would have qualities of "tone," "loudness," "softness" and would be "rhythmic."[369] In every word he used to express himself there was not the slightest hint of some neo-mimesis, but only of a non-mimetic perception of art and architecture.

In his Monadnock Building, Root had intended to render the exterior surface in three colors. It was the first such building to have clean surfaces uncluttered with the disguise of decoration. (fig. 66) The colors were to be yellow, brown and black,[370] but unfortunately, the client would not permit the use of colors. Root's intentions, however, reveal that he had made an important discovery: i.e., when the forms of an architectural work have clean surfaces they invite the full use of the art of architecture, use of colors of light, not the colors of building materials.

67. *Megaliths, France*, The Field Museum of Natural History, Chicago. The first great architects of natural stone. The exterior-interior are one. The future of architecture is inherent in this large scale building of man.

He understood that architects could again possess the use of color, that art of light which had once been present in every work of architecture. Upon seeing Root's studies for the 1893 Chicago Fair, a visiting English artist described them as having an "exuberant, barbaric effect" with "lots of color."[371] No question about it, Root saw future architecture as colored in the light colors of the painter, not in those of materials.

Certainly Root's early death had tragic consequences for the future of American art and architecture. If only he had been permitted to continue as the head of the planning for the Chicago Fair. As it was, his premature death in 1891 permitted the decadent New York architects to take over the planning for the Fair and virtually glut it like a Latrobe with vacuous cake-like neo-Roman buildings. (fig. 54) New York architects would henceforth dominate future American architecture. The results that followed not only accelerated the further decadence of skyscraping but inflicted a similar consequence on house architecture and interiors. The great promise of the machine and its materials for a new architecture would now be completely hidden by a mountain of masonry rubbish, namely, the absurd neo-Roman imitations of handcraft masonry as the new disguise for engineer building.

What had happened to the great promise of the American's natural response to the machine, by which he made a natural transition from handcraft to machinecraft long before the Europeans? Where was the new art and new architecture Root foresaw in the 1880's? Recall that by 1851, as Giedion pointed out, Americans had mechanized most of their handcrafts. On seeing these machinecrafts at the 1851 London Exhibition, Europeans were both surprised and impressed, not only by their simplicity but also by their "fitness for purpose"[372] without resort to "ornamental embellishments."[373] All that was in sharp contrast to what the Europeans were doing, for they were subjecting the machine to the destructive task of imitating the great handcrafts the machine was supposed to replace, not imitate.

Four decades later, at the 1893 Chicago Fair, everything was reversed. The American juries gave all prizes and

114

68. Mosha Safadie, *Habitat 67*, Montreal, Canada, 1967, photo Mosha Safadie.

awards to the "heavily ornamental" articles from Europe.[374] Henceforth Americans followed in the direction of the defeated Europeans by also simulating handcraft with the machine, just as a century later American artists would follow the Europeans' compulsive attachment to the obsolete arts of painting and sculpture, *even simulating them with machinecraft*. Architects would similarly follow with their obsolete structuring of space-displacement. The New York architects who had taken over after Root's death had done their job well. They were determined from the beginning to reject what they called anything "new" or "original;" determined that all the arts should follow their destructive intention of simply emulating (regressing) what the past had already done. New York, which became the center for American art of painting and sculpture in the 1870's, now became the center for regressive architecture in the 1890's.

Wright had ample reason for denouncing New York. He saw it as crushing and corrupting men of talent, as assuming that nothing "arrives" until New York "has seized it."[375] Five years before the Chicago debacle, in one of his last publications, Root had warned of the danger to American art that was taking place in New York, then only the center for painting and sculpture. He warned that fashion was "false" to the artist, "killing" while promising "life" to art. Most importantly, he saw that fashion "destroys" the "continuity" and the "development" of art. Fashion, he said, was a power thrown away on "insignificant" efforts.[376]

Root did not live to see the art of architecture submitted to the stupidity of New York fashion mongers. In any case, he would not have been deterred from his view that American architecture would become "phenomenal" in the context of the world's history[377] for, had he lived, he would be achieving his own development towards that end, soon to be joined by Wright and his achievements.

What was it that convinced Root of the future promise of art and architecture in America? Considering the time and place in which Root worked, and the not impressive state of American art, his observations and assump-

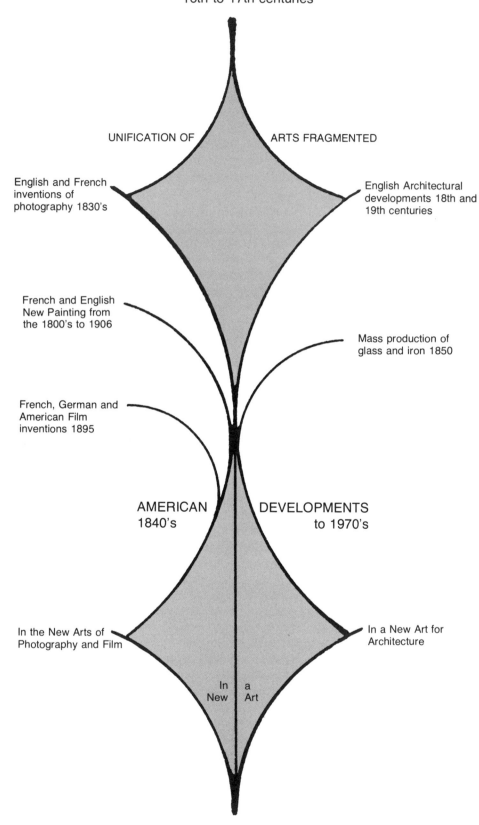

EUROPEAN DEVELOPMENTS

Italian Painting and Architecture
16th to 17th centuries

UNIFICATION OF ARTS FRAGMENTED

English and French
inventions of
photography 1830's

English Architectural
developments 18th and
19th centuries

French and English
New Painting from
the 1800's to 1906

Mass production of
glass and iron 1850

French, German and
American Film
inventions 1895

AMERICAN DEVELOPMENTS
1840's to 1970's

In the New Arts of
Photography and Film

In a New Art for
Architecture

In a
New Art

UNIFICATION OF ALL VISUAL ARTS

116

69. *Carnac Rock, Aligment, France*, photo The Field Museum of Natural History. As an architect man became one with his perception of form and space in his genetic experience of nature's light as lunar.

tions were remarkable. In 1888, Root wrote that it was the American artist who was most free of the "shackles" *of tradition*, in a great and "significant sense."[378] For that reason the American could approach the European tradition "from without," which would be reinforced by the consequent advantage of a "clearer vision." He would then be less "fixed" (conditioned) in his perceptions than the European, more ready to "receive impressions" (perceptions), hence more able than others to realize the "new era" which a new art and new architecture would bring.[379] Understandably it was hardly possible in 1883 to perceive that Europe's reign in art would collapse in another fifty years or so, and Americans would then have the opportunity to continue the further evolution of art and architecture. Root did, however, have a remarkable presentiment of Americans playing leading roles in the future of art, indeed greater roles than Europeans, because they were more free from being "fixed" to the past. In 1919, Wright felt the "real American spirit" would be formed in the West and Mid-West.[380] A quarter of a century later, while living and working in Paris, the present writer independently came to conclusions similar to those of Root and Wright with regard to the Mid-West alone.

Root saw the new architecture of the future as possessed of a "new spirit" and a "new beauty" which, while it emerged from the past was "not tied" down by it. While studying European "tradition" the American would not be "enslaved" by it.[381] Throughout all aspects of Root's reasoning there was the recognition that the American was more free to take on the "new era" in both art and architecture, because he was less conditioned by the past than were Europeans. Root recognized that it was precisely the fact that there was "nothing,"[382] no great American art past, that made possible the future greatness of the American arts. For the American was free of any "artistic tradition,"[383] permitting him to be more responsive to a future "new era." In short, the American was simply not fixed in "grooves."[384] In other words his future was not predetermined by conditioning as was the European's. Root, in 1883, could not have asserted such unorthodox views for the future of the American artist and architect without an intense insight into the potentials for a great and fundamental change in future art and architecture. Only such an insight could have permitted Root to discern that the future advantage of the American would lie in the fact he had no significant tradition in his past arts. It is evident today that those not deeply involved in a great era of art that is ending are better able to cope with an upheaval of such enormous change as that from mimetic to non-mimetic art and architecture. Certainly it was extraordinary that in his time, Root alone had such perception of the future.

Having shown the American that he was more free than others to meet the future head-on without compromise, having indicated the new art as one of "pure color," more specifically an art that will be only "of itself" and not a "slave" to anything else [385] — a non-mimetic art — Root then attached an extremely serious warning: namely, that all the unique advantages of the Americans would be utterly useless and would end in failure and defeat unless the pursuit of a new art were based on a new perception of nature. As Europeans discovered the relationship between art and nature was fragmented and useless, they responded by inverting perception. Root, like Monet and Cezanne, saw the imperative need of *giving extension to the extroverted perception of nature*. The new artist, he wrote, must study "nature's methods," thus acquiring an appropriate perception which no longer imitates nature's creations but instead perceives nature as a creative process. This was emphasized when he stated such a perception of nature would lead to an "organic" architecture. Root urged the artist to perceive the "natural laws," revealing the "primary" importance of nature,[386] the necessity "continually" to return to the study and experience of nature and "nature's methods.[387]

A few years later Wright would also stress the need for an "organic" architecture; the need to perceive the "natural laws," the "laws of creation,"[388] through the study of nature. As early as 1896, Wright said the new architecture would have "no prints or pictures," suggesting a new form of art which would eliminate the "easel picture,"[389] would arise with the new architecture.

It is a great tragedy for American art and architecture that Root did not live to develop his remarkable insights into the future. But there is that even greater tragedy, the price American art and architecture has had to pay for ignoring the substance of Root and Wright. Today's American art and architecture is misled by the acclaim Europe accords it. After all, Europe sees itself mirrored in the American effort at neo-art and neo-architecture, both continuing the obsolete forms of art.

* * * * * *

For more than a half century something else has waited to be said for Wright. It was only after Europeans saw his published works in 1910 and 1911, that there was anything in Europe which could be called "modern" architecture. One has only to place the Larkin, the Unity, the Robie next to anything done by any European up to that time, to see the enormous *perceptual* difference. Until Wright, Europe's architects were in an uneasy state of mind between the mimetic masonry handcraft of the past and the machinecraft structuring released by the new technology and the engineer. After Wright came the "box" architecture of the International Style to serve the "machine god," and Wright's early works were virtually forgotten.

For five centuries Europe had been the center for all the great handcraft arts of the western world; understandably the Europeans could not escape this long period of conditioning. Indeed the Europeans' conditioning to the past's obsolete perception was so complete they were only subconsciously aware of it, hence the insults hurled against their own past. They could only "do battle" with their past and nature. Their retreat into introverted mimesis prevented the Europeans from perceptually comprehending Wright as he was instead of distorting his work with the irrationality of their inverted neo-Cubist perception.

Early in the effort to glorify the machine and machine materials, the disastrous view was taken that future architecture, a new architecture, was free of the demands of "historical continuity" and therefore architects miraculously had become free to begin architecture anew, apparently out of a vacuum. Hence there was no awareness that a transition from masonry to machine architecture, such as that achieved by English architects and Wright, was absolutely essential. The inescapable consequence was to insure that architects would be left only with the old obsolete perception which would then be regressed and remain buried deeply in the subconscious. Modern architecture *continued* the decadence of, not a development from, past architecture.

For all its modernism, architecture was no more genuinely new than were the obsolete arts of painting and sculpture. Just as the latter regressed the obsolete subject and/or structure of mimetic perception, so architecture regressed the obsolete mimetic structure of cave architecture.

Hitchcock saw Sullivan as so many others did, as the first "great" modern architect,[390] as the most creative designer of the 19th and 20th centuries, and regarded his Guarantee Building as the "prime" architectural monument since the early 18th century, when Sullivan in fact led modern architecture to its certain defeat. He was not the truly great architect that the youthful Root and Wright were. Both saw a future that has survival value. Sullivan did not. He was destructive to the future.

France, Germany and Holland may have been the places where "modern" architecture originated, as Hitchcock believed,[391] but the art of future architecture was born in Chicago, in the houses of Wright. Hitchcock reports that Loos dominated domestic planning after the first World War,[392] after the first flush of Wright's European influence had begun to fade. In contrast to Loos' low opinion of the future role of art in architecture, it was Wright who opened the way to bending the new technology to the humane needs of a genuine *new art* of architecture.

118

15. *Unification*

Man is unique from all other forms of organic life in two important ways. He is the only organism which is truly destructive, and his capacity to destroy steadily increases. It is a capacity, however, that can lead to the eventual destruction of human life itself. But there is another aspect to man's uniqueness. He alone of all organisms has the capacity to extend ceaselessly his potential to create. With that capacity, which no other form of life has, man can give *creative extension to his natural condition* and thus reach for ever higher orders of experiencing Nature and his own nature. The survival of man depends on his capacity ceaselessly to evolve the area of his natural creative condition in nature. Conversely, whenever man does as animals do, or repeats any other part of his past — as our century has done in art and architecture by disguising the past as new — the law of nature condemns man psychopathically to regress below what he was in the past. Therefore, if the amoeba must always be what the amoeba has always been if it is to survive, man must always be what he has not been if he is to survive as well as the amoeba. Thus man is not limited, as is an animal, to one form of life which each generation must repeat. Man alone is literally compelled to abstract creatively about the "natural" condition of life itself, in order to achieve ever greater creative plateaus of the natural. This is to say that man, of all living things, is not limited to imitating nature. Thus, in our century, out of the creative process of nature man as artist has become a non-mimetic creator. In that creative sense I propose some general considerations which new art suggests in order to continue Wright's achievements of the "natural house" as a prototype for future architecture. Where a Wright house often retained qualities of natural materials, the new natural house to be proposed here will not do so in any sense. Rather it will depend entirely on the use of prefabricated machine forms carrying colors as the visible aspect of a work, in the sense that Root envisaged the use of color in architecture. Such a natural house will not employ, in form or color, attributes peculiar to visible nature. To the contrary, in all its aspects the new house will exemplify qualities which are not to be found anywhere in visible nature, since these qualities are possible only to the unique creative nature of man when in harmony with creative nature.

* * * * * *

Stone architecture began as a result of the early architects' observation of nature, observation of the way in which nature creates an entity through building with similar units of structure. Thus the early stone architect hit on the notion of building with units of stone. Eventually he discovered the enormous advantage of "machining" his units of stone structure, either by cutting or moulding, which enabled him to build with precision. The early architect's discovery of this simple mode of structuring made possible the eventual complexity of subsequent mimetic architecture. Hence, the great flexibility of a very simple structural unit permitted ever increasing creative structural compexities. It was a grand simple harmony between the unit of building and the architectural forms built with it, each of similar geometric form — the rectangle block. In principle, this unit system remained unchanged throughout the mimetic era of cave architecture. What changed were the developing structural principles perceptually inspired by the *art* of architecture, and their ever more complex creative relations with nature. In that ancient and remarkable solution of a building unit lay the key to the resolution of the crisis of architecture in this century, but first the development of new art was necessary before the ancient prototype solution could supply the key to new architecture.

Through the structural development of the new art of creation the discovery was made that a new kind of building unit was necessary, one unique to the differing needs for structuring a new architecture. It would be necessary to replace the ancient, now obsolete, units of stone or brick block. Such sculptural units were only appropriate to the now obsolete "block" and "box" cave architecture of the mimetic sculptural past. A unit was needed that would allow for the particular *creative evolution of new architecture*. As the mimetic perception of form and space for architecture had to be a process of extension, so now the ancient building unit itself must be given extension, thus realizing a unit appropriate to the structurally new perceptual goal of non-mimetic architecture.

Painter Cezanne produced the new unit for both art and architecture. But that unit could not be recognized until the mimetic transition out of painting was completed in the birth of a new three-dimensional art. Early in this century one man created the use of this unit as it might apply to architecture. That man was Wright. But neither he nor the Europeans suspected the full import of his discovery: namely, that the *plane as space plane was also the new building unit* for new architecture. Only in reference to his skyscraping did Wright refer to the use of a "unit

70. Charles Biederman, *Work No. 5, Paris 1937.*

system,'' actually units which were not planes. When he wrote of freeing the house from the box, the plane was not presented as a single uniform unit system. He distinguished between the ancient "enclosing walls" and the release from the cave with "unattached" walls.[393] Yet by freeing the walls from the box, a transition to space planes replacing walls altogether had begun.

Once again the rectangle, this time as the plane spatially freed from the space displacing sculptural "block" of the past unit system, offered the appropriate structuring unit for the further development of Wright's house architecture. That is, planes and only uniform planes would encompass all the spaces between roof and floor. The spatial plane as building unit would replace the whole notion of walls. After all, walls were meant to close out exterior space and close in interior space, the obsolete structuring practice of cave architecture. Vertical planes would not be used to close out or close in space; each plane itself would stand in and open up into both exterior and interior space at the same time. The planes would alternate as opaque and transparent structures, all planes being of a uniform size throughout all structuring of the house. Along with their spatial role, the play between opaque and transparent planes would be to create the variances of the creative life of light for both exterior and interior. That would be to achieve the "new light" for the "new era" of art and architecture which Root envisaged in the early 1880's. Roofs, floors, ceilings would consist of a plurality of units to achieve such areas, but these horizontals would terminate in secondary planes of light. (figs. 82, 83)

Hence, the mimetic unit of the building block — form as space displacing or enclosing — would be replaced by the unit of spatial plane where space became a palpably integrated part of the perceived structure. The structuring possibilities of the new spatial units were beyond any estimation. For the first time a house could be wholly constructed as a completely non-mimetic creation, a spatial structuring of forms in the colors of light with only the use of a single uniform unit.

The underlying principle of the ancient unit system has endured to this day, even become the principle of an entirely new type of unit system because it is a *structural principle of nature's creative process itself*. Hence the

120

71. Charles Biederman, *Work No. 23, Red Wing, 1949*,
collection John and Eugenie Anderson.

structural law that operated in the past does so in the new architecture. And just as the "machined" uniformity of the ancient sculptural unit system offered a grand simplicity for building increasingly more complex mimetic structures, so, too, the new uniform unit system of spatial planes in the light would serve for future architecture.

The solution for both new art and new architecture first appeared in the structural achievements of Cezanne's very last landscape paintings. He did not set out to destroy the solidity of form structuring, but rather to give structural extension to it by releasing the planes from the space displacing forms. So, too, in architecture one does not destroy the box; one simply frees its planes in a new order of space and light. Thus the ancient building block of space displacement has been replaced by a spatial plane of light. One does not destroy rectangular composing of past architecture, one extensionalizes its use to form the *first structuring stage* of a new spatial architecture of light.

There are those, however, in both neo-sculpture and neo-architecture, who advance the view that retaining the old "mass" of space displacement will add "variety" to what they assume constitutes spatially disposed structuring. The unconscious assumption appears to be that the new is unable to stand on its own feet, unable amply to achieve all its own necessary "variety." Such attempts are clearly efforts to compromise the new with the old, which leads to regression.

It must be strongly emphasized that the creative objective of a spatial art is *structurally distinct* from that of "mass" space displacing perceptuality. Rather than supplying "variety" the introduction of the obsolescence of "mass" structure would only serve to confuse the achievement of the new perceptuality, as all neo-architecture attests. In effect, what is being proposed is the attainment of "variety" for non-mimetic structuring by having the

72. Charles Biederman, *Work No. 45, Red Wing, 1953–68*, private collection.

option of introducing mimetic structuring. One must make a clean perceptual break with the old or he certainly will break with the old and the new, too.

While the non-mimetic house will deal with shelter, this will be achieved without the prevailing overemphasis this subject receives as a substitute for want of anything else to say about architecture. More importantly, in contrast with cave architecture, the new house will be completely open to space and light. Light will flow around and with all the space planes to generate ceaseless creative changes of light (color) as in nature itself. The alternating opaque and transparent planes will evoke rhythms of motion for form, space and light to become part of the motion of nature. The new house born of a new perception will alter the visual life of man to an extraordinary degree; *a degree crucial to his useful physical-mental survival.*

The new house will not "socket" itself to, or seek to "blend" with, nature. Such an orientation was proper and necessary to past architecture, which floored itself to the earth as in natural caves. The new house will stand distinct from, yet remain in harmony with, nature. It will be raised from the surface of the site on non-visible supports, enough to allow the first floor to act as a space plane, and so come into spatial concert with all the other planes of the structure. The "ground floor," the very notion of a "ground plan," will pass into obsolescence with the cave structuring to which it mimetically belongs. It will be replaced by space plans. Raised directly into the space and light, the new house will attain that creation which was dormant and untapped in nature's creative process, which would never have reached creation without the presence of creative man within nature. The new house will not compromise nature to achieve a new harmony with nature. Indeed, nature will be revealed in a wholly new perceptuality induced by new art and new architecture.

The new architecture offers a true beginning. While it is an evolutionary artistic advance, creatively and structurally, it must also achieve a true beginning just as mimetic architecture did. To do so naturally requires a perceptual transition to non-mimetic nature and architecture.

73. Charles Biederman, *Work No. 23, Red Wing, 1954–68*, collection of Mr. and Mrs. Edson Spencer.

In the grand works of past space-displacing, the large interior and high ceiling served as an important spatial release from the confining walls. With the abolishment of walls in new architecture, and their replacement by colored spatial planes, space will flow primarily in all horizontal directions to become one with exterior space. As Wright was the first to discover, this will eliminate the need for high ceilings.

In mimetic architecture, the structure of form dominated and determined the lesser roles of space and light as the lighting of displaced or contained space. With form as plane amalgamating with space, the element of the color of light, the great dream of Root is released by giving the plane of Wright the color of light. Wright's choice of the color of building materials, rejecting applied color of paint, is carried to a third choice, i.e., the fabrication in optical colors of the building units themselves. Thus the vertical planes of color will respond to the ceaselessly changing varieties of light from the sun and sky. White planes will take in the varied colorations which light will give them, as all colored planes will reflect their own varieties of color. It will indeed be a "house of light" where color, as in nature, ceaselessly creates changing light colorations around and on all sides of all planes.

Horizontal planes will engage another order of light. Roof, ceiling and floor planes, each extending sub-planes beyond the verticals, will change from sun to sky planes as the sun moves across the sky. Where verticals and horizontals meet each other, where planes either intercept or allow light to pass, another structure of light (color) will appear. The color planes, as in new art, are reflecting or absorbing light planes mixing new colors in the light. At night, light will move in a reverse direction, through transparent planes which will light some of the sun and sky planes. Hence, the three orders of the motion of the colors of light are the sun, the sky, and artificial light. There is, then, the final full release of the fourth dimension of motion, as explained earlier with respect to the new art of light. For even at night, artificial light will be so devised that, as with sunlight, imperceptible motions will color the interior. A whole new world of perceptual creation will be opened up with a seemingly unlimited future for its creative evolution.

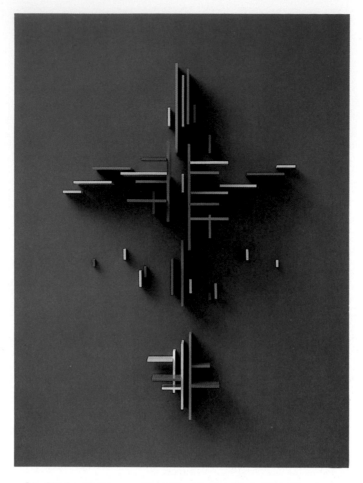

74. Charles Biederman, *Work No. 45, Red Wing, 1959–68*, private collection.

However, if the architect arbitrarily exploits the new means, and most will, one can predict with certainty that deserved failure will result. If the American does not want to continue the post-Cezanne-Wright defeat of Europe, he must recognize the inescapable laws of the *natural order of perceptual development*, already discussed in an earlier chapter. Therefore, the new natural house must develop from a proper beginning of simplicity which will allow for a coherent architectural evolution towards ever greater creative complexity. It is easy to be complex if one substitutes inventive conjurations for creation. The rectangular geometry of the plane supplies that simplest of geometry in three dimensions as the proper genetic means for *composing* a non-mimetic work, not "designing" it. Hence the geometry of the building unit will be structurally extensionalized throughout the work. The geometry of composing will evolve as the course of creative evolution structurally develops the new architecture. The evolutionary principle applies to the structural aspects of the composing.

Color too, must begin with simplicity and not with arbitrary exploitation. The primaries are introduced with white, one at a time, as creative development becomes ready for them. At such time as the general creative evolution reaches that need, the complementaries will be introduced again, one by one. In short, the order of development for the new art, based on the study of nature, will also serve as the order of structural development for new architecture. Thus, form, space, and light, all set in motion, will evolve together from a simple beginning to ever greater complexity of creation. Again, as in past art, the beginning and subsequent evolution of architecture will be imposed on man because the course of man and nature are firmly locked together. But, as with all other non-mimetic forms of art, the post-natal condition is in effect. Therefore, the evolution of architecture is not inescapably imposed, as it was in the past mimetic era. That is, the architect can reject it at a price, the price being the regressions of neo-architecture and its inevitable perceptual confusions. It is necessary to establish the fundamentals of the new architecture if, like mimetic architecture, it is to have a base from which to evolve. It is evident then, that to advocate the necessity for structural simplicity such as will permit creative evolution, is to advocate

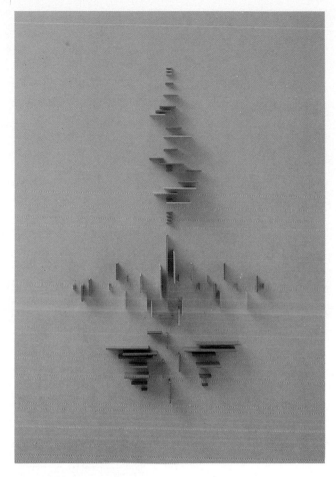

75. Charles Biederman, *Work No. 19, Red Wing, 1958–64*, collection of Mr. and Mrs. John Andrus.

the very reverse of the reductionist absurdity prevailing in today's art and architectural theories. Reductionism is but another disguise for destructionism. Hence, Mies's "less is more" eventually leads to the place where there is no "more" from which to make "less."

In applying the principle of creation, the new art will finally receive an architecture appropriate to it. For the new architecture of light will create an environment fulfilling the needs of the new art of light, the kind of space and light in which the motions of the new art will become the total architectural reality. Thus the new art and new architecture will exist together in the creative diversity of the motion of light as in the creations of nature. Together these two new arts will arouse the new perception of both nature and art in the eyes of all.

As in past architecture, development will be intimately bound up with the need for a mass-produced building unit, whether for houses or public structures. After more than a half century of attempts, all efforts to produce a mass-fabricated house have failed because of the general failure to approach the problem in the true sense of *art, not technology, as the key to mass-production*. The results have been at the expense of the art of architecture. The neo-Cubist solution, the invention of cubes or other shaped forms that can then be capriciously fastened to each other, is equally insensitive to the notion of new art and to mass-production. The former attempt has already desecrated so much land, crudely exploiting and perpetuating the box in its starkest ugliness; the latter kinds of solutions, authored by neo-architects or engineers posting as architects, are creatively and structurally so much nonsense. There exists a total ignorance of the need to produce a new building unit. Such failures are strictly due to the failure to achieve a genuine solution for the art of new architecture. A prefabrication for houses, says Hitchcock, is further from being solved than it was in the 1930's. Actually, there has not been a single genuine solution since the beginning of the mass production of building materials more than 125 years ago. It is the failure of architects and not, as Hitchcock believes, "in part" the public's failure because it lacks enthusiasm for domestic prefabrication. Architects have failed because they never understood the problem properly in the first place —

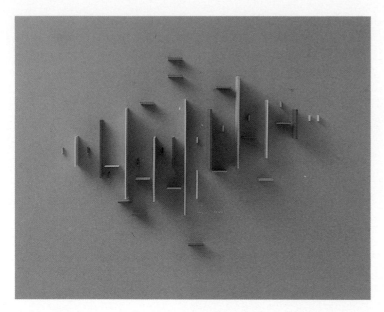

76. Charles Biederman, *Work No. 11, Red Wing, 1957–64*, private collection.

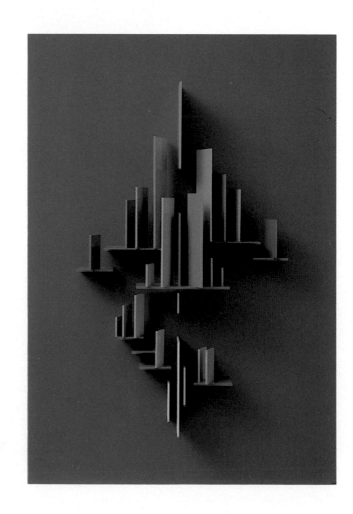

77. Charles Biederman, *Work No. 43, Red Wing, 1960–66*, private collection.

126

78. Charles Biederman, *Work No. 56, MKM, 1974–76*, collection of the artist.

namely, that the solution is one of art. The new architecture of light does supply a solution.

The new pre-cast building unit, the rectangular spatial plane, has already been described as a single uniform size for both opaque and transparent units. There is the simple solution. The new uniform unit system will be mass-produced by the machine, which will supply all that is needed to structure both vertical and horizontal aspects of a house. Most important, like the past building unit, the new one will possess the flexibility which allows each individual architect to achieve his own unique creation, providing, of course, that he does not neglect the demands of the *natural perceptual order of creative development*. With such an economically mass-produced unit system at his disposal, the great diversity of genuine architecture will once more be opened to the gifted architect.

Again, as Root warned a century ago, the architect must understand that the world of architecture opened to him by the new art, unless based on an extensional perception of nature, will avail him nothing except to corrupt the new with clever inventions in place of creative perceptions of nature.

We now discover a remarkable fact, one that reminds us of the great architectural accomplishments of the past. The fallacious course of neo-architecture is reversed. *It is the artistic principle, the new spatial form in the color of light composed in optical motion, not functional engineering, which provides a viable principle for the mass production of a house as a genuine work of art.* The artistic principle provides the creative principle within which the problem of function must be solved. Thus a symmetrical building unit capable of being mass produced is again possible, which allows for creative diversity. And, as with the mass produced works of great music, of great prose, poetry, photography and film, so the great works of future architecture would be available to all. This would have an enormous effect on the perceptual life of the majority of people.

In 1937, when this writer began the work out of which a new art would emerge, replacing the obsolescence of painting and sculpture with the machine medium, it became apparent the mass production of art had become possible. In this respect there are similar-differences between new art and new architecture. In the former, a

79. Charles Biederman, *Work No. 25, MKM, 1974–76*, collection of the artist.

symmetry building unit is present — the rectangular spatial plane. The simplest plane and all planes of the same dimension advocated for the beginning stages of new art are also advocated for the beginning stages of new architecture. The new art, however, has been developing since 1949; therefore, there already exists a small plurality of different dimensions in the planes. These are still very limited in both size and number, in color composition and the use of space, for if one attempts to hasten evolution, one ends in manipulating the structure of the new and literally ceases to create art. As the evolution of the new house develops, however, structural extension will gradually be introduced by the creative act of the art of architecture.

Any single original work of new art can be duplicated exactly in *un*limited mass production. In new architecture mass production becomes the means for producing original works. In the former then, the original is mass produced, while in the latter mass production makes original works possible. Thus the new architecture reverses the motto of skyscraping, stating that "function follows art." The advocates of the reverse view have been reduced to such a state of confusion that the architect talks only of function and materials as if he were talking about the sum and substance of architecture. Since the question of the art of architecture has become totally obscured, with each architect existing on his own little "puny" island in the "murky chaos," there then remains for discussion only the dubious certainty of function. Like the neo-sculptor, the neo-architect's works range from obvious space displacement to the "drawing" of "lines" representing a completely regressive notion of space. So eclectic has neo-architecture become that architects change style from one work to the next. The very nature of architectural development has become so thoroughly obscured since the Robie, the architect must speak of other things *as if* he is speaking about the substance of architecture. This is not to advocate indifference to function. Actually the dichotomy between art and function ceases in the new architecture of light. The symmetry building units, the spatial color planes of light, not only form the visible aspect of a work but each plane carries within its pre-cast interior all of the necessary technology. This will mean that all the ancient handcrafts of masonry architecture will become obsolete. New building machinecrafts will have to deal with the new materials and structuring. As Banham points out, the new technology has advanced to such a degree that nearly "any form" can now be given to the

128

80. Charles Biederman, *Work No. 3, MKM, 1974–76*, collection of Mr. and Mrs. Peter Butler.

81. Charles Biederman, *Work No. 39, Red Wing, 1961–71*, private collection.

82. Charles Biederman, *House Model 1972*, Red Wing. The reunification of exterior-interior now in a solar response of spatial form to nature's light.

structuring of architecture.[394] There lies the great danger; the neo-architect uses technology capriciously in "any form," rather than using the new technology to liberate each new development which the *new art* of architecture *demands*, e.g., as Wright did with his use of environmental technology in the Baker and Robie houses.

Contrary to recent belief that architecture is the "mistress of the arts" it has been demonstrated throughout history that great architecture has followed the perceptual-artistic determinations, first of sculpture and then of painting. This process continues in the new art which presents a creative three-dimensional structural resolution for a genuine new art for architecture. It is necessary to note that architecture is, in fact, an "applied art." As such, for its own creative welfare it must rely on the new art which is not restricted by the task of application, thus allowing it to supply the art and the theories essential to all applied art. In this respect it is necessary to note the new art is central to all the visual arts because it is the only art of the machine whose creative effort is not affected by the need for commercial application. For that reason, only the new art is able to devote its whole attention to perceptual evolution for a purely creative non-mimetic art. Its discoveries are then applicable to the various forms of applied art*s*. This is not to say that the new art does not have a functional role, for the last remarks are dealing with exactly such a role. There is, however, an even more basic function in which the fundamental nature of the new art calls attention to the fundamental quality of human beings, knowledge of which is essential if the new world is to be achieved — that is, the supreme quality of human life to be creative, not destructive, in all it does. For it is from the act of creation that all becomes possible for a viable future for human life. In the new art the non-mimetic perception of artistic creation will be evident in its purest state as the source for the very life of a new architecture, that is, perception as a developing, humanizing, creative principle.

In the history of art, the 19th century was most extraordinary. It remains to be fully understood and appreciated. New and immense problems arose then which still remain to be resolved, and denouncing the previous

83. Charles Biederman, *House Model 1972*, interior.

century, as has been done all too often, solves nothing. Out of that negative attitude has arisen the belief that art has become so free it can dispose of the past and nature. Consequently the artist's ignorance of the past and nature has engendered his enormous ignorance of himself, and his alleged superiority to nature has left him roaming in the wasteland of the "puny" isolated self. He has become an artistic automaton — a faker. The consequences are devastating. Wishing to be superior to the past artists and architects have fallen below the past, they have regressed it. In their indifference, if not hostility, to perceptual nature they are doomed to certain defeat. *Nature will have the artists one way or another*; there has never been a time in all the past history of art when as much was possible as is possible in this century.

For 50,000 years man has practiced the great handcraft arts of painting, sculpture, and architecture and one by one, each has become technically and artistically obsolete. Figurative sculpture soared to its last great achievements with the Romans. Architecture on the European continent fell into disarray after the fall of the Baroque. The greatness of mimetic painting rose to its last summit with Courbet, and painting itself reached its last greatness in Cezanne. With the opening of our century all the arts were not only fragmented from each other, but each art itself lay in fragments. All the arts in our century had ceased to have any unity of purpose.

Long before the confusion of the arts became evident the new machine arts began to appear, to prepare for a new future for art without hostility to the past. The camera appeared in 1839, and within another hundred years three machine arts existed to replace the mimetic handcraft arts of painting, sculpture and architecture. The unification process is again flowing; all the genuine uses of the machine arts are unified in purpose and the unity of the arts is again a reality. The unification process which had begun to disintegrate is again in motion. The new arts are unified by similar mediums and by a common perceptual attitude towards nature — hence the non-mimetic art of the camera, of pure creation, of architecture. Indeed the unifying impetus contained in the three new arts was present in their common birth, for the final resolution of each was born in the single art of painting. Thus painting, the image of light, is continued by each of the new arts, each giving a special optical extension for human

132

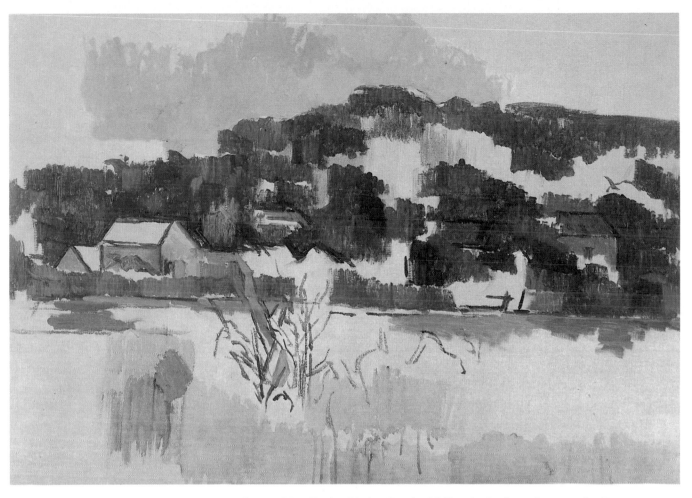

84. Paul Cezanne, *Houses On The Hill*, 1900–06, collection Marion Koogler McNay Art Institute, San Antonio, Texas.

perception. Only the camera continues non-mimetically the recording of images carried by visible light. The remaining two arts are both three-dimensional, creating, as does nature, with the actual reality of light. The unity of mimetic art is now the unity of non-mimetic art.

Each new art, then, shares with all others a related perceptuality, just as all past arts shared a common perception. In adopting a non-mimetic perception, the dichotomy between creative nature and creative man has vanished. Indeed it is not mere coincidence that that very dichotomy of the past reached its highest pitch in history precisely when the introverted effort was made to perpetuate each handcraft art after it became obsolete.

In the new art, the perception of nature is no longer prejudiced by man's aspirations to create art from what nature has already created. The true art of the camera, then, possesses a perception of nature wholly devoted to images of what nature has in fact created, without the falsifying introverted wish to modify deliberately the perceived image with art. The true artists of the camera will teach us to perceive the remarkable creations of nature. To this end it is necessary to perfect the machines for recording images of light. One day more perfected images will reach into every home; they will be life-size and life-like, easily mistaken for the images originating in our own eyes.

Architecture too, will cease to be mimetic. It will no longer imitate what is unique for nature to create, but create what is unique for man to create. Thus architecture will have greater rapport with nature than was previously possible. It will not do to disguise the fragments of the past in glittering materials. All that will be left behind as the architect gradually learns to release his new creative freedom in the forming of space and light. At last art can again become the central purpose of architecture, as it was in the grand temples of Egypt. Technology, engineering, the machine — these will become the invisible slaves of the new arts. Man will live where form, space and light flow around him; he will live and work in the harmony of *contrasts*, not *compromises*.

The art of the camera centers attention on the incredible creations of nature. The genuine camera artist will open the eyes of all to what is there to be seen but was not seen before.

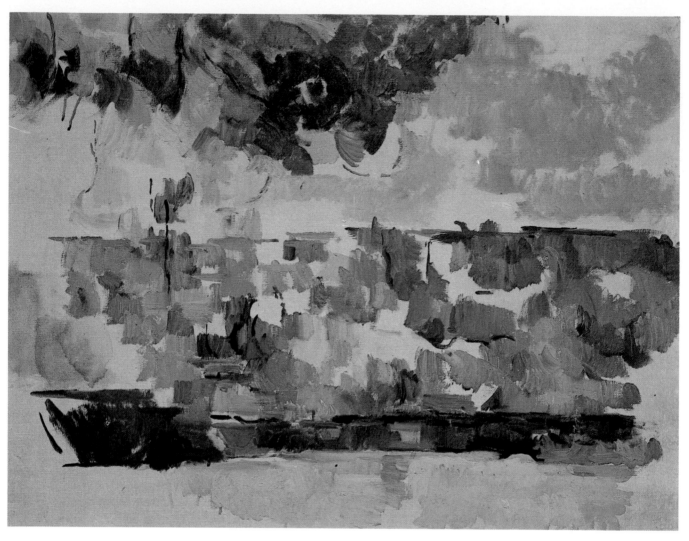

85. Paul Cezanne, *Garden at Le Lauves*, The Phillips Collection, Washington.

The art of pure creation, however, derives from perceptual creations inherent in the creative process of nature, which nature yields only to the creative effort of man. The new art is the most realistic vision of art ever to appear, because it engages the full scope of the reality spectrum, nature's creative process. Just for that reason the new art is fundamental to the proper understanding of the other two machine arts which still are badly understood. Indeed the perceptuality of the new art is related to all past modes of perception, making possible new insights into the past art of vision. If the old makes the new possible, the new makes possible a renewed vision of the old. The new art confirms what the scientist prizes above all in a theory; the capacity to account more completely for the nature of past and present facts, and to suggest where to watch for unknown new facts.

The first new art, photography, long ago became the first mass producing machine art, making its images accessible to everyone. The camera image can now be instantaneously transmitted universally. In spite of the mass production of the camera for laymen, few are aware of the fundamental perceptual nature of the new art.

Apart from skyscraping, the greatest abuse of mass production in architecture has occurred in the building of houses. In the future, however, it will be possible for the best works of the best architects to be mass-produced in any number desired. Such mass production will be particularly feasible for the house of new architecture, as it never could be for past domestic architecture. The new house will be distinct from and not "merged" or "socketed" or "blended" with nature. Accordingly any single work will have inherent variable potentials for orientation to a number of variable sites in nature, in the same way an oak tree is able to grow in various natural sites. Therefore the new natural house will not be sculpturally oriented to the natural site. By introducing a new

134

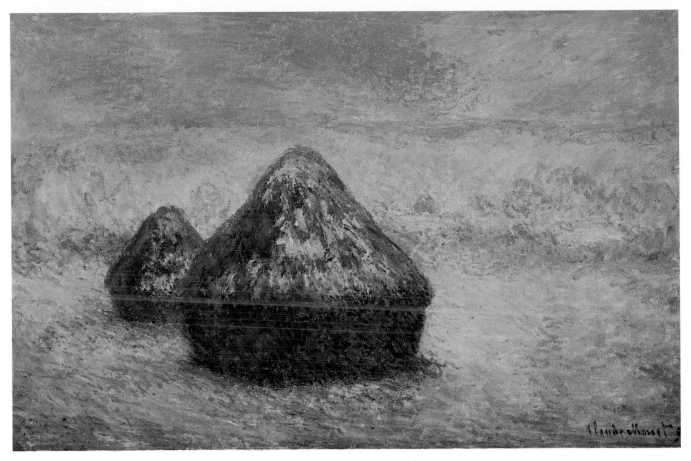

86 Claude Monet, *Haystacks, Setting Sun*, collection The Art Institute of Chicago.

non-mimetic configuration of structure, the relation of site to architecture will also be given perceptual extension. In mimetic architecture each individual work was inescapably oriented to a very limited perception of the variances inherent in any natural site. In the new architecture, any individual house can adapt to a number of natural sites. In this way, architecture can achieve a parallel with the structure of motion in nature because, as noted above, architectural creations will achieve the adaptability of nature's creations. If this extension of the fourth dimension of motion in architecture is properly understood perceptually, houses of a similar kind will all appear different due to their orientations to different natural environments.

Therefore, the new perception of nature's reality is not a static, absolute, mathematically computerized mechanical simulation of reality, but rather a reality where all entities possess an open-endness allowing them the variant possibilities of creative motion. In place of the past's quest for the perfect or absolute, the new artists and architects will perceive each individual work as a creative process, rejecting the still-born consequences of the absolute. Hence, mass-produced spatial planes will allow each architect to create individual houses, any one of which can then be mass-produced. As great works from the most gifted architects are accumulated, there will then be available a sufficient variety of houses, each adaptable to a large number of natural sites. The mediocre architect will become truly obsolete as the work of the best architects becomes available to all.

<p style="text-align:center">*　*　*　*　*　*</p>

Considering the extremely fundamental changes and ensuing chaos that have taken place in art, especially since 1839, it is not surprising that the teaching of art has become thoroughly confused. Consequently art schools have been reduced to play-pens, following the example of the New York art world.

Not so long ago, art schools were grounded in a narrow, dull, fictional allegiance to the past from which the student had to free himself if he wished truly to confront the past and the realities of his own art times. Today, however, the student has all the freedom he wants, because no one knows what is wanted of him. It is a useless

87. Charles Biederman, *Work No. 30, MacM, 1977–78*, collection Mr. and Mrs. John Ballion.

freedom. Again the student is caught in a narrow allegiance, but this time to an aimless freedom in the present where past and future are as nothing. He, too, must free himself if he is to confront the realities of his art times.

What then do the new arts portend for the future teaching of art? On the foundation of the new arts a new kind of education is possible. There is *first* the necessity for achieving a genuine art education in public schools. The following is a proposal of fundamental significance to the education of both artists and laymen, from kindergarten through university. It was suggested to this writer almost forty years ago while writing a new history of art.

Art education would consist of two directions of experience, each reinforcing the other. The child has an instinctive need to be an artist; he begins on a naive mimetic level of perception which is reinforced by bringing to his attention similar levels of perceptual effort. As in the earliest attempts of the cave man to produce an image, he thus begins by actually and naturally experiencing the genesis of art along with the study of the genesis of man's art, through visual and verbal material. Each time the child advances he will go on to study a still further stage of man's evolution as an artist as he himself is reaching a similar stage of experience as an artist. Thus, as the artist develops he will at the same time be developing his understanding of man's past efforts as an artist.

As an artist student of art and its history, one would be recapitulating in a condensed form the evolution of man as artist. Each child begins as an artist as naturally as did early man; the child passes through a similar perceptual evolution as he, too, becomes a mimetic sculptor and painter. It is imperative the child understands he is individually experiencing, not imitating, the past of man as artist. Just as each child must learn from the beginning to acquire language, to count, etc., so he must learn to acquire the perceptual experience of art from the beginning.

136

88. Charles Biederman, *Work No. 7, Boudin, 1977–79.*

In this way each individual child will receive a genuine art education in the perceptual experience of mimetic evolution both within himself and as that evolution took place in man's past. However, early in the child's mimetic evolution he will be made aware of the devastating force and consequence of perceptual conditioning. In this way the student will experience an unconditioned mimetic perceptuality of both nature and art which only the greatest artists of the past achieved. He will then experience nature and art as a *process of perpetual perceptual renewal*, the pace of which will be greatly accelerated in the case of non-mimetic perception.

The above, briefly presented, offers a way of truly beginning every child's visual education in the arts. Architecture will of course, be included, along with painting and sculpture. The important results of such an education are these: those students who leave school to make art their vocation will have been prepared to enter a new kind of art school: all the other students will become the first laymen in the arts who leave school truly educated in art. They will be prepared to respond individually to whatever appears in comtemporary art. Future art will no longer be at the mercy of non-artists who dictate to artists and laymen alike what shall or shall not be accepted in art. A well-educated art public will remedy that intolerable system which prevails: art will become truly democratic. All people will become visually educated when the greatest art and architecture is available to all through mass production.

For the student determined to become a professional artist, his further education will then commence in a new kind of art school, *The School of Unified Arts*. Here he will take his first steps to becoming a non-mimetic artist through a new perception of nature. He will achieve this new perception in a way similar to its achievement by the

89. Charles Biederman, *Work No. 17, MacM, 1977–78*.

first machine artists, by himself becoming a camera artist. This will include not only students who intend to become camera artists, but will also include students in the other two machine arts. All students from all fields of art will, as camera artists, take the first step into the new vision of nature and art.

What is being proposed is this: to achieve the non-mimetic vision of nature and art it is essential this vision develop in an order of evolution similar to the one in the past, the past representing as it does, the *natural order of perceptual development*. The laws of creative growth will prevail.

Accordingly, each student will realize his first non-mimetic or photographic vision of nature without the distortions of past notions of art or the destructive perceptual beliefs of neo-art. The student will see nature with an unprejudiced eye, nature as it had not been seen in the mimetic past. Thus will begin the future artist of pure creation, the artist of architecture as well as of the camera.

Next the three groups of art students will move to the perception of nature as a creative structural process, beginning with the structural transitions by which to reach a purely creative non-mimetic vision. Accordingly all students will begin to create non-mimetically with the simple space displacing form of the solid cube, at the same time engaging in creative structural studies of nature which will prepare them to become artists of the new spatial art of light. The use of the non-mimetic space displacing cube does not create new art, rather it is the beginning of transitional structural studies which naturally begin with the simplest of forms in their simplest space displacing relation. Too many wish to be instant artists of the new art, they are not prepared to learn.

Finally all three groups of students will take up the perceptual transition from cave building to a new architec-

90. Charles Biederman, *Work No. 9, Turner, 1977–79.*

ture of light. Again they will make a structural transition beginning with cubical space displacement, and gradually evolving to the new spatial art of architectural creation.

It goes without saying that during the three stages of the unification of perception in the three new arts, this education will be supplemented by the study of the past and the study of the development of the machine arts in Europe and America.

The student having experienced the three major new arts of the machine, having become fully aware of the new unification of all art, will then be prepared to follow his own new art or arts.

All that has been advocated here concerning the education for the new arts has been deliberately limited to brief general principles. There is a crucial need not to hasten at once to a detailed, programmatic solution. We are still at the beginning of the new arts and we must gradually find our way. Attempts immediately to encase the general principles in a neat formula will have the devastating effect of obscuring the way with scholarly clap-trap. Today artists either avoid standing for any principles or they make art the captive of formula. Therefore one takes great care to achieve general principles which will permit experience in the new arts to produce gradually the knowledge for more and more specific determinations. Only out of the experience of art can genuine theories arise.

* * * * * *

Europe gave birth to the first perceptually non-mimetic art, the art of photography. America gave birth to the first perceptually non-mimetic art of architecture, and to the first perceptually non-mimetic art of pure creation.

91. Charles Biederman, *Work No. 8, Monet, 1977–79*.

These arts, especially the last, now make unification possible in all the arts.

It has been made evident that what has been stirring in American art for more than a century and a quarter has realized what the future promises for art. The perceptual revolution, the first fundamental one in the whole history of art, was brought to its decisive realization by Americans. The American has not been sufficiently aware of those few Americans since 1840 who have realized an entirely new world of visual art, which Americans were uniquely fitted to realize. Three non-mimetic machine arts have extensionalized the handcraft methods and the perception of nature and art. All this remains to be perceptually comprehended.

There is now the promise of Monet and Root, an art and architecture of light. There is now the promise of Cezanne and Wright, the new structuring for arts of light.

Will Americans continue the achievements of their predecessors? Will American artists fulfill the promise of America's first great artists, the marvelous camera artists — Watkins, Muybridge, O'Sullivan, Jackson, Russell and others — the promise of Brady, Griffith, Root and Wright. Or will they continue holding a mirror to the obsolete handcraft arts of Europe, reflecting mutual defeat in the fallacies of European neo-art introversion?

* * * * * *

The Americans, never even a remotely significant part of the past's great mimetic art, did not produce any Giorgiones, Leonardos, Vermeers, Rembrandts, Poussins, Courbets, Monets, Cezannes. But for that very reason

140

they are most fitted to complete the transitions from the old to the new or non-mimetic arts, as the photo-landscapists of a century ago, as Brady, Griffith, Root and Wright have clearly proved. Americans are not superior to the Europeans anymore than the Italians, French, Romans, Greeks, etc., were superior to each other. Great changes require special conditions if art is to go further, conditions that leave artists sufficiently free of being psychically burdened by the great European past. These special conditions exist in the mid-West.

When the Dadaists spoke of civilization as "decadent" and "disintegrating," they were speaking of European civilization. With few exceptions, to the Europeans, America was culturally nothing. In the 1880's, an American, John Root, saw this "nothing" as precisely why the future of art would be in America.

Almost 140 years ago, America began to produce the new breed of artists. Like Monet and Cezanne they cherished the past and nature as the source of what it was possible for the new arts to achieve. Unknown to the chauvinists of American art, who are still with us, America had begun creating a unique and significant past, the achievement of the few who genuinely accepted the machine as the means to future new arts. The American artists of the future, like those before them in Europe, will achieve art as Americans, fulfilling their role in the continuity of the human evolution of art in the tradition of the great artists of the European past, from the cave artist to Paul Cezanne.

"The perception of beauty is directly related to the power of perception possessed by the artist."
 Courbet

Beauty?
"There's no such thing."
 Picasso

BIBLIOGRAPHY

a. *The Art of Painting*, Vol. 2 ed. by Pierre Seghers and Jacques Charpier, Hawthorn Books, New York 1964.

b. *Realism and Tradition in Art*, 1848–1900, by Linda Nochlin, Prentice Hall, Inc., Englewood Cliffs, New Jersey 1966.

c. *Impressionism and Post-Impressionism*, by Linda Nochlin, Prentice Hall, Inc., Englewood Cliffs, New Jersey 1966.

d. *Claude Monet*, by Stephen Gwynn, Country Life, Ltd., London 1936.

e. *Art as the Evolution of Visual Knowledge*, by Charles Biederman, Art History Publishers, Red Wing, Minnesota 1948.

f. *The History of Impressionism*, by John Rewald, The Museum of Modern Art, New York 1946.

g. *Georges Seurat*, by John Rewald, Wittenborn & Co., New York 1943.

h. *Letters to his Son Lucien*, by Camille Pissarro, Pantheon Books, New York 1943.

i. *Paul Cezanne*, by Joachim Gasquet, Bernheim-Jeune, Paris 1921.

j. *Conversation with Cezanne*, by Emile Bernard, R. G. Michel, Paris 1926.

k. *The New Cezanne*, by Charles Biederman, Art History Publishers, Red Wing, Minnesota 1958.

l. *Beaux Arts*, 1936, No. 177.

m. *Odilon Redon, Gustave Moreau, Rodolphe Bresdin*, by John Rewald, Dore Ashton, Harold Joachim, The Museum of Modern Art, New York 1961.

n. *Post-Impressionism*, by John Rewald, The Museum of Modern Art, New York 1956.

o. *Selected Writings of Gerard de Nerval*, ed. by Geoffrey Wagner, Grove Press, New York 1957.

p. *The Theory of the Avant-Garde*, by Renato Poggioli, Harvard University Press, Cambridge, Mass. 1968.

q. *From Baudelaire to Surrealism*, by Marcel Raymond, Wittenborn, Schultz, Inc., New York 1950.

r. *From Cubism to Surrealism in French Literature*, by Georges Lemaitre, Harvard University Press, Cambridge, Mass. 1941.

s. *The New York Times*, December 18, 1965.

t. *Julio Gonzales*, Museum of Modern Art Bulletin, New York 1956.

u. *Life with Picasso*, by Francoise Gilot and C. Lake, Signet Books, New York 1965.

v. *Picasso: His Life and Work*, by Roland Penrose, V. Gollancz, Ltd., London 1958.

w. *Juan Gris, His Life and Work*, by D. -H. Kahnweiler, Curt Valentin, New York 1947.

x. *Picasso, Forty Years of His Art*, ed. Alfred H. Barr, Jr., Museum of Modern Art, New York 1939.

y. *The Cubist Epoch*, by Douglas Cooper, Phaidon, New York 1971.

z. "Goerges Braque," *Cahiers D'Art*, #1–4, Paris 1935.

aa. *Georges Braque*, by H. R. Hope, Museum of Modern Art, New York 1949.

bb. *Cubism*, by P. W. Schwartz, Praeger, New York 1971.

cc. *G. Braque*, by Pierre Descargues, Abrams, New York 1971.

dd. *The Dada Painters and Poets*, ed. by Robert Motherwell, Wittenborn, Schultz, New York 1951.

ee. *Fantastic Art Dada Surrealism*, ed. by A. H. Barr, Jr. Museum of Modern Art, New York 1936.

ff. *The Cubist Painters*, by Guillaume Apollinaire, Wittenborn, Schultz, New York 1944.

Footnote Numbers. Footnote numbers appear in the first column. The second column of letters refers to the corresponding letters in the bibliography indicating the book referred to, the last column giving the page in the book.

1 . . . a, 302
2 . . . b, 85
3 . . . c, 38
4 . . . b, 86
5 . . . d, 84
6 . . . e, 264
7 . . . f, 434
8 . . . g, 49
9 . . . g, 7
10 . . . g, 57

11
11 . . . g, 50
12 . . . h, 127
13 . . . f, 370
14 . . . h, 221
15 . . . h, 126–127
16 . . . i, 90
17 . . . h, 275–276
18 . . . j, 82
19 . . . i, 90
20 . . . k, 15

21
21 . . . l
22 . . . i, 92

23 . . . j, 81
24 . . . m, 112
25 . . . m, 112
26 . . . n, 158
27 . . . o, 38
28 . . . n, 148–149
29 . . . p, 58
30 . . . q, 12

31
31 . . . r, 30
32 . . . m, 122
33 . . . s
34 . . . m, 25
35 . . . n, 170
36 . . . m, 13
37 . . . m, 22
38 . . . m, 25
39 . . . m, 114
40 . . . m, 21

41
41 . . . r, 33
42 . . . m, 18
43 . . . t, 44
44 . . . u, 69

45 . . . w, 133
46 . . . w, 133
47 . . . w, 61
48 . . . x, 13
49 . . . y, 51
50 . . . w, 71

51
51 . . . x, 16
52 . . . z, 21
53 . . . aa, 90
54 . . . u, 254
55 . . . u, 252
56 . . . u, 253
57 . . . u, 113
58 . . . u, 66
59 . . . u, 67
60 . . . x, 16

61
61 . . . x, 10
62 . . . bb, 165
63 . . . u, 53
64 . . . q, intro.
65 . . . x, 16
66 . . . aa, 149

67 . . . u, 53
68 . . . u, 54
69 . . . u, 54
70 . . . u, 248

71
71 . . . cc, 243–244
72 . . . u, 122
73 . . . j, 106
74 . . . u, 70
75 . . . y, 22
76 . . . y, 29
77 . . . dd, 144
78 . . . dd, 102
79 . . . ee, 15
80 . . . r, 169

81
81 . . . r, 170
82 . . . dd, 294
83 . . . r, 171
84 . . . r, 173
85 . . . r, 175
86 . . . r, 172
87 . . . dd, 263
88 . . . p, 62

gg. *Art of This Century*, ed. by Peggy Guggenheim, Art of This Century, New York 1942.

hh. *Surrealism*, the road to the absolute, by Anna Balakian, Noonday Press, New York 1959.

ii. *The History of Surrealism*, by Maurice Nadeau, Macmillan, New York 1965.

jj. *Plastic Art and Pure Plastic Art*, by Piet Mondrian, Wittenborn, Schultz, New York 1945.

kk. "On Abstract Art," by Piet Mondrian, *Cahiers D'Art*, Paris No. 1, 1931.

ll. *Piet Mondrian*, catalogue, Guggenheim Exhibition, New York 1972.

mm. *Piet Mondrian, Life and Work*, by Michel Seuphor, Abrams, New York 1956.

nn. *Essays on Art, 1*, by Kasimir Malevich, Borgens, Forlag a.s. Copenhagen, 1968.

oo. *De Stijl, 1917–1931*, by H.L.C. Jaffe, Alec Tiranti Ltd. London 1956.

pp. *Form #1*, Cambridge, England 1966.

qq. *Paintings, Sculptures, Reflections*, by Georges Vantongerloo, Wittenborn, Schultz, New York 1948.

rr. *Le Neo-Plasticisme*, by Piet Mondrian, Leonce Rosenberg, Paris 1920.

ss. *Surrealism*, by Patrick Waldberg, Skira, Lausanne 1962.

tt. "Mondrian, the Dutch and De Stijl," by J. J. Sweeney, *Art News*, Summer, New York 1951.

uu. "An Interview with Mondrian," by J. J. Sweeney, *Museum of Modern Art Bulletin*, Vol. XII, No. 4, New York 1948.

vv. "Mondrian in New York, A Memoir," by Carl Holty, *Arts*, New York Sept. 1957.

ww. "Van Doesburg, Stijl and All," by O. Leering, *Art News*, New York 1968.

xx. "The Constructive Idea in Art," by Naum Gabo, *Circle*, ed. by J. L. Martin, Ben Nicholson, N. Gabo, Faber and Faber, London 1937.

yy. "Sculpture: Carving and Construction in Space," by Naum Gabo in *Circle*, Faber and Faber, London 1937.

zz. *Gabo-Pevsner*, Museum of Modern Art, New York 1948.

aaa. See the "Realistic Manifesto," 1920.

bbb. *Constructivism*, Origins and Evolution, by George Rickey, Braziller, New York 1967.

ccc. *The Philosophical Impact of Contemporary Physics*, by Milic Capek, D. Van Nostrand & Co., Princeton 1961.

ddd. "A retrospective view of Constructive Reality," by N. Gabo, *Three Lectures on Modern Art*, Philosophical Library, New York 1949.

eee. "Russia and Constructivism," *Interview with N. Gabo*, in *Gabo*, Harvard University Press, Cambridge, Mass. 1957.

fff. "Constructive Art," by N. Gabo, *Horizon*, July, London 1944.

ggg. *Beyond Painting*, by Max Ernst, ed. R. Motherwell, Wittenborn, New York 1948.

hhh. *Max Ernst, Life and Work*, by John Russell, Abrams, New York 1967.

iii. *Surrealism*, by Patrick Waldberg, McGraw Hill, New York 1965.

jjj. *Dreamers of Decadence*, by Philippe Jullian, Praeger Publishers, New York 1971.

kkk. "Art in Crisis," by C. Biederman, *Studies in the Twentieth Century*, Troy, New York 1968.
"A note on new arts," by C. Biederman, *Studio International*, London, January, 1970.

lll. *Photography and the American Scene*, by Robert Taft, Dover Publications, New York 1964.

89 . . . dd, 28
90 . . . ff, 15

91
91 . . . gg, 17
92 . . . dd, 102
93 . . . hh, 143
94 . . . cc, 36
95 . . . gg, 141
96 . . . n, 149
97 . . . i, 92
98 . . . gg, 17
99 . . . gg, 16
100 . . . gg, 14

101
101 . . . j, 83
102 . . . j, 97
103 . . . i, 117
104 . . . i, 90
105 . . . j, 89
106 . . . j, 92
107 . . . i, 85
108 . . . j, 82
109 . . . j, 79
110 . . . i, 84

111
111 . . . i, 116
112 . . . i, 94

113 . . . i, 83
114 . . . j, 80
115 . . . j, 81
116 . . . m, 114
117 . . . ii, 97
118 . . . jj, 42
119 . . . jj, 54
120 . . . jj, 42

121
121 . . . kk
122 . . . ll, 25
123 . . . jj, 10
124 . . . jj, 42
125 . . . ll, 25
126 . . . mm, 74
127 . . . nn, 19
128 . . . nn, 24
129 . . . nn, 37
130 . . . oo, 133

131
131 . . . oo, 154
132 . . . pp, 5
133 . . . qq, 28
134 . . . mm, 323
135 . . . jj, 58
136 . . . rr, 10
137 . . . rr, 3
138 . . . rr, 138

139 . . . ss, 47
140 . . . jj, 59

141
141 . . . jj, 47
142 . . . mm, 317
143 . . . jj, 19
144 . . . vv, 18
145 . . . tt, 62
146 . . . uu, 16
147 . . . rr, 12
148 . . . kk
149 . . . vv, 18
150 . . . ww, 39

151
151 . . . jj, 19
152 . . . xx, 6
153 . . . yy, 106
154 . . . yy, 107
155 . . . yy, 108
156 . . . yy, 107
157 . . . u, 209
158 . . . jj, 13
159 . . . zz, 52
160 . . . aaa

161
161 . . . aaa
162 . . . bbb, 225
163 . . . ccc, 4

164 . . . aaa
165 . . . yy, 105
166 . . . yy, 106
167 . . . yy, 105
168 . . . yy, 105
169 . . . ddd, 71
170 . . . xx, 3–4

171
171 . . . eee, 159
172 . . . eee, 180
173 . . . oo, 144
174 . . . mm, 323
175 . . . xx, 4
176 . . . yy, 109
177 . . . yy, 109
178 . . . ff, 19
179 . . . yy, 106
180 . . . xx, 8

181
181 . . . fff, 61
182 . . . xx, 8
183 . . . aaa, 183
184 . . . bbb, 23
185 . . . i, 102
186 . . . i, 119
187 . . . i, 125
188 . . . q, 241

mmm. *D. W. Griffith*, The Years at Biograph, by R. M. Henderson, Farrar, Straus and Giroux, New York 1970.

nnn. "Touching the Broader Issues of Modern Art," by John Szarkowski, *Art News*, Sept. New York 1973.

ooo. "Man Captures Records of Light," in *Art as the Evolution of Visual Knowledge*, by C. Biederman 1948.

ppp. "Dialogue on Art as Imitation or Creation," by C. Biederman, *Main Currents of Modern Thought*, March-April, 1962, New York.

qqq. "A non-Aristotelian Creative Reality," by C. Biederman, *Structure*, Fourth Series, 2, Amsterdam 1962.

rrr. "Sphere and Cube," by C. Biederman, *Structure*, Sixth Series, 1, Amsterdam 1964.

"Symmetry, Nature and the Plane," by C. Biederman, *Structure*, Third Series, 1, Amsterdam 1960.

sss. *Eric Mendelsohn*, by Wolf von Eckardt, George Braziller, New York 1960.

ttt. "Cubism and Relativity," by Paul M. Laporte, *Art Journal*, xxv, 3, New York 1946.

uuu. "Art and Science as Creation," by C. Biederman, *Structure*, Fourth Series, 1, Amsterdam 1958.

vvv. *Biology and Man*, by George G. Simpson, Harcourt, Brace and World, New York 1964.

yyy. "Nature and Art," by C. Biederman, *Structure*, Second Series, 1, Amsterdam 1959.

xxx. "Constructivism and Content," by John Ernest, p. 154, *Studio International*, April 1966, London.

yyy. "Nature and Art," by C. Biederman, *Structure*, Second Series, 1, Amsterdam 1959.

zzz. "Creative or Conditioned Vision," by C. Biederman, DATA, Faber and Faber, London 1968.

A. *The Art of Painting*, Vol. 1, ed. by Pierre Seghers, Hawthorn Books, New York 1964.

B. *A Documentary history of Art*, Vol. 1, ed. by Elizabeth G. Holt, Doubleday, Garden City, New York 1957.

C. *The Architecture of Humanism*, by Geoffrey Scott, Doubleday, Garden City, New York 1954.

D. *Pioneers of Modern Design*, by Nikolaus Pevsner, Penguin Books, Middlesex, England 1970.

E. *Modern Architecture in Color*, by W. Hofmann and U. Kultermann, Viking press, New York 1970.

F. *Space, Time and Architecture*, by S. Giedion, Harvard University Press, Cambridge, Mass. 1943.

G. *The Chicago School of Architecture*, by Carl W. Condit, University of Chicago Press, Chicago 1964.

H. "The Chicago School of Architecture," A Symposium, Part 1, Part 2 by Winston Weisman, et al., Prairie School Review, Vol. IX, Nos. 1 and 2, The Prairie School Press, Illinois 1972.

I. *Louis Sullivan*, by Albert Bush-Brown, George Braziller, New York 1960.

J. Paul Johnson in *The New Statesman*, Dec. 8, 1972.

K. *A Visual History of Twentieth-Century Architecture*, by Dennis Sharp, New York Graphic Society, Ltd. Greenwich, Conn. 1972.

L. *John Wellborn Root*, by Harriet Monroe, The Prairie School Press, Park Forest, Ill. 1966.

M. *The Literature of Architecture*, ed. by Don Gifford, Dutton, New York 1966.

N. *The Architecture of John Wellborn Root*, by Donald Hoffmann, John Hopkins University Press, Baltimore 1973.

O. *The Rise of an American Architecture*, by R. Hitchcock, A. Fein, W. Weisman, V. Scull, Praeger Publishers, New York 1970.

189 . . . q, 250
190 . . . ggg, v

191
191 . . . hhh, 210
192 . . . iii, 60
193 . . . jjj, 25
194 . . . jjj, 28
195 . . . jjj, 35
196 . . . jjj, 200
197 . . . ggg, v
198 . . . jj, 42
199 . . . oo, 215
200 . . . jj, 41

201
201 . . . u, 69–70
202 . . . m, 29
203 . . . m, 32
204 . . . m, 44
205 . . . j, 94
206 . . . i, 115
207 . . . kkk
208 . . . e
209 . . . e
210 . . . lll, 69

211
211 . . . lll, 69
212 . . . lll, 311
213 . . . mmm, 172

214 . . . nnn, 50
215 . . . ooo
216 . . . j, 105
217 . . . ppp
218 . . . qqq
219 . . . i, 92
220 . . . rrr

221
221 . . . bbb, 117–118
222 . . . ccc, 13
223 . . . sss, 14
224 . . . ttt, 246
225 . . . uuu
226 . . . ccc, 13
227 . . . yy, 108
228 . . . yy, 108
229 . . . vvv
230 . . . vvv, 4

231
231 . . . qq, 9
232 . . . xxx, 154
233 . . . yyy
234 . . . zzz
235 . . . R, 181–183
236 . . . C, 36
237 . . . B, 241
238 . . . JJ, 93
239 . . . JJ, 94
240 . . . JJ, 95

241
241 . . . JJ, 112
242 . . . C, 40ff
243 . . . C, 54–55
244 . . . C, 60ff
245 . . . JJ, 97
246 . . . JJ, 97
247 . . . JJ, 98
248 . . . D, 133
249 . . . E, 9
250 . . . D, 42

251
251 . . . E, 16
252 . . . F, 10
253 . . . G, fn. 51
254 . . . G, 27
255 . . . KK, 344
256 . . . I, 21
257 . . . J, 226
258 . . . K, 281
259 . . . G, 106
260 . . . M, 467

261
261 . . . G, 140
262 . . . N, 86
263 . . . O, 156
264 . . . O, 116
265 . . . F, 183
266 . . . F, 195

267 . . . F, 183
268 . . . F, 193
269 . . . F, 10
270 . . . F, 193

271
271 . . . P, 96
272 . . . Q, 526
273 . . . G, 160ff
274 . . . H, #1, 6ff
275 . . . JJ, 25
276 . . . JJ, 162
277 . . . JJ, 162
278 . . . PP, 190
279 . . . JJ, 180
280 . . . NN, v.55

281
281 . . . OO, v.32
282 . . . PP, 12
283 . . . PP, 13
284 . . . PP, 96
285 . . . PP, 128
286 . . . PP, 128
287 . . . PP, 129
288 . . . R, 33
289 . . . M, 389
290 . . . M, 607

291
291 . . . M, 612

P. *Architecture, You and Me*, by S. Giedion, Harvard University Press, Cambridge, Mass. 1958.

Q. *The Eternal Present*, by S. Giedion, Bollingen Foundation, New York 1964.

R. *History of the House*, ed., by Ettore Camesasca, G. P. Putnam's Sons, New York 1971.

S. "F. L. Wright, 1867–1967," by H. R. Hitchcock, *Prairie School Review* Vol. IV, No. 4, The Prairie School Press 1967.

T. *Frank Lloyd Wright: Writings and Buildings*, ed. by Edgar Kaufmann and Ben Raeburn, The World Publishing Co., Cleveland 1969.

U. *On Architecture, F. L. Wright*, ed. by F. Gutheim, Grosset & Dunlop, New York 1941.

V. *Genius and the Mobocracy*, by F. L. Wright, Duell, Sloan & Pearce, New York 1949.

W. *Pier Luigi Nervi*, Ada Louise Huxtable, Braziller, New York 1960.

X. *Theory and Design in the First Machine Age*, by Reyner Banham, The Architectural Press, London 1960.

Y. *An American Architecture*, F. L. Wright, Horizon Press, New York 1955.

Z. *Architecture, Man in Possession of His Earth*, by F. L. Wright, Macdonald, London 1962.

AA. *The Work of F. L. Wright*, The Wendigen Edition, Bramhall House, New York 1965.

BB. *The Natural House*, by F. L. Wright, Horizon Press, New York 1954.

CC. "Art and Architecture," *Structure*, Vol. I, Amsterdam 1958.

DD. *Le Corbusier*, by Francoise Choay, George Braziller, New York 1960.

EE. *Mies van der Rohe*, by Philip C. Johnson, Museum of Modern Art, New York 1947.

FF. *Architects on Architecture*, by Paul Heyer, Walker & Co., New York 1966.

GG. *A Testament*, by F. L. Wright, Bramhall House, New York 1957.

HH. *Architecture of the Well-Tempered Environment*, by Reyner Banham, The Architectural Press, London 1969.

II. *The Meanings of Architecture*, by J. W. Root, ed. by Donald Hoffmann, Horizon Press, New York 1967.

JJ. *Architecture In The Age of Reason*, Emil Kaufmann, Dove Publications, Inc., New York 1955.

KK. *Architecture: Nineteenth and Twentieth Centuries*, Henry-Russell Hitchcock, Penguin Books Middlesex, England 1975.

LL. *Architecture and Design: 1890–1939*, edited by T. and C. Benton, Watson-Gupil Publications, New York 1975.

MM. *Three Revolutionary Architects*, Boullee, Ledoux, Lesque, Emil Kaufmann, Transactions of the Philosophical Society, V. 42, 1952.

NN. "Picturesque In Architecture," Nikolaus Pevsner, Journal of the Royal Institute of British Architects, V. 55, London 1947.

OO. "Picturesque Eclecticism," C. L. V. Meeks, Art Bulletin, V. 32, London 1950.

PP. *The Picturesque*, Christopher Hussey, 1927 Archon Books, Hamden, Conn., x, 1967.

QQ. *The Domination of Nature*, William Leiss, Beacon Press, Boston 1974.

RR. "A Sense of Crisis About the Art of Architecture," Ada Louise Huxtable, New York Times, Feb. 20, 1977.

SS. *Frank Lloyd Wright*, Marco Dezzi Bardeschi, The Hamlyn Publishing Group Ltd., Middlesex, England 1972.

TT. Age Of The Masters, Reyner Banham, Architectural Press Ltd. England 1975.

292 . . . M, 615	319 . . . T, 43	344 . . . MM, 443	**371**
293 . . . S, 7	320 . . . T, 284	345 . . . MM, 470	371 . . . M, 592
294 . . . T, 55		346 . . . MM, 446	372 . . . F, 259
295 . . . U, 26	**321**	347 . . . MM, 516	373 . . . F, 262
296 . . . T, 71	321 . . . V, xiii	348 . . . LL, 171	374 . . . F, 264
297 . . . V, 110	322 . . . V, 65	349 . . . MM, 479	375 . . . U, 91
298 . . . U, 24	323 . . . BB, 155	350 . . . MM, 699	376 . . . II, 26–27
299 . . . U, 26	324 . . . CC, 48		377 . . . II, 208
300 . . . T, 60	325 . . . T, 285	**351**	378 . . . II, 25
	326 . . . BB, 186	351 . . . MM, 435	379 . . . II, 25
301	327 . . . V, 104	352 . . . RR, 33	380 . . . T, 95
301 . . . F, 151	328 . . . DD, 22	353 . . . FF, 27	
302 . . . F, 151	329 . . . DD, 30	354 . . . AA, 58	
303 . . . D, 30	330 . . . LL, 132	355 . . . GG, 131	**381**
304 . . . W, 16		356 . . . GG, 131	381 . . . II, 222
305 . . . W, 17	**331**	357 . . . U, 148	382 . . . II, 25
306 . . . LL, xix	331 . . . KK, 21	358 . . . V, XII	383 . . . II, 222
307 . . . X, 151	332 . . . KK, 416	359 . . . T, 58	384 . . . II, 25
308 . . . X, 187–188	333 . . . KK, 395	360 . . . T, 227	385 . . . II, 177
309 . . . X, 188	334 . . . KK, 386		386 . . . II, 31
310 . . . Y, 76	335 . . . KK, 578	**361**	387 . . . II, 20
311	336 . . . EE, 184	361 . . . jj, 26	388 . . . V, 3
311 . . . Z, 11	337 . . . KK, 48	362 . . . GG, 19	389 . . . T, 102
312 . . . Y, 35	338 . . . KK, 428	363 . . . HH, 111	390 . . . KK, 279
313 . . . Y, 38	339 . . . MM	364 . . . V, 41	
314 . . . Y, 42	340 . . . MM, 439	365 . . . N, fn. 163	**391**
315 . . . T, 23		366 . . . N, fn. 163	391 . . . KK, 513
316 . . . QQ, 88ff	**341**	367 . . . II, 178	392 . . . KK, 476
317 . . . AA, 87	341 . . . MM, 444	368 . . . II, 179–180	393 . . . Y, 77
318 . . . AA, 88–89	342 . . . MM, 439	369 . . . II, 185	394 . . . TT, 30
	343 . . . MM, 440	370 . . . N, 163	

BOOKS BY BIEDERMAN

ART AS THE EVOLUTION OF VISUAL KNOWLEDGE, 1948, *out of print*
LETTERS ON THE NEW ART, 1951, *out of print*
THE NEW CEZANNE, 1958, *in print*
SEARCH FOR NEW ARTS, 1979, *in print*

Printed in the United States of America,
by the North Central Publishing Company,
St. Paul, Minnesota.